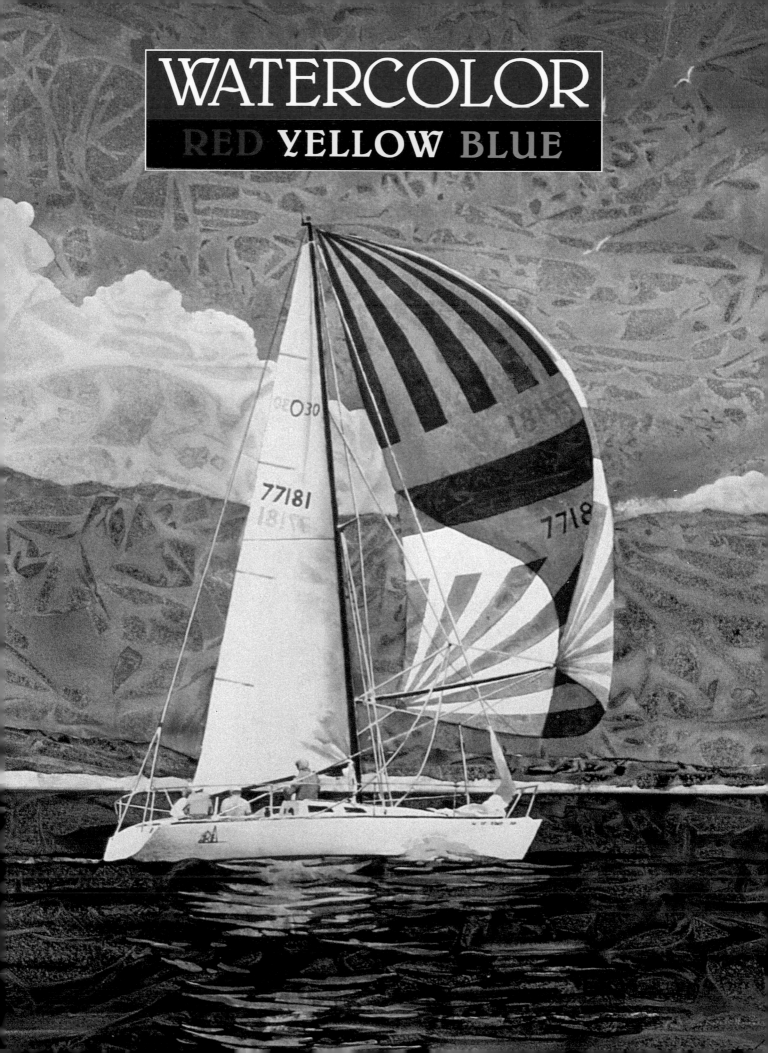

WATERCOLOR
RED YELLOW BLUE

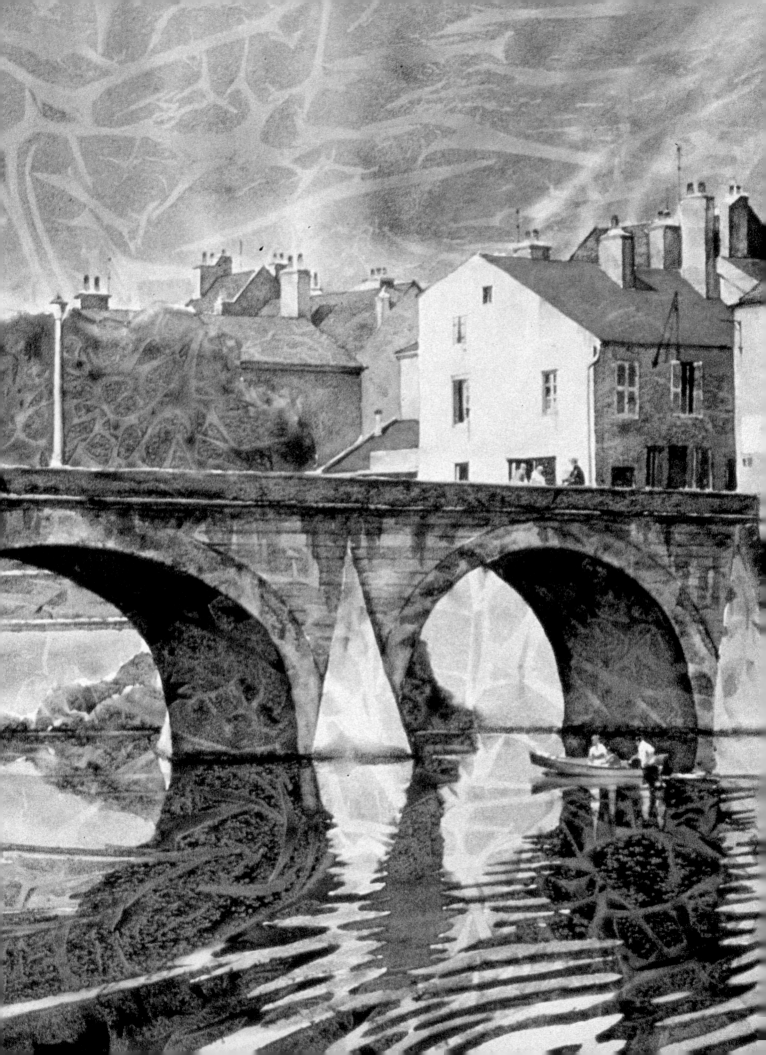

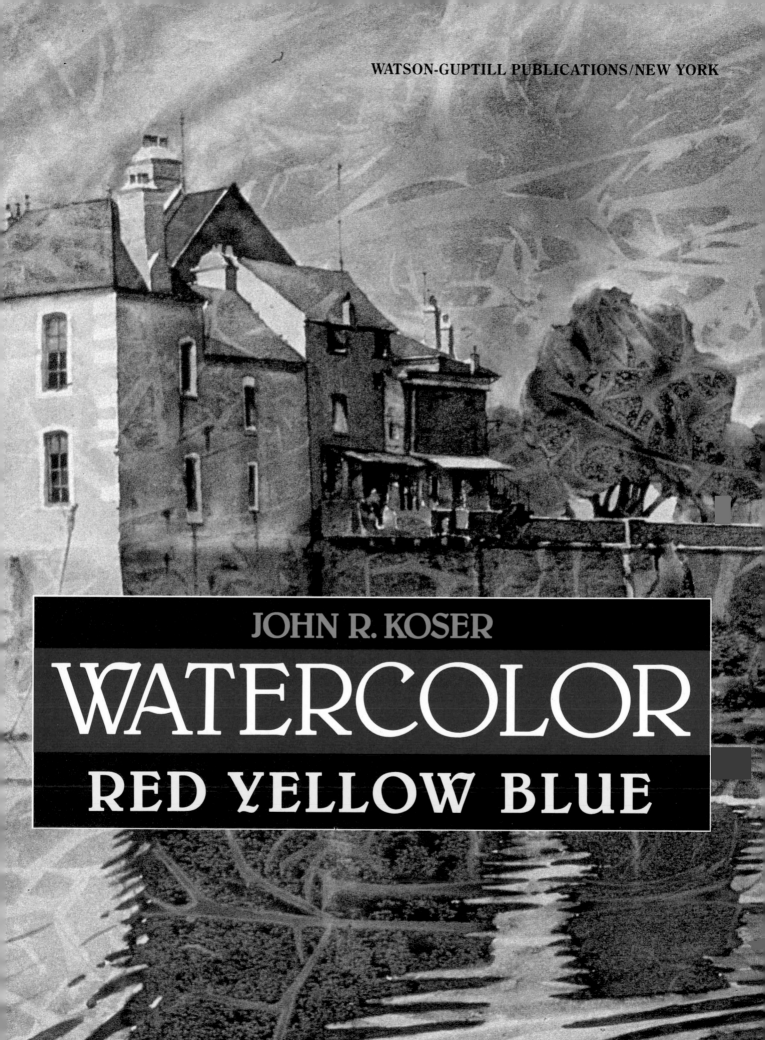

WATSON-GUPTILL PUBLICATIONS/NEW YORK

JOHN R. KOSER

WATERCOLOR

RED YELLOW BLUE

Half-title page:
SUNDAY AFTERNOON CHANNEL SAILING,
watercolor, 25″ x 20″ (63.5 x 50.8 cm).
Collection of Dr. David P. Tonnemacher.

Title page:
SUMMER REFLECTIONS,
watercolor, 22″ x 29″ (55.9 x 73.7 cm).
Collection of Mr. and Mrs. Gary Osborn.

Page 6:
LION ARTED,
watercolor, 32″ x 22″ (81.3 x 55.9 cm).
Collection of Mr. and Mrs. Kenneth Fullerton.

Pages 10–11:
CATSKILL FIRE WOOD,
pencil, 9″ x 12″ (22.9 x 30.5 cm).
Collection of the artist.

Pages 26–27:
LAKEWOOD FENCES,
watercolor, 20½″ x 28½″ (52 x 72.4 cm).
Collection of Mr. and Mrs. Ronald E. Newell.

Pages 60–61:
SPRING FLOWER STILL LIFE WITH IVY, SERIES II,
watercolor, 17″ x 21″ (43.2 x 53.3 cm).
Private collection.

Pages 104–105:
CALIFORNIA ARROYO,
watercolor, 20″ x 25″ (50.8 x 63.5 cm).
Collection of Dr. David P. Tonnemacher.

Copyright © John R. Koser

First published in 1990 in the United States by Watson-Guptill Publications,
a division of Billboard Publications, Inc., 1515 Broadway, New York, NY 10036.

Library of Congress Cataloging-in-Publication Data

Koser, John R.
 Watercolor red yellow blue : intermediate techniques for bringing
color to life with a primary palette / John R. Koser.
 p. cm.
 ISBN 0–8230–5679–1
 1. Watercolor painting—Technique. 2. Color in art. I. Title.
ND2420.K64 1990 89–70579
751.41'2—dc20 CIP

Distributed in the United Kingdom by Phaidon Press Ltd.,
Musterlin House, Jordan Hill Road, Oxford OX2 8DP.
Distributed in Europe, the Far East, South East and Central Asia, and
South America by RotoVision S.A., 9 Route Suisse, 1295-Mies, Switzerland.

Manufactured in Singapore

First printing, 1990

1 2 3 4 5 6 7 8 9 10 / 94 93 92 91 90

For Cyndi, Debi, and Cecilia.

Acknowledgments

My thanks to my wife, Bettye, for her support and practical help through all the phases of authorship.

To Marian Appellof, my editor and friend, for her insight and professionalism, and for giving the text structure and direction.

To Betty Newell and Janet Ramont, for their expertise in words and photography.

To Mary Suffudy, who started it all over dinner at The Chronicle.

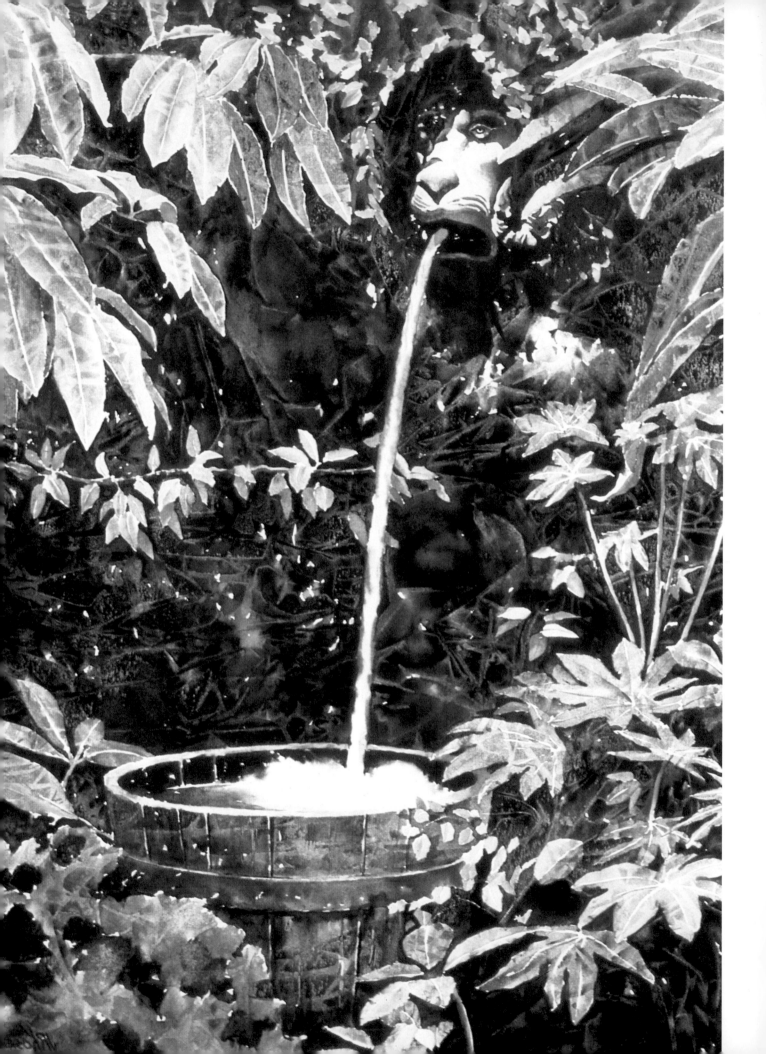

CONTENTS

PREFACE 9

PART 1 DRAWING: A WAY OF SEEING 10
Choosing Subjects 12
Exploring New Subjects 13
What Happens When You Draw? 14
Exploratory Drawings 16
Making a Painting Plan 20

PART 2 DESIGN: ORGANIZING THE COMPOSITION 26
Unifying the Composition 28
Basic Design Elements 29
Basic Compositional Formats 33
Establishing a Horizon Line 44
Distant and Close-up Views 46
Hard and Soft Edges 47
Open and Closed Compositions 48
Dealing with Space in Design 49
Value in Design 54

PART 3 COLOR AND TEXTURE: EXPLORING NEW FRONTIERS 60
Understanding Color 62
Basic Color Terms 64
Local and Reflected Colors 65
Warms and Cools 66
High Key and Low Key 68
Contrasts and Complements 69
Muted and Intense Colors 70
Using a Limited Palette 72
Physical Properties of Pigments 74
Potency Factor of Pigments 75
Working with Primary Colors 78
Mixing Color Directly on the Painting Surface 80
Non-Contact Method 82
Regulating Paint Flow 88
Adjusting Color: Glazing 90
Warming Up 92
Lifting Color and Using Resists 94
Creating Textures 96
Paper and Pigment Textures 97
Monoprinting 98
Nonabsorbent Wrapping Paper for Monoprinting 100
Other Texturing Techniques 102

PART 4 TECHNIQUES: EXPERIMENTING WITH COLOR, TEXTURE, AND MIXED MEDIA 104
Approaching New Techniques 106
Rooted in the Past 108
Pacifica Series VII 110
Tina's Cottage 114
Early August on Elk River Road 118
Stolker Castle on Loch Linnhe 124
Bibury Row Houses 128
Portloe 132
Spring Waterfall in Dartmoor 134
Prairie Creek Redwood Stump 138
Duanesburg Tunnel and Waterfall 140
Index 143

PREFACE

At this point in my life, the decision to write a book on my attitudes and beliefs in art was not easy. It was only after much careful and meditative consideration on my part, advice from my wife, Bettye (who would surely bear the brunt of the highs and lows of authorship), and encouragement from Watson-Guptill's Executive Editor, Mary Suffudy, that I decided to embark on the task of sharing my experiences.

In *The Winning Ways of Watercolor,* Rex Brandt wrote, "There are no absolutes in painting. All is measured by the relative term, quality. It is in this search for quality that the artist is, of necessity, the eternal student." To this I will add my belief in the need for constant searching and exploring by all artists. It is hoped that this will lead to new horizons, both as one learns from the work of others and as one learns by self-expression, experimentation, intuitive response, and continual practice.

At present, I work primarily in watercolors, but I have used various media such as graphite pencil, charcoal, and Conté crayon for drawings; pastels, which I have incorporated into my watercolors; oils; and printmaking. Though each medium has its own characteristics and personality, they all share the laws and principles that can determine the elements of good color, form, balance, mood, tonal value, and effective use of space. Edgar A. Payne offers this thought in his book, *Composition of Outdoor Painting*: "The study of art does not consist of continually searching for something new in the way of principles, but rather in an intensive analysis of old principles. When the purpose and flexibility of principles is understood, it is easier to form new ideas and translations built upon these very essentials."

Early in my art career, depicting the subject as truly as possible was my major priority. I still occasionally accept commercial commissions where being clear, explicit, and technically correct are the primary objectives. But I never completely set aside my personal feelings for design, line, and "eye appeal" even in these seemingly unaesthetic commercial assignments.

In my paintings I use the subject material for inspiration. I feel a strong and compelling desire to know and understand it thoroughly and to find and "own" its inner spirit.

The most reliable way for me to capture the true nature of my subject is through drawing. I try to draw with an open mind, like an explorer searching for its essence and spirit. By learning enough about the subject, I can feel free to use abstraction to portray it.

In the following pages I will try to share with you some basic, fundamental principles that have worked well for me. I have included effective, informative techniques, the impact of color, and design and compositional principles and formats that will, I hope, help you in your artistic endeavors.

BACK STREET BAROQUE,
watercolor, 25" x 20" (63.5 x 50.8 cm).
Collection of Dr. David P. Tonnemacher.

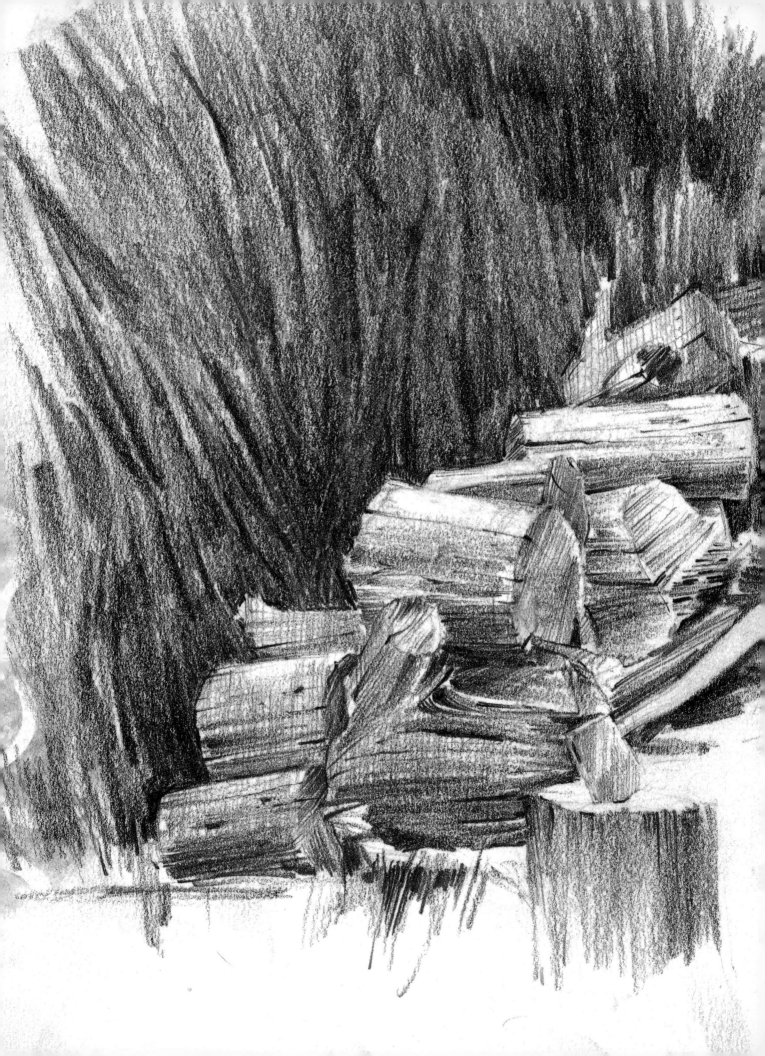

PART 1

DRAWING

A WAY OF SEEING

CHOOSING SUBJECTS

Choosing what to paint is an important factor in the initial stage of the creative process. For that reason, I will mull over some facts and opinions that may help shed some light in this area.

Painting what you know well is a safe, practical, and positive rule. If you are familiar with the subject (whether it is a person or object), you will be able to clearly define your relationship and interpret it on paper. The more firsthand knowledge and understanding you gain of the subject, the better your chances are of making a good painting.

As an initial step, you should observe, evaluate, and closely examine the everyday things in your immediate surroundings. You may find your next subject in your home, on a walk through the park or neighborhood, or even in your studio. Many great artists used their everyday environment as subjects for their artwork. Matisse is well known for his still lifes and interiors. Shoes, chairs, and flowers helped van Gogh stretch his imagination to its limit. Cézanne's landscapes were painted from nearby surroundings.

By studying the shapes of objects and knowing what draws you to them, you will discover numerous subjects for painting. It is the spiritual attachment or deep feelings you have about a subject that adds the personal touch that makes a painting. With this in mind, you can literally paint a part of yourself into your art.

Another factor you must consider is the renderability of the subject. Regardless of which style you choose to work in—totally abstract, expressionistic, impressionistic, or photorealistic—you must ask yourself, "Is the subject paintable? Can I 'see' myself through the entire technical rendering?" If you cannot visualize a workable way through to the painting's completion, then the painting idea, the inspiration for that particular subject may remain only an idea.

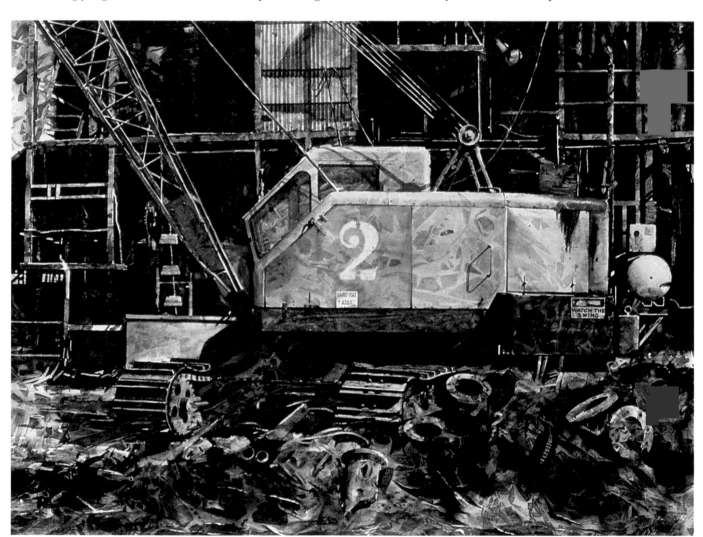

JUNKYARD DOG, watercolor, 22″ x 34″ (55.9 x 86.4 cm). Collection of the artist.

EXPLORING NEW SUBJECTS

I try to avoid consciously searching for something "new" to paint. More often, finding new subject matter is an exciting and unexpected event. There never seems to be a shortage of subject matter. Instead, for me, there seems to be a shortage of time to probe, sketch, study, explore, and finally express what I have found.

Exploring a subject that you have never used before can be inspiring and help you develop new ideas. In approaching new subject matter you must do some in-depth studying of its structure, its natural composition. Visual notes, exploratory drawings, and color notes are important in understanding how you plan to proceed. Remember that only in the dictionary does "success" come before "work." These preliminary preparations allow you, the artist, to truly "know" the subject and will help you build carefully toward the painting plan (see page 20). Once again, it is only through greater knowledge and understanding of your subject that you will be free to totally devote your creative talents to the painting.

The more you work, the more you paint, the more experience you have in selecting subject matter. You may even want to explore a different category than the one you usually work in, such as still life, landscape, seascape, cityscape, portraiture, or figure painting.

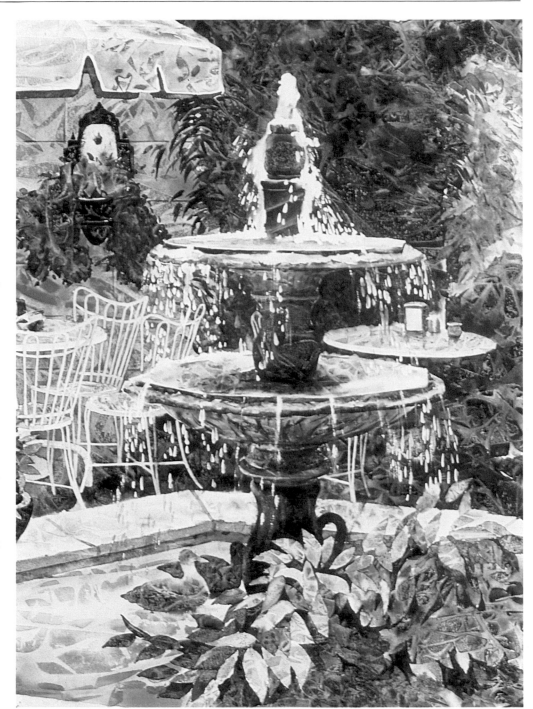

BACK STREET FOUNTAIN, watercolor, 25" x 20" (63.5 x 50.8 cm). Collection of the artist.

WHAT HAPPENS WHEN YOU DRAW?

The role of drawing in creating art is a complex issue. Do you sketch to produce lines, shadows, forms, and positive and negative shapes so that you can use them as reference materials for your paintings? Is a drawing only a visual record? Does a drawing allow you to understand or know a subject's spirit and character better? When you draw, do you reshape and adjust the nature of your subject to suit your needs?

I will discuss some facts and theories that may help clarify some of these questions. Hopefully, this discussion will give you the opportunity to find your own answers.

If your writing is legible, if you can peel an apple or shuffle a deck of cards, you have ample dexterity to draw well. Drawing is not a skill of dexterity, but a skill of seeing. I am not speaking of the capacity of the eye to see, for the eye as a sensory organ only perceives light. You see with your mind and it usually "sees" what it is taught, or conditioned, to see.

Drawing enables an artist to process visual information with personal inspiration. The processing of visual information requires the brain to be used in a different way than usual. In fact, many artists think that drawing actually alters their state of awareness. Speaking from my own experiences, I have learned that what I have not drawn, I have never really seen.

Recent research dealing with the functions of various parts of the brain indicates that the right hemisphere of the brain is the one suited for drawing. Thus, learning to see, or perceive, creatively is really learning to use the right hemisphere of the brain. Information is processed spontaneously and in spatial relationship in the right hemisphere. In the left hemisphere information is processed in a linear, verbal, analytical, and logical manner.

It is in the right hemisphere of the brain where artistic challenges are resolved— accurately recording what you see; resolving spatial problems; moving and rearranging the subject matter into a sound composition; and understanding the spirit of the subject.

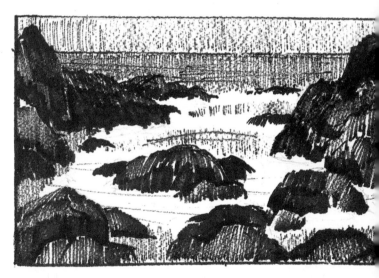
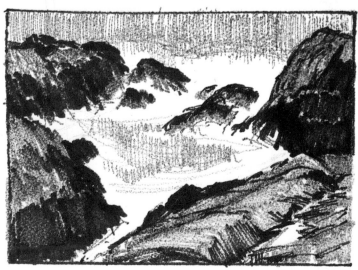

When sketching in direct sunlight, I often work with a marker pen. Because of the sun's glare, I need the dark contrast of the marker on white paper. Pencil and charcoal are subtler and more difficult to see in direct sunlight. By using marker pen on cold-press watercolor paper, I was able to let some of the white of the paper reflect through, producing values and textures.

SURF AND SHORE OF PUERTO VALLARTA, MEXICO, marker pen on watercolor paper.

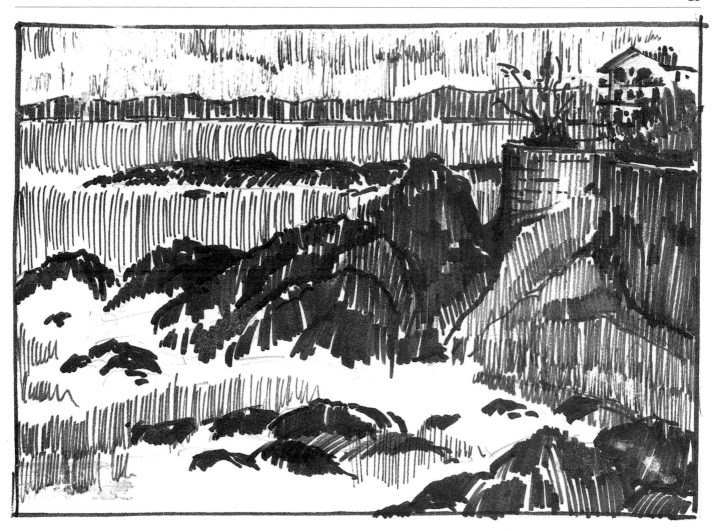

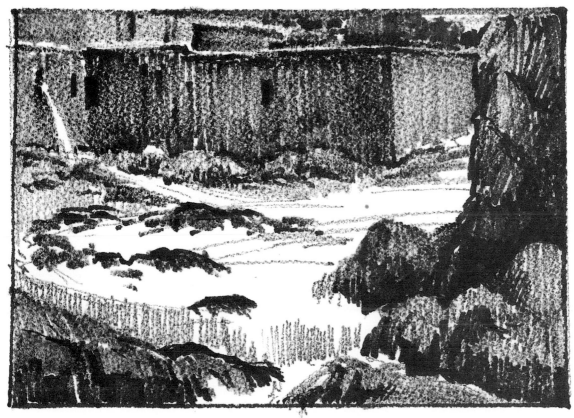

EXPLORATORY DRAWINGS

Exploratory drawings are usually executed not to be an end in themselves but as part of an adventure in inventiveness. It is the initial stage in discovering the various possibilities for composing the subject. In this type of drawing you can investigate the form and shape of the subject from different perspectives without getting involved in too many details. You can draw freely and try many compositional ideas and formulas on the spot, while the actual scene is before you, without it becoming a tedious, boring task.

For exploratory drawings, I like to use a felt-tip pen or a stubby laundry marker because it flows quickly and with ease. I try to capture the subject as a whole, shading in various shapes rather than getting caught up in specific details.

If you want to break away from your typical patterns of composition, try doing quick, spontaneous exploratory drawings. When you look at your subject, pay attention to any design it may suggest. Look at the values and think of them as shaded shapes. Think of how to arrange these shapes into a composition. This is the time to create new ideas.

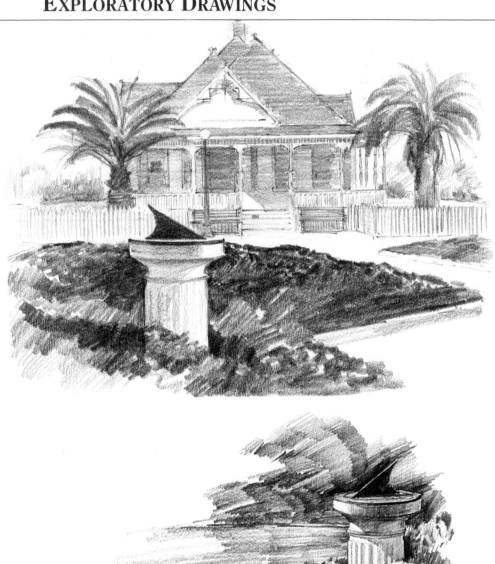

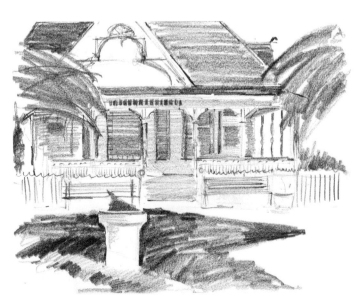

ARBORETUM SUNDIAL STUDIES, pencil, 9" x 12" (22.9 x 30.5 cm).

I feel exploratory drawings are enhanced by the speed in which they are produced. I work rapidly, setting time limits for each sketch so I don't get trapped by unimportant details.

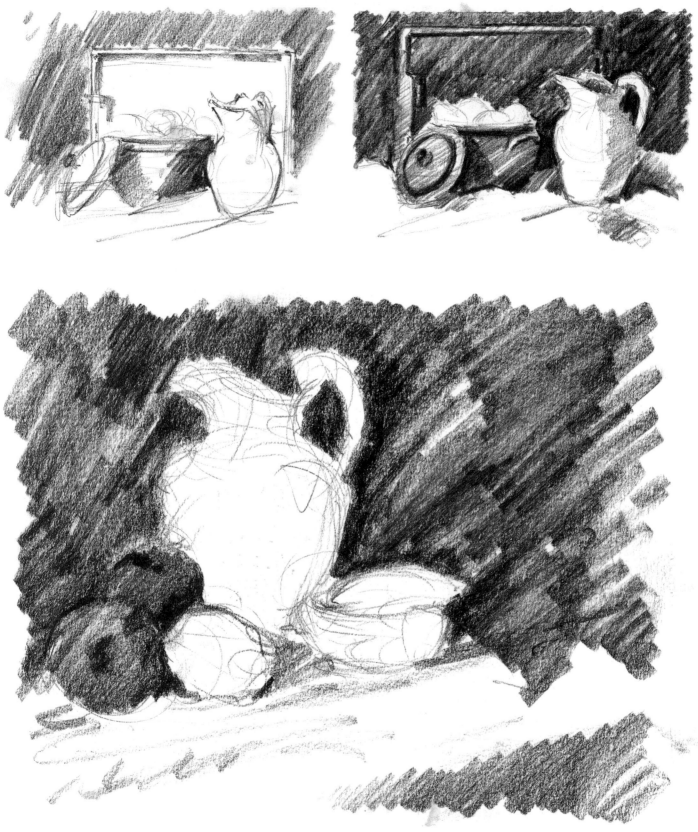

STILL LIFE STUDIES, charcoal, 9" x 12" (22.9 x 30.5 cm).

With charcoal, I was able to work quickly to establish the values and the large, simple shapes in these exploratory still life drawings.

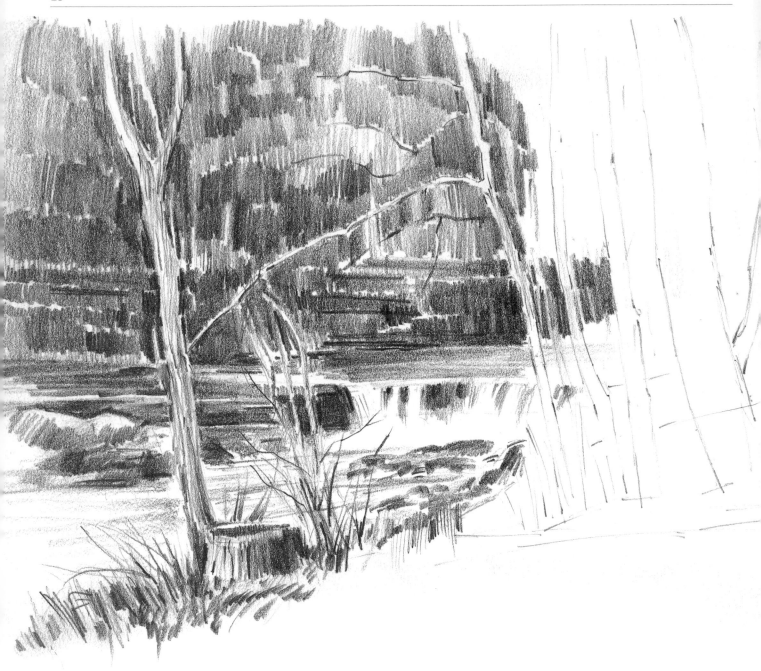

CATSKILL WATERFALL STUDIES, pencil, 9″ x 12″ (22.9 x 30.5 cm).

In exploratory sketches the drawing must be free and spontaneous. I try to proceed without fear of "failure."

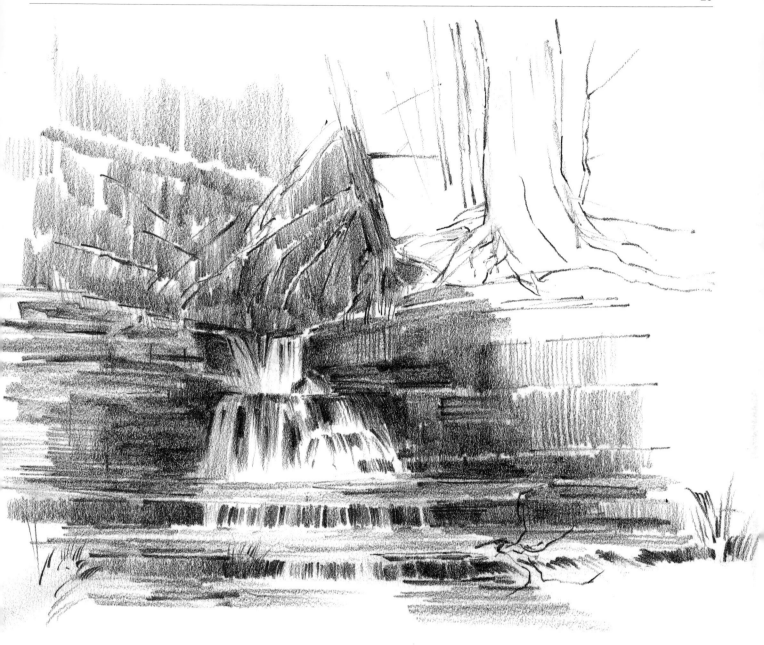

MAKING A PAINTING PLAN

A "painting plan" is a drawing, or a study, that can be used as a guide to creating a painting. An exploratory drawing may develop into a painting plan, and from that point it is possible that the painting plan may evolve into a finished artwork. Let me review some of the reasons such a plan is necessary.

In a painting plan, you can solve almost any value problem by using black, white, and a variety of gray midtones to indicate shapes. To indicate the boundaries between shapes, you can draw lines or abut shapes that have different values. You can also use silhouettes to enhance forms. A dark shape against a light background will make the shape recede, and a light shape against a dark background will push the shape forward.

When overlapping shapes have the same tonal value, the only way to differentiate the shapes is through color. But in order to paint well in color, you must see well in values, in lights and darks. A major function of the painting plan is to find the most effective way to distinguish the values of the subject. Only then will color be used properly in the painting. Color alone cannot help a poor painting plan or carry the burden of poor form.

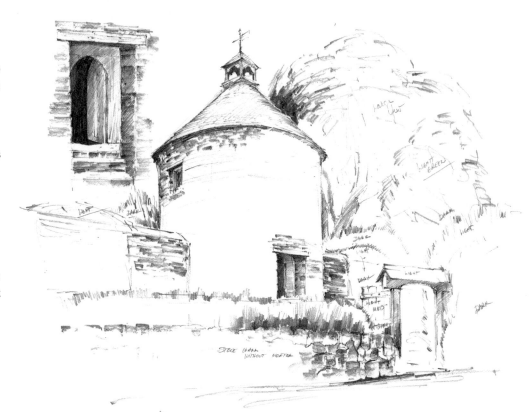

I worked out my painting plan in pencil to determine the main shapes and the values. When I began to paint, I got the large main shapes down first, then filled in those areas with subtle textures.

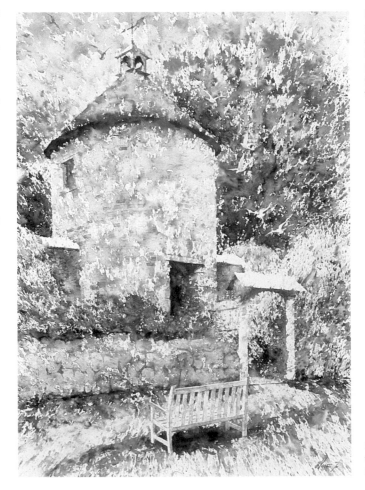

PRIORY DOVECOTE IN DUNSTER, watercolor, 27½" x 19¾" (70 x 50.2 cm). Collection of Mrs. Phyliss Smith.

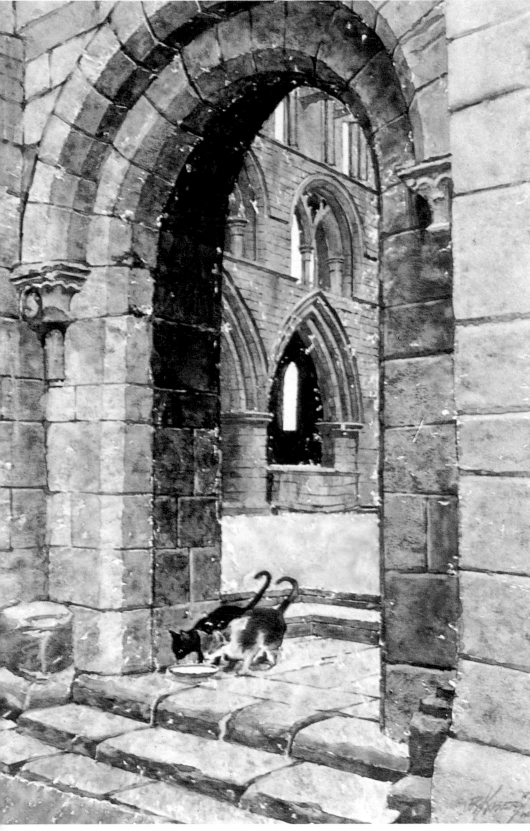

I added the cats to this charcoal pencil of English abbey arches to bring life into a rather cold architectural subject. It seems to me that every English abbey is inhabited by at least half a dozen well-fed cats. As you can see, I followed my painting plan very closely when I did this painting. The values remained the same.

LUNCH AT GOLDEN ARCHES, watercolor, 20" x 14" (50.8 x 35.6 cm). Collection of Mr. and Mrs. Arthur Johnson, Jr.

Once you have the values down, you can select a color scheme. Take color notes on the subject and jot down color samples. The colors do not have to be true to nature, but rather your interpretation of how you see it. When I do color sketches, I think of them as "my colors."

How you handle the "edges" of shapes is another major challenge. An edge composed of two forms with different values can be sharp and crisp, with no transitional tonal area. This is an "either, or" edge. There is no blending or integrating—each side has a different value. On the other hand, a soft edge has a gradual value transition from one shape to the next—it may take a millimeter or ten millimeters to go from one shape to the other. A soft edge suggests a vaporous, gentle change in form. You should be careful when softening edges, because they can create ambiguity and reduce the importance of an area in the painting. To produce an exciting visual statement, you can combine sharpness and softness on one edge. Variety in edge design can be ascertained in the painting plan. It is part of the role the drawing process plays in helping to create an extraordinary composition.

The exploratory pencil drawings and color sketch were done on site. To familiarize myself with the subject, I sketched two different angles and a detail. For the color sketch, I used the same pigments I planned to use for my finished painting. A color sketch is a more accurate and creative way to develop a color scheme for a painting than using a color photograph as an information source. I developed a painting plan in charcoal pencil from the exploratory drawings and color sketch, clearly defining the subject's shapes and values.

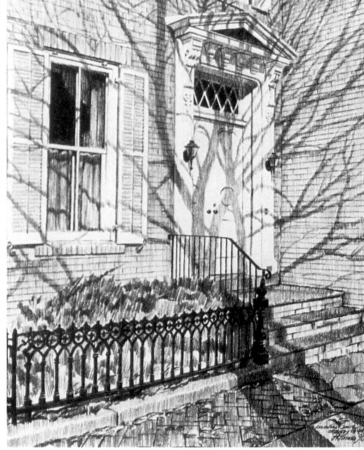

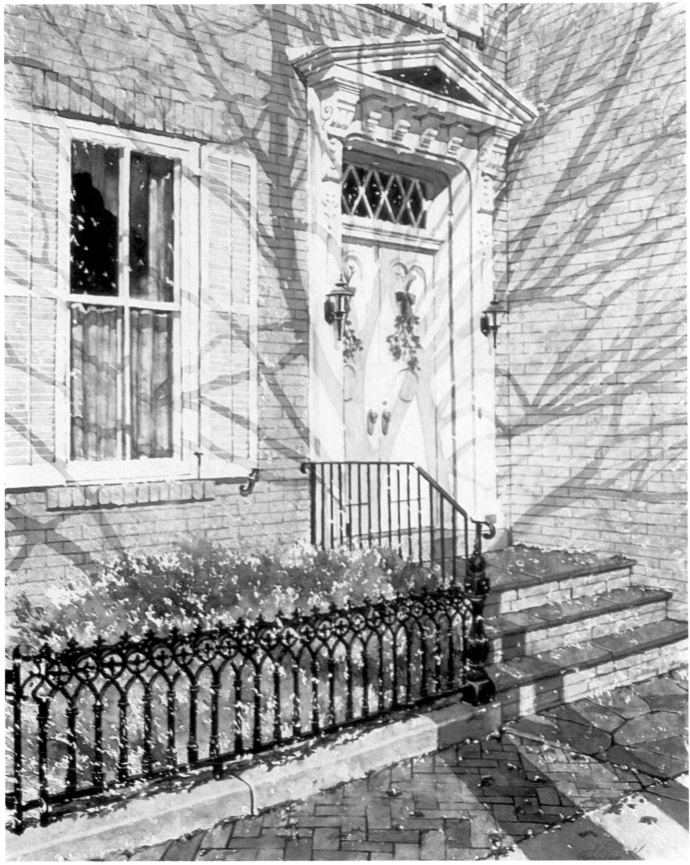

AUTUMN MORNING, COLONIAL DOOR SERIES, watercolor, 25″ x 20″ (63.5 x 50.8 cm). Private collection.

I was able to establish the strong directional lines of the tree shadows by following my plan.

The completed drawing plan is a culmination of creative problem solving, decision making, adjusting, and refining. The plan may not in itself be a completed object, but it does provide the artist with the fundamentals of "how to" create a finished painting. Just as a map will guide you to a specific destination, the painting plan will help ensure that you reach your predetermined goal. The successful painting plan should include the following information.

- All elements, such as line, size, shape, and color, should be clearly defined.
- The composition needs to be harmonious with the subject.
- The full range of values should be used—dark, light, and midtone values.
- Make sure the most important point of interest is emphasized.
- Use sharp and soft edges to help portray the form.

A sound painting plan will guide you through the fundamental principles of painting. Combining it with your intuition, there will be no limits to your creativity.

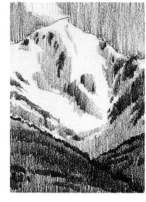
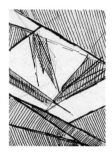
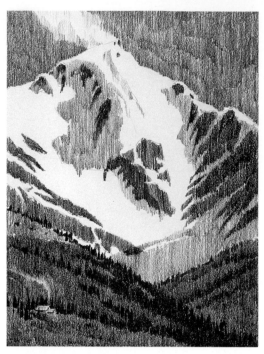

My exploratory drawings (above) are extremely simple but they define major design shapes. The small ink sketch allowed me to ascertain my dominant shape. Then I was ready to develop a painting plan. The snow-covered peak and vapor cloud were developed by contrasting them with the dark sky shape in the background. The foreground of tree-covered slopes was developed by contrasting it against the light snow. The crest of the mountain against the sky is sharp and clear, while the vapor of the cloud is soft and vague. The shadows and lines of the terrain in the foreground are made up of a variety of edges to portray the changes in topography.

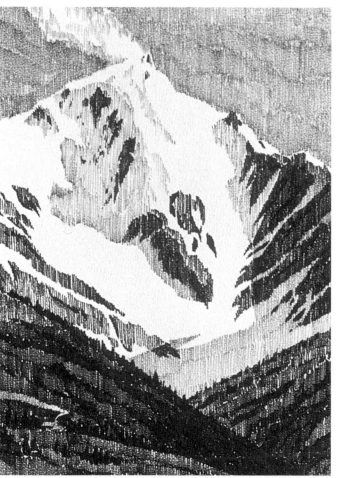

Using marker pen, I rendered a larger painting plan (right) in a size closer to that of the proposed watercolor painting. This also gave me additional experience with my subject, allowing me to paint most of the watercolor without looking at reference materials.

PAYNE'S PEAK SERIES VI, watercolor, 29" x 22" (73.7 x 55.9 cm). Collection of the artist.

In the final painting (right) I was able to concentrate on the painting process, allowing for a freer approach.

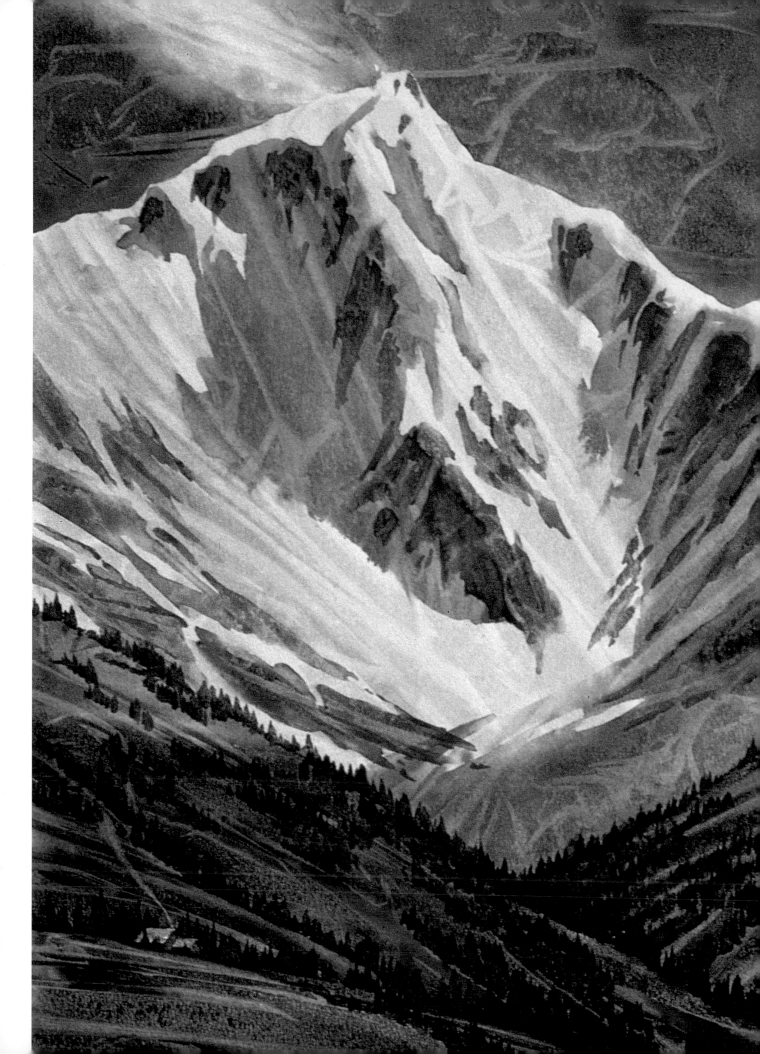

PART 2
DESIGN
ORGANIZING THE COMPOSITION

UNIFYING THE COMPOSITION

"Unity of design" is a concept you must explore in order to organize the vast storehouse of design elements. By welding together separate parts and making them into one, you will give a composition coherence. Unity is accomplished when the elements of design share a common goal.

In this part I will discuss some of the basic elements of design and composition, such as selecting a format that's compatible with your subject and understanding the relationship between shapes. Knowing how to design the space in a composition is also an important factor. Another major consideration is how to handle values—knowing where to place the lightest lights and the strongest darks, and how to use the broad range of midtone values.

The elements I have mentioned so far are the larger elements, or the macrodesign. In the following part I also explore the smaller elements, the microdesign, of a painting, which includes textures and the designs within the design elements— shapes and the areas they create, which are referred to as negative shapes. (I wish there were a better term for these large areas of space produced by other shapes. They are anything but "negative" in their impact on a good painting.)

I try to avoid using the terms "rules" or "laws" when discussing composition; such terms allow no flexibility and limit the options or choices. Composition and design principles should be thought of as a springboard to better art. I'm sure that a good sense of composition can be born into an individual in the same manner as a good sense of color. But a "quality" sense of design and composition can be acquired through study, patience, and most of all, painting experience.

JULIA'S PLACE, watercolor, 25" x 22" (63.5 x 55.9 cm). Collection of Dr. David P. Tonnemacher.

This beautiful building was designed by Julia Morgan (1872– 1957), a pioneer among women architects and an influential force in West Coast design.

BASIC DESIGN ELEMENTS

Knowing the basic elements of design—line, shape, perspective, and value—will guide you in creating a strong composition. You should view design elements as basic building blocks that can be used in various combinations to produce a unified composition. For instance, most if not all of the shapes in a linear composition will be made from either the "right angle," the "acute angle," the "curve," or a combination of all three. Working from this standpoint, you can plunge into limitless design possibilities by interchanging and interlocking these basic shapes.

Design principles and concepts are concerned with how the design elements relate to one another, but it takes an artist's intuition and imagination to design a creative composition.

Static, slow dynamic, and fast dynamic design elements (shown left to right)—using the right angle, the curve, and the acute and obtuse angles—are illustrated in these studies. Each study has a color dominance with a relief, or subdominant, color. A subdominant warm color enhances a dominant cool composition, and a subdominant cool color enhances a dominant warm composition.

Rectilinear—Static Design

A rectilinear composition is made up of right angles that are usually shown as squares or rectangles. When square and rectangular forms are the dominant shapes, the composition will appear firm, solid, and motionless, or "static." If you wanted to compose a cityscape, with skyscrapers and bridges, you would use a rectilinear design to depict the solid, massive man-made structures.

The rectilinear dominance of this composition (above) is relieved by the subdominance of curvilinear lines created by the tree branches and cast shadows. A directional movement is produced in this otherwise static design. The accompanying diagram indicates all the main rectilinear shapes I needed to incorporate into my painting. Using simple lines without details, I was able to develop my composition.

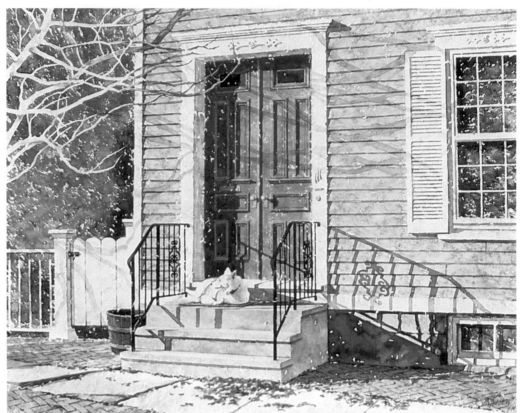

WHITE DOG WITH ORANGE DOOR, COLONIAL DOOR SERIES, watercolor, 20" x 25" (50.8 x 63.5 cm). Private collection.

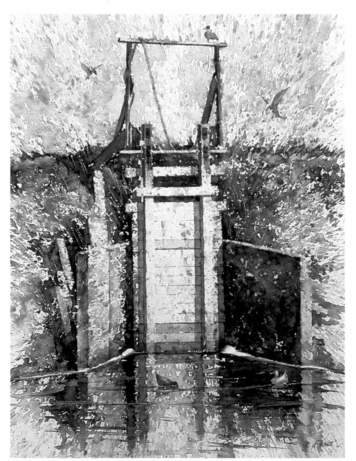

DELTA WATERFOWL, watercolor, 20" x 15" (50.8 x 38.1 cm). Collection of Mr. and Mrs. Richard Watts.

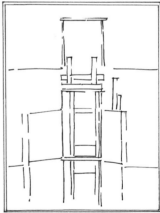

In this painting (left), the dominant rectilinear shapes are relieved with curves in the bird shapes and in the land. The diagram shows the lines I used to organize the placement of my main rectilinear shapes.

Curvilinear— Slow Dynamic Design

The curve produces a feeling of motion. I refer to this energy and force as "slow dynamic" because it is usually a relaxed and casual motion. You can use a curvilinear design for a number of different subjects, such as the human figure, rolling hills, an ocean, and so on. The soft undulating curves of rocks and waves on a seashore suggest the use of a curvilinear design.

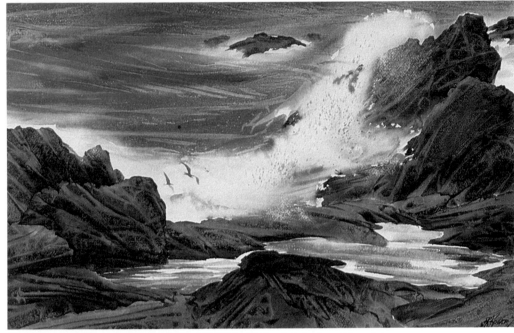

PUERTO VALLARTA SURF I, watercolor, 13½" x 20" (34.3 x 50.8 cm). Collection of the artist.

With the surf pounding on the rocks of this shoreline, I needed to use a curvilinear design to establish a slow dynamic composition. The diagram helped me to decide on the direction of my movements.

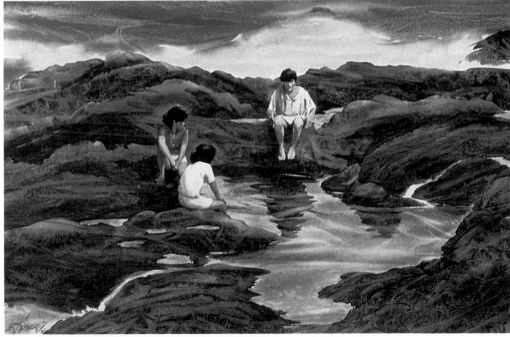

The sitting figures add a vertical relief to this curvilinear composition. The horizon line stabilizes the slow dynamic design in that area of the composition. The diagram allowed me to capture the movements I planned to use for my painting.

TIDE POOL PALS, watercolor, 13½" x 21" (34.3 x 53.3 cm). Collection of the artist.

Diagonal—
Fast Dynamic Design

Acute and obtuse angles produce a forceful movement, which I call "fast dynamic." The diagonal movements created by these angles create a feeling of excitement and tension. Some examples of diagonal compositions would be sailboats leaning into the wind at sea, or a mountainscape with steep slopes.

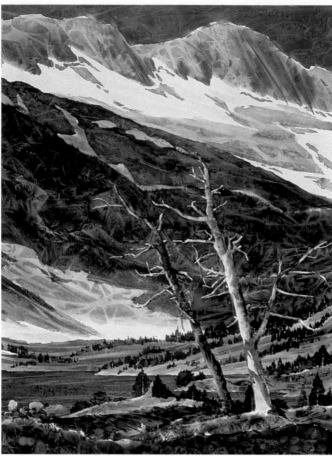

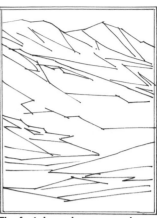

The fast dynamic movement created by the diagonals is relieved by the vertical lines of the trees. The motion is stopped, adding variety to the painting.

SIERRA LANDSCAPE, watercolor, 34″ x 24″ (86.4 x 61.0 cm). Collection of the artist.

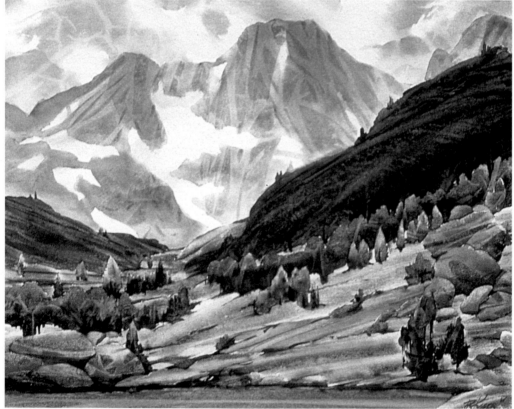

The diagonal lines of the steep mountain slopes create a forceful movement.

PAYNE LAKE, watercolor, 13″ x 16″ (33.0 x 40.6 cm). Collection of Mr. and Mrs. William Miner.

BASIC COMPOSITIONAL FORMATS

Format is derived form the Latin word *forma,* which means shape. In art, format has a broad interpretation with regard to shape, but it does deal with the artist's use of shape or form for balance. Format is considered a major design principle that produces balance and unity through selecting a dominant shape that draws the viewer's eye to the focal point of the composition. Some of the most common formats, as well as some optional ones, are discussed in this section.

Cruciform

The cruciform format is established when dominant vertical and horizontal shapes intersect, producing four corners of negative space. The negative corners should always support, not compete with, the cruciform. Avoid intersecting the vertical and horizontal shapes in the "center," where the juncture will appear as a bull's-eye. Cross the forms in a way that avoids dividing the paper into perfect halves or quarters. Remember, the focal point of the composition is at or near the intersection of the vertical and horizontal shapes.

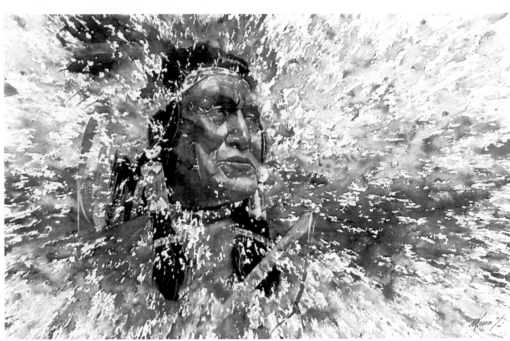

OUR HERITAGE, watercolor, 18″ x 27″ (45.7 x 68.6 cm). Collection of Maruka Machinery Corporation International.

The cruciform format is ideal for portrait paintings. When the cross formed by the vertical and horizontal thrusts is off center, the focal point of the portrait will be away from the center of the page. For these paintings, I used textures to cover the paper's surface, making sure that the corner areas had the least amount of texture in order to support the cruciform format. In the sketches I was careful not to divide the corners into equal white areas. Notice how the faces, placed near the intersecting shapes, become the focal points.

LONDON BOBBY, watercolor, 24″ x 14″ (61.0 x 35.6 cm). Collection of William J. Abate.

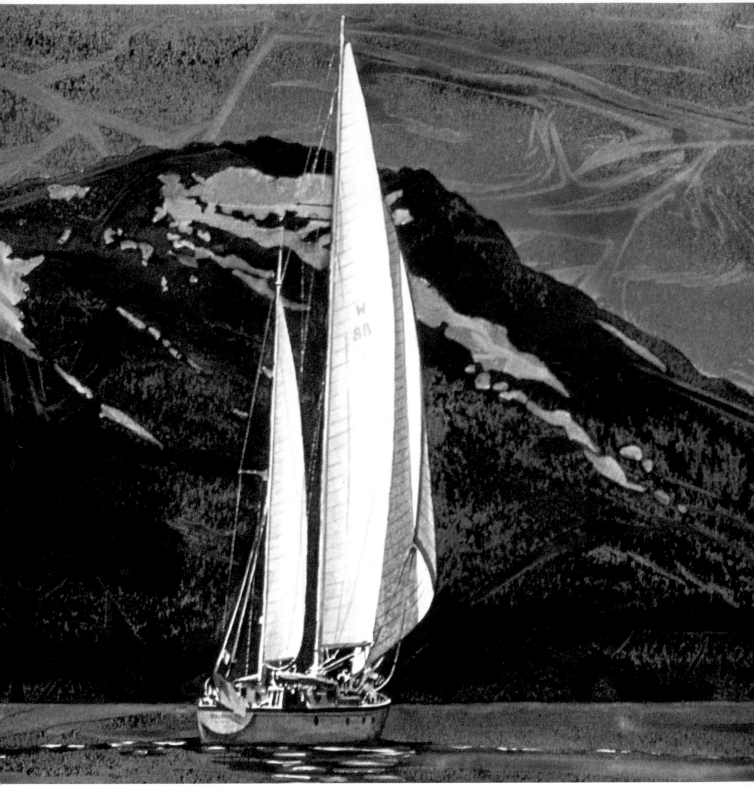

NORTHWEST PASSAGE II, watercolor, 14″ x 21″ (35.6 x 53.3 cm). Collection of Mr. and Mrs. Dennet Withington.

Steelyard

The "steelyard," named after the weighing implement, is perhaps the most simple format. This format is similar to a seesaw, where a bar rests on a support, or fulcrum. The largest weight rests on the shortest end of the bar, closest to the fulcrum, while the smallest weight rests on or near the long end of the bar. In such a design the natural placement for the focal point will be on or near the fulcrum, or near the main weight. You can also connect the main weight and the small weight with a line, a horizon, or another object, to unify the composition.

The large and small steelyard weights should have similar values and colors to create a repetition that establishes the relationships the shapes have with one another. But the steelyard shapes do not have to be placed on the same eye level. One shape can rest on the foreground and the other can be placed in the background to produce a unique perspective. Like most formats, the steelyard has a wide range of variations.

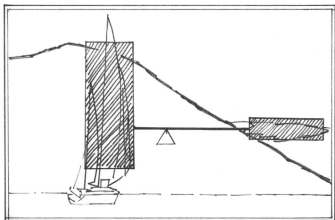

The steelyard format in this painting meets some of the most critical design criteria: the fulcrum point lies horizontally in the center of the painting; the large white shape of the sails is located near the fulcrum; the smaller snow shape balances the large shape because it is a distance away from the fulcrum. The lesser weight is compatible with the heavier weight in color and value. Often, the steelyard format is used in conjunction with one or more other design formats; in this painting I combined it with a diagonal format. The accompanying diagram illustrates how I carefully worked out the placement of all elements to accomplish this successfully.

Horizontal, Vertical, and Grid

The "horizontal" format is composed of dominant horizontal bands that are repeated consistently. In such a format you can add slight relief by using curved lines or some verticals as long as they do not interfere with the visual impact of the horizontal bands.

A "vertical" format is produced with dominant vertical bands that are also repeated consistently. You can use some curves or horizontals to add a slight relief to the design.

By combining vertical and horizontal lines, you can create a "grid" format. Both vertical and horizontal lines must be strong enough so that one type does not dominate the other, but equal parts are not necessary. With this compositional plan, you can cover an entire surface with a finely woven design that produces unity and an illusion of perspective.

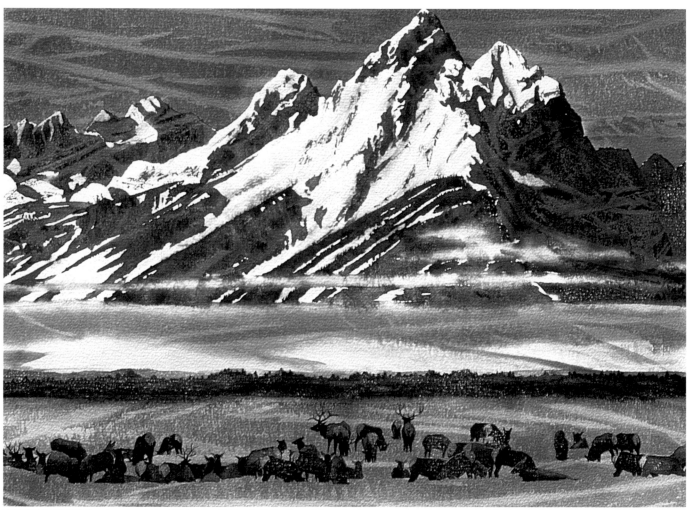

GRAND TETON ELK IV, watercolor, 16″ x 20″ (40.6 x 50.8 cm). Collection of the artist.

The diagram shows how I established the foreground, middleground, and background areas for my painting. I added diagonal lines for relief. Throughout the painting, I repeated the horizontal format consistently, in bands of various sizes. The diagonal thrust of the rocky peaks of the Tetons enhances the dominant horizontal patterns.

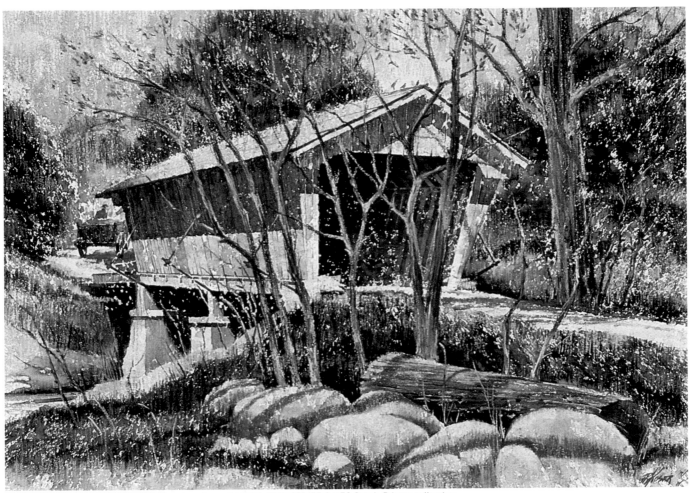

CATSKILL MOUNTAIN COVERED BRIDGE, watercolor and pastel, 22" x 30" (55.9 x 76.2 cm). Private collection.

By interweaving a number of vertical and horizontal shapes, I was able to establish a grid pattern for this painting. The vertical and horizontal lines maintain a strong balance so that one doesn't dominate the other. Unity is achieved from a subtle weaving, a give-and-take of shape, color, value, and directional thrust.

Diagonal and S-Curve

The "diagonal" format is a compositional plan in which a line or a series of shapes runs diagonally on the page—from the upper left-hand corner of the paper to the lower right-hand corner, or from the upper right-hand corner to the lower left-hand corner. The strong thrust, or slant, of this diagonal format needs some opposition to counter the great force it creates. A "stopper" can be created by using a subdominant vertical, horizontal, or grid shape, placed outside the main diagonal line to produce a secondary point of interest. An opposing shape will help to stabilize the "eye-carrying" power of the diagonal format.

An S-curve, or compound curve, format uses curvilinear lines to suggest movement. Usually, the S-curve is suggested by lines or grouped edges rather than by mass. The dominant curves of this format create a graceful movement, with each part of the composition relating easily one to another.

In landscape or seascape paintings you will see this format used to depict rivers, arroyos, roads, and shorelines. You can also create a still life with this format by positioning and placing tabletop props in an S-curve. And if you use a tablecloth, the folds of the fabric in the foreground and background of the still life will help support the rhythm of the S-curve.

In the diagram, note how the lighthouse and other verticals—the tower and poles—relieve the strong diagonal thrust of the line that extends from the lower left-hand corner to the upper right-hand corner. In the painting, rich-valued, vibrant colors support the diagonal area. The tower and poles effectively intercept the diagonal thrust but are subtle in color and value so they do not compete with the force of the diagonal.

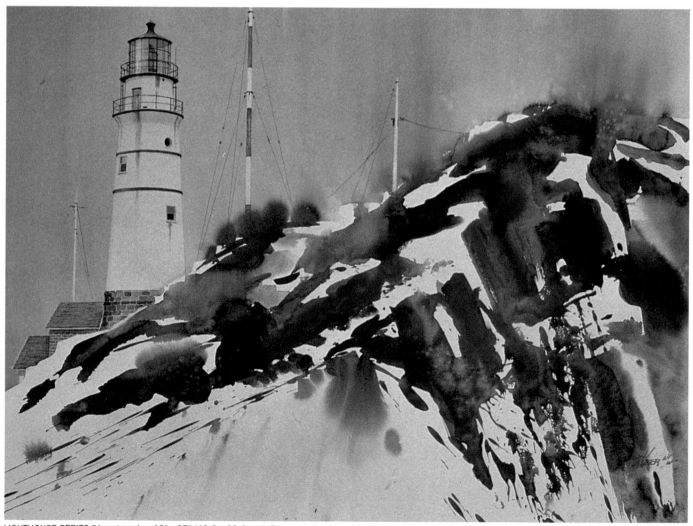

LIGHTHOUSE SERIES IV, watercolor, 19" x 27" (48.3 x 68.6 cm). Private collection.

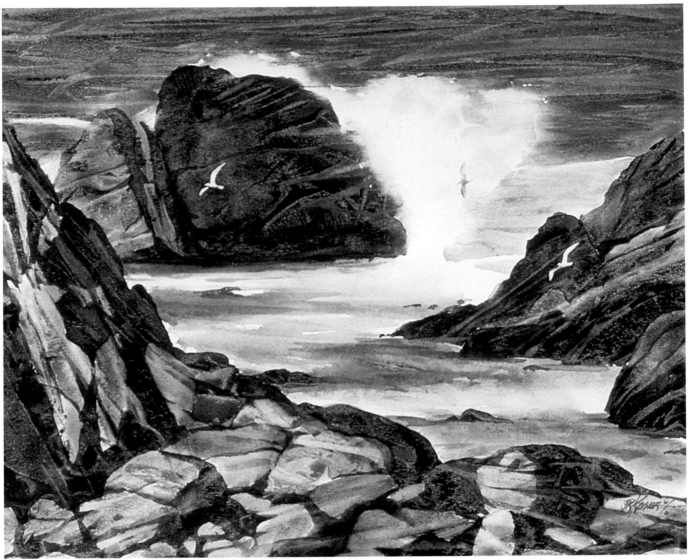

PACIFICA SERIES III, watercolor, 14″ x 16″ (35.6 x 40.6 cm). Collection of Dr. David P. Tonnemacher.

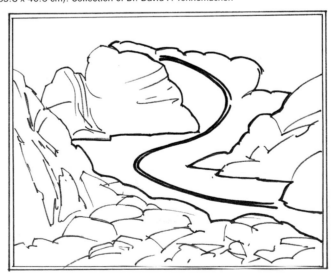

The S-curve that dominates the design of this painting is produced by the large rock shapes, as emphasized in the diagram. In this seascape of Trinidad, California, I contrasted the dark wet rocks with the white surf to draw the viewer's eye to the area of the S-curve.

Pyramid

The pyramid, or triangular, format adds strength, stability, and permanence to a composition. The pyramid form can be established with line, edge, or mass. But if the pyramid is made up of solid forms that are too close together, it can cause too much stability. You must be careful not to make a composition appear contrived. The pyramid format should only roughly indicate a triangle. Within the triangular area you can also incorporate another compatible format, such as the circular.

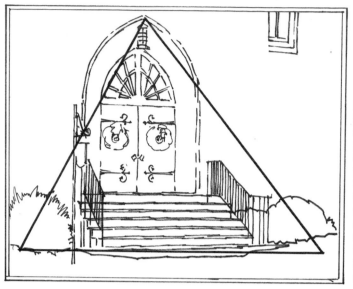

In this painting the base of the pyramid is formed by the shrubs and the first row of steps. The point of the Gothic arch is the apex. In order to prevent the pyramidal format from appearing too contrived, I placed a small window outside the pyramid. The window reduces some of the stuffy stability and introduces a steelyard format. I made the heavy door shape compatible with the window in value and color.

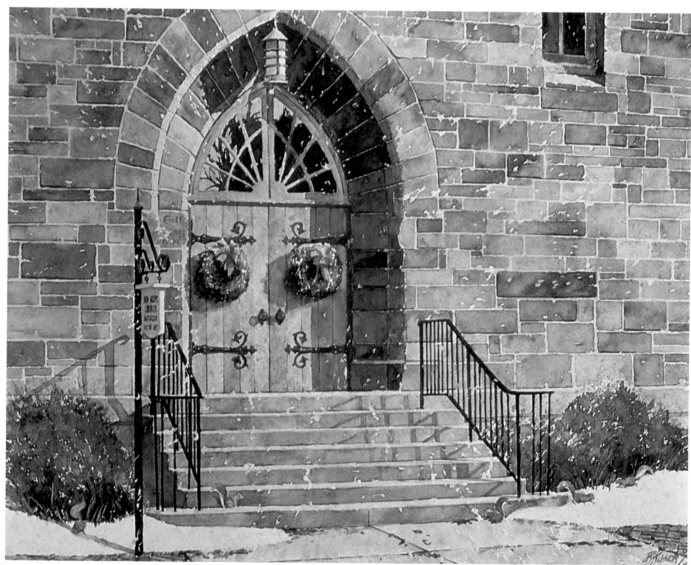

COLONIAL CHURCH DOOR, watercolor, 20″ x 26″ (50.8 x 66.0 cm). Private collection.

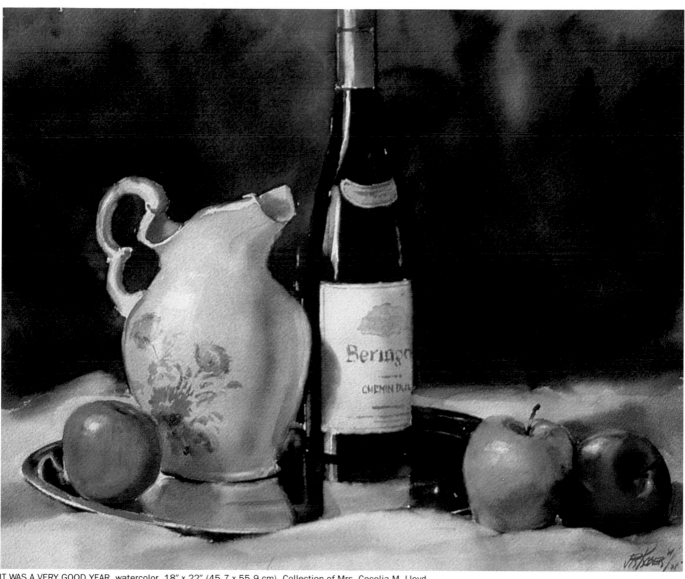

IT WAS A VERY GOOD YEAR, watercolor, 18″ x 22″ (45.7 x 55.9 cm). Collection of Mrs. Cecelia M. Lloyd.

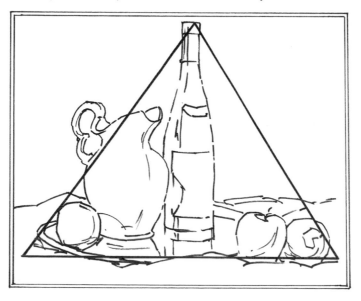

This tabletop still life arrangement makes the most of the pyramid format. The grouping allows the orange and the red apple to anchor the base of the inverted "V." The top of the bottle is the apex. The handle of the pitcher effectively intercepts the slope of the pyramid and prevents the composition from appearing too contrived. The variety of curvilinear objects enhances the pyramidal format.

Circle

A circle format is a sound method for achieving design unity, especially when the main circular area is the focal point. You can construct a circular format by roughly outlining a rounded, irregular area. The outline may be formed by line, edge, or mass. The focal point of interest can be the objects that make up the circular shape or it can be the negative space within the circle. By adding opposing lines or shapes—verticals, horizontals, or various combinations that are not curvilinear—you can vary your composition as well as stabilize the circular movement.

The circular format of the stone bridge is stabilized by the horizontal line of the river bank. By creating the strongest value contrast within the circle, I reinforce and unify the circular format.

STONE BRIDGE IN LAKE DISTRICT, watercolor, 17″ x 22″ (43.2 x 55.9 cm). Collection of Dr. and Mrs. Steven Keiser.

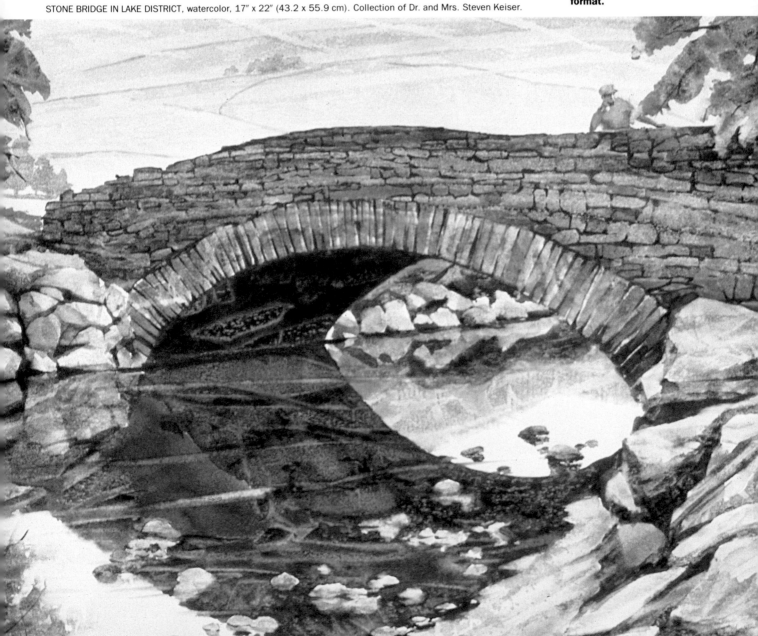

Overall Pattern

The overall pattern format is an abstract principle that does not call for any specific design format, although it combines certain formats by interlocking them.

By interlocking shapes, you can produce a mosaiclike quality in a composition. All areas may have equal importance; there does not have to be a main focal point. Interlocked shapes can also create a unique spatial relationship. When shapes and the shadows they cast overlap and interlock, a push-and-pull effect is produced that creates a feeling of perspective.

The overall pattern format is ideal because it depends almost entirely on the artist's feeling for unity. At the same time this format is difficult and demanding because of its lack of specific form; it depends heavily on imagination, ingenuity, and an instinctive feeling for harmony when it appears before you in nature or in your mind.

There is a push-pull interplay with the blossoms and foliage that creates a mosaiclike pattern of value and color. In this painting there is no single point of interest. Unity and harmony are produced through interlocking shapes and rely heavily on the artist's imagination and instinct.

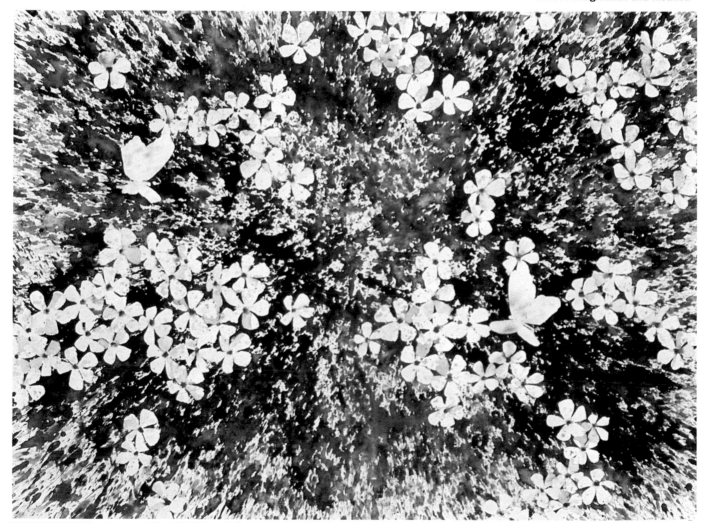

WILD WHITE PHLOX, watercolor, 18″ x 24″ (45.7 x 61.0 cm). Private collection.

ESTABLISHING A HORIZON LINE

Where you place the horizon line, whether it's for a landscape, seascape, or cityscape, will influence the design of the total composition. For instance, a high horizon will produce a strong "foreground" painting, while a low horizon will produce a strong "sky" painting. If you place the horizon near the middle of the paper, you will produce a format where neither foreground, middleground, or background is more important than the other. It may become troublesome if you divide the page into equal parts with a horizon, because it tends to convey indecisiveness. Since the horizon line in itself is a powerful, dramatic statement, it is best to avoid placing it in the center of the page.

ALPINE PASTURE, watercolor, 16″ x 20″ (40.6 x 50.8 cm). Collection of the artist.

In *Alpine Pasture* (above), a high horizon format, the mountain range is the horizon line. The sky shape is important only as an indicator of light. With a high horizon I had ample painting surface for the middleground and the foreground.

For *Virga* (right), I needed a low horizon to emphasize the sky. I wanted to capture the phenomenon of the high desert weather when a summer afternoon rain shower falls from a moisture-laden sky, only to be vaporized by the heat of the desert terrain. The background, middleground, and foreground become supports for this dramatic sky painting.

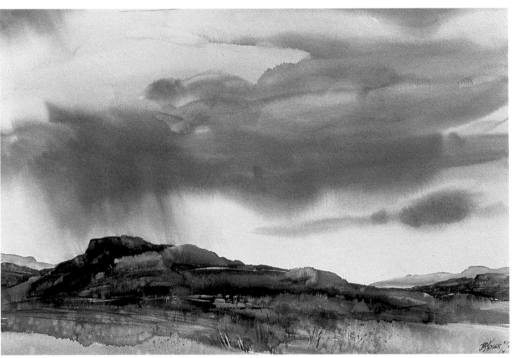

VIRGA, watercolor, 16″ x 24″ (40.6 x 61.0 cm). Collection of Mr. Craig Newell.

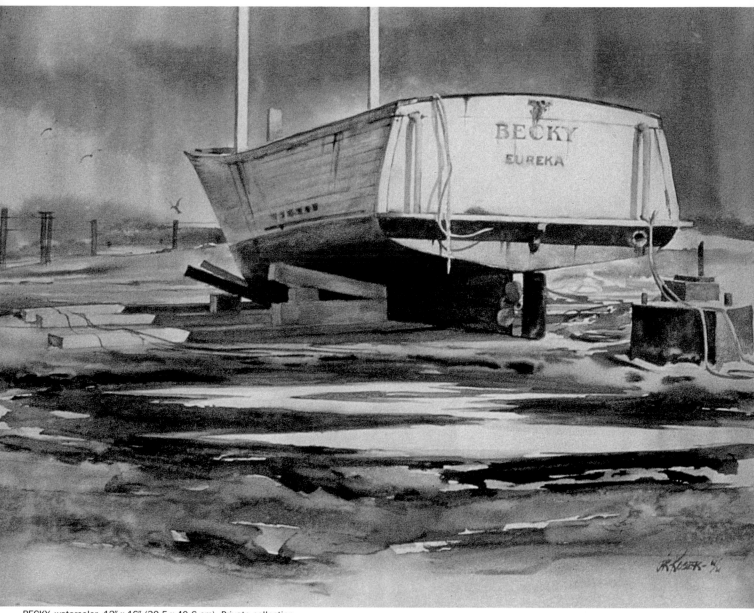

BECKY, watercolor, 12″ x 16″ (30.5 x 40.6 cm). Private collection.

The horizon in this painting is positioned near the middle of the paper, but I was careful not to divide the painting into equal parts. Thus I was able to play down the importance of the sky and the foreground, allowing the subject, the boat hull in dry dock, to be more easily presented as the primary point of interest.

DISTANT AND CLOSE-UP VIEWS

When considering distant and close-up views, you need to think of the space and distance between the object and the viewer's eye. For example, the vastness of a range of mountains, the sweeping height of the sky, or the craggy depths of a canyon, are best depicted at a distance, in order to get the full impact of the scene. The "distant" format is ideal for immense landscapes. In order to achieve perspective in landscapes, you must be quite a distance from the subject matter. Only then can you interpret the distance, depth, and spirit of gigantic canyons, dramatic mountain ranges, grand waterfalls, rugged coastal cliffs and surf, and vast prairies and plains.

At the other end of the spectrum, and just as dramatic, is the "close-up" format. The subject matter you choose may need to be painted at close range to capture the details that interest you. For example, a part of an archway of a building, a statue in a fountain, a portion of a crumbling wall, a reflection in a glass window, roots and bark of a tree stump, the textures and shadows of rocks in a stream bed are some subjects that lend themselves to a close-up format. By using the close-up format, you explore in depth, almost inch by inch, the character, surface, and parts of a whole. Portraits and still lifes are most often done as close-ups. But you can also compose a still life on a tabletop near a window, looking out onto an expanse of miniature landscape; in such a case you are combining the close-up and the distant formats in one composition.

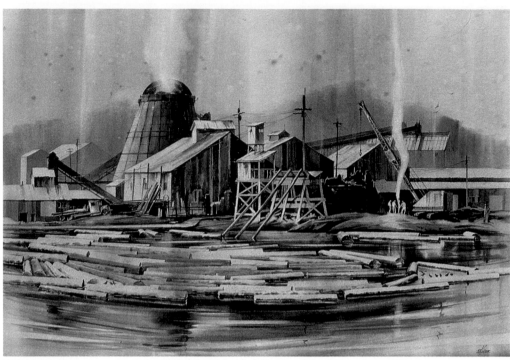

OREGON SAW MILL, watercolor, 22″ x 30″ (55.9 x 76.2 cm). Collection of Mr. and Mrs. James Nelson.

CREEK BED, CHRISTMAN RESERVE, watercolor, 18″ x 22″ (45.7 x 55.9 cm). Collection of Mr. and Mrs. Vernon Knourek.

In *Oregon Saw Mill* (above), a distant composition, the environmental color and light is introduced in broad vertical bands. I did not use the "local" colors of any of the objects depicted. Color and edges soften with distance. The bands of atmospheric light running from the sky and reflected in the water help unify the composition.

A fraction of the total scene was selected for this close-up painting (left) of a beautiful creek bed in the Christman Reserve in the Catskill Mountains. I had done several watercolor sketches of waterfalls, streams, wooded banks, and dramatic rock forms when I came upon a frog sunning in a patch of shallow water. I wanted to do a watercolor painting to show the magic of a shallow pool—comparing the glistening colors of wet rocks and branches to the muted colors of dry rocks and branches.

HARD AND SOFT EDGES

The type of edges you use to join shapes, whether soft or hard, is a major consideration for good design. Edges can relay emotional statements to the viewer. For instance, edges that blend and blur will soften the subject and add a calm or mystical quality, while edges that are hard and crisp will clearly define the subject. Usually both soft and hard edges are used in a composition, but there should be only one type of edge that dominates the design.

Edge quality is one of the most subtle design elements, but it acts as a powerful unifying device. Soft edges predominate in this painting. The hard, chiseled, sharp edges of the mill structure are very much contained, or surrounded, by the soft edges of the sky, background trees, water, and foreground vegetation.

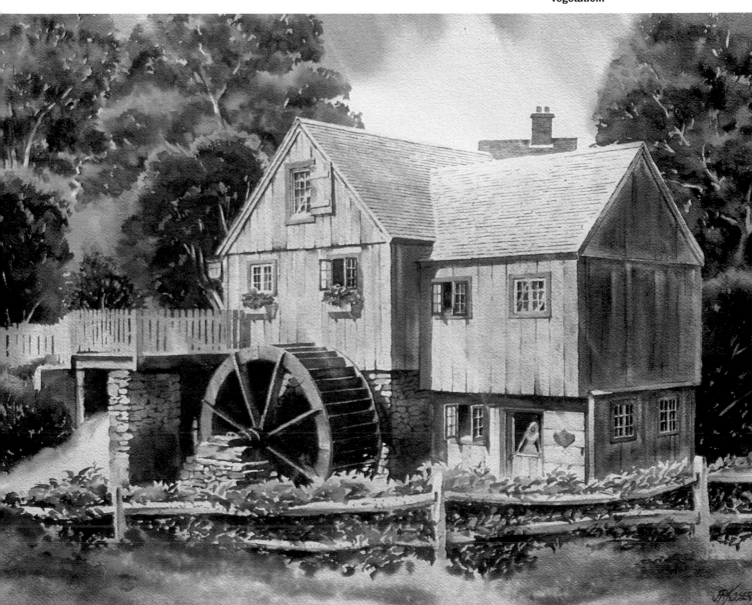

THE MILLER'S DAUGHTER, watercolor, 18" x 24" (45.7 x 61.0 cm). Collection of the artist.

OPEN AND CLOSED COMPOSITIONS

In an "open" compositional format, portions of the subject matter may go off the page and just give you an idea of a part of the whole, a sort of slice of the pie. The open format lends itself well to many different subjects. When working in an open format, you will face a number of challenges. You are responsible for balancing shapes, sizes, and values within, as well as along, the edges of the paper. You are also responsible for the balance and harmony of the implied subjects that go beyond the borders of the paper. These unseen areas have a strong impact in the mind of the viewer and must not be overlooked.

A "closed" format is a contained composition that shows everything—it is not a part of something, it is the whole. Many Renaissance painters relied heavily on the closed format. The areas near the edges of a closed-format painting are filled with negative shapes with little texturing. There are no intense color contrasts at the edges. Along the edges, colors are subdued to support the contained image, which lies well within the edges.

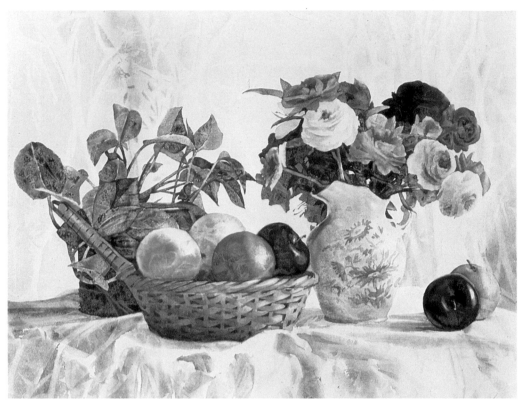

SPRING FLOWER STILL LIFE WITH IVY, watercolor, 17″ x 21″ (43.2 x 53.3 cm). Collection of Dr. David P. Tonnemacher.

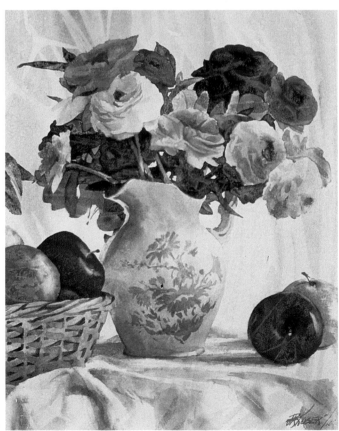

The still life painting above is a classic closed composition—a format that expresses containment, that says visually, "This is all of the story."

An open composition (left) shows only a part of the whole. The subject goes off the page with a degree of decisiveness; it reveals a planned composition, not an accident. The spirit of the whole subject should be felt even though it may not be depicted within the painting's borders.

SPRING FLOWER STILL LIFE WITH WOVEN BASKET, watercolor, 17½″ x 11½″ (44.5 x 29.2 cm). Private collection.

DEALING WITH SPACE IN DESIGN

Most people view space as an empty area, but for the artist, designing space in a painting is a real challenge. For instance, by arranging shapes in a composition, you are also dealing with the space around the shapes as well. When you overlap shapes you produce a perspective that gives an illusion of spatial depth.

In this section I will discuss the main principles of designing the space of a composition through linear, aerial, and atmospheric perspectives, and cast shadows.

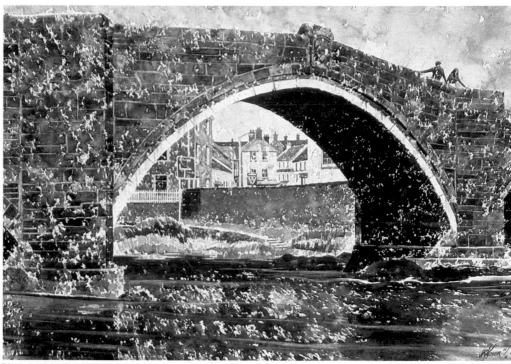

TOWN BRIDGE IN LLANRWST, WALES, watercolor, 20″ x 29″ (50.8 x 73.7 cm). Collection of Mr. and Mrs. Arthur Johnson, Jr.

The illusion of space is established with the bridge's archway, which frames a background of overlapping town buildings.

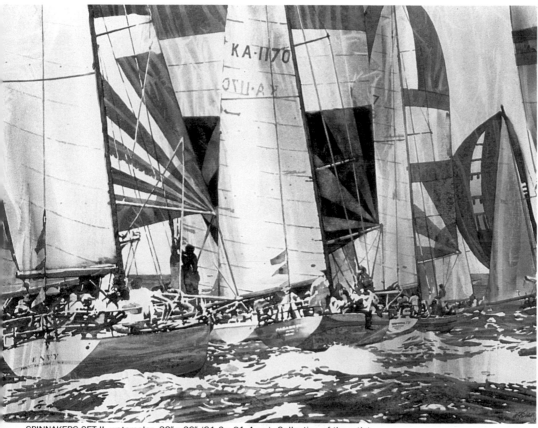

SPINNAKERS SET II, watercolor, 32″ x 36″ (81.3 x 91.4 cm). Collection of the artist.

By overlapping the sails and the hulls of the boats, I was able to create an illusion of space as well as a kaleidoscope of color and value changes.

Linear Perspective

In linear perspective, objects are foreshortened as they recede into the distance, with lines converging to a vanishing point that corresponds to the observer's viewpoint. As an example, imagine railroad ties diminishing in size as they stretch into the distance and converge at the horizon. Each railroad tie is what I call a "diminishing repeat." It is important to note that to be effective, objects depicted as diminishing repeats must be of a recognizable and regular size— telephone poles, fire hydrants, fenceposts, and so on. They must be objects that you know are getting smaller by the distance between the object and the observer, creating a spatial illusion. A tree would not be a good diminishing repeat, since trees come in different heights, sizes, and shapes.

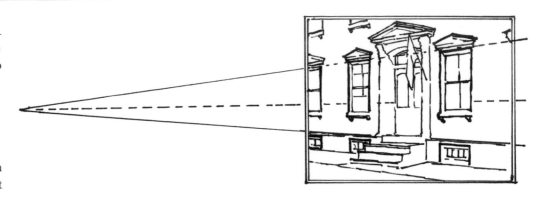

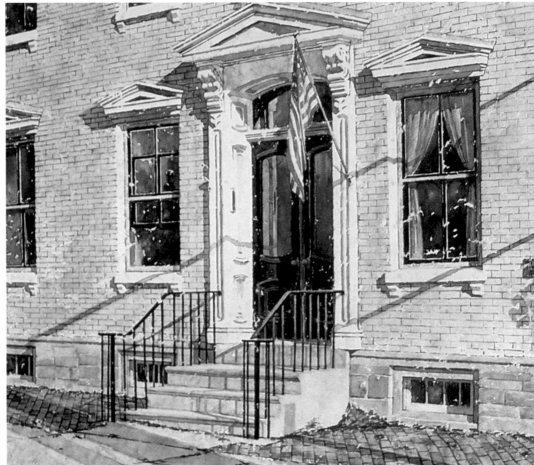

BLACK DOOR WITH AMERICAN FLAG, COLONIAL DOOR SERIES, watercolor, 20" x 25" (50.8 x 63.5 cm). Private collection.

Linear perspective and diminishing repeats were used in tandem in this cityscape. The building is closer to the viewer on the right side of the painting, where the commemorative plaque hangs, and becomes distant on the left side. The feeling of spatial perspective is achieved by the diminishing manner in which the building's base line and the line formed by the second-story windows appear to taper as they move away from the viewer's eye. The diminishing repeat of windows from the largest on the right to the smallest on the left demonstrates the element of linear perspective in this painting.

Cast Shadows

Cast shadows of objects can establish a powerful illusion of space. You can produce a shadow from a single light source, or you can use several light sources to produce shadows that extend in different directions. By casting shadows, you can add movement and direction in your design as well as an intricate light-dark distribution. With this design element, you can establish an illusion of space and distance between objects.

Several types of shadows are used as spatial elements in this cityscape—the shadows of the doorway, window boxes, stairs, and railing create an illusion of depth and contour. The shadows cast by the tree branches, which are not in view in the painting, create interesting swathes of diagonals across the front of the building. A foreground shadow of an unseen tree trunk, or post, appears on the right and moves across the front walk, exiting on the left.

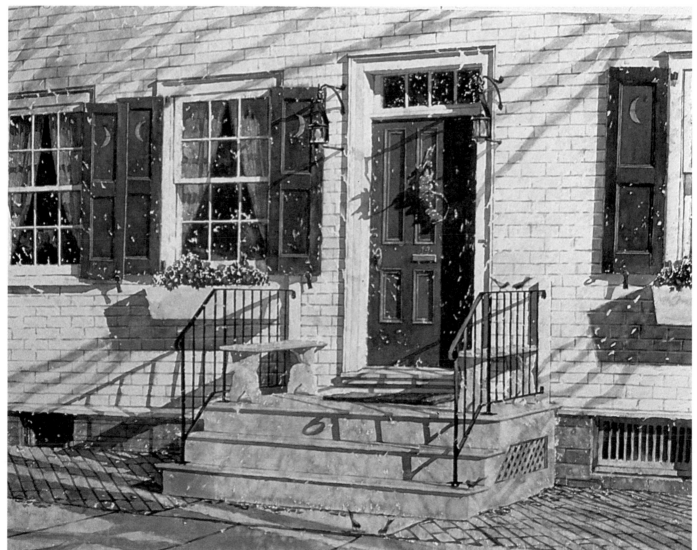

SHUTTERS WITH MOON DESIGN, COLONIAL DOOR SERIES, watercolor, 20″ x 25″ (50.8 x 63.5 cm). Private collection.

Aerial Perspective

In an aerial perspective composition you are looking down on a scene. At such an angle the objects or shapes overlap and appear as if they are stepping up the ground plane. For example, imagine a scene in terms of horizontal grids and place the objects you are looking down on at different points on the grid. The object closest to you will be the largest shape and will be placed on the lower portion of the paper. The other shapes recede into the background and get smaller as they get closer to the horizon.

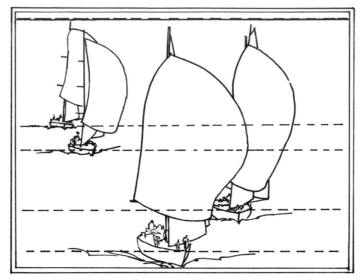

In this aerial perspective composition, overlapping shapes were used in conjunction with placing them on different levels of a horizontal grid. Notice how the sizes of the shapes vary, with the largest shape in the foreground and the smallest shape in the background.

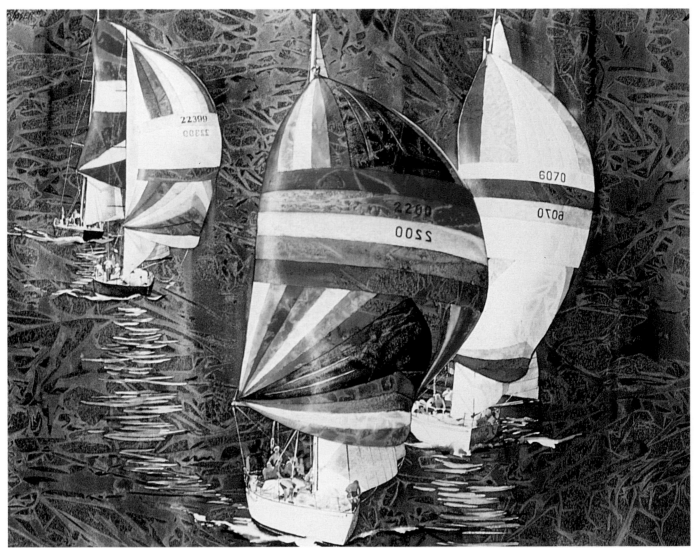

SPINNAKERS BLOOMING, watercolor, 20″ x 25″ (50.8 x 63.5 cm). Collection of Dr. and Mrs. John Molitor.

Atmospheric Perspective

Atmosphere acts as a screen or filter to cut out light. As a result an object you see in the distance is not as bright or light as an object you see in the foreground. The atmosphere reduces the brilliance of distant objects.

Working with color and variations in a color's value, you can produce an effective atmospheric perspective. A push-pull effect in a painting can be created by using warm, vibrant colors in the foreground and muted colors in the middleground. Cool colors—blues, greens, violets—recede into the distance, while warm colors—yellows, reds, oranges, browns—move forward.

The illusion of distance can also be achieved by graying or softening colors, and by using lighter values. (I will discuss the principles of color and value in the next part.) For example, a misty haze painted in a midtone value with a light foreground creates a contrast that gives an illusion of spaciousness.

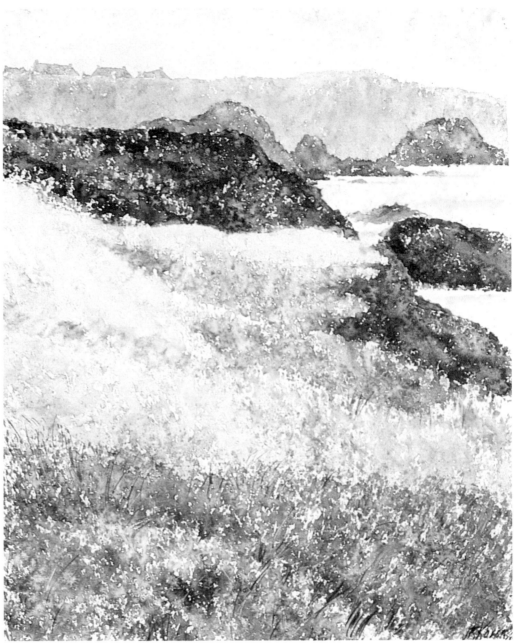

COAST OF SCOTLAND, watercolor, 22″ x 15″ (55.9 x 38.1 cm). Private collection.

Color and value were used to create a spatial illusion in this painting. The warmest and strongest valued pigments were used in the foreground and middleground, while more muted colors and values were used for the background. Colors become paler and more subdued in the distance because the atmosphere acts as a screen and filters out light.

VALUE IN DESIGN

Value means the relative lightness or darkness of a color or of the different parts of a picture. White is the lightest value, and black is the darkest value. Then there is a whole range of midtones in light, middle, and dark values. Black-and-white photographs show the full value range of the subjects portrayed.

A light-value painting produces an ethereal feeling: celestial, airy, and delicate (light-value paintings are also referred to as high-key paintings). Usually a clean white is used in a light-value painting, which in some cases is the white of the paper. Nothing is very dark or bold in a high-key composition.

In a middle-value painting, all whites are painted out and no blacks are used. There is a mosaiclike quality to the middle-value painting, since there are only subtle differences in the lights and darks in this range.

A dark-value painting, also referred to as low key, creates a rich, dense effect. The darkest darks are used, which can be made from mixing complements or can be tube blacks.

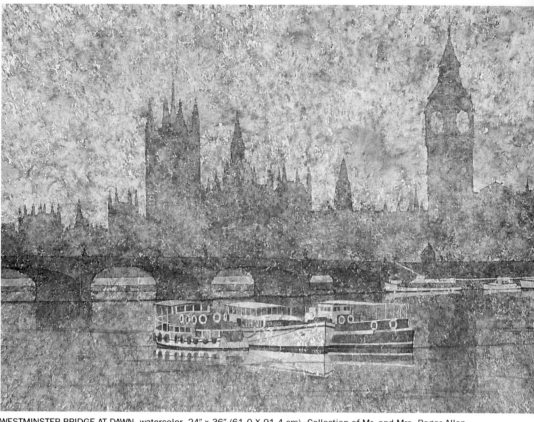

WESTMINSTER BRIDGE AT DAWN, watercolor, 24" x 36" (61.0 X 91.4 cm). Collection of Mr. and Mrs. Roger Allen.

The misty, ethereal light of a London dawn is the most lasting memory of the first time I viewed the Thames River at Westminster Bridge. The atmosphere created by this high-key light remains very vivid in my mind; the structures are harder to recall. Natural elements and sensations—fog, rain, smoke, smell, and temperature—are best conveyed with values.

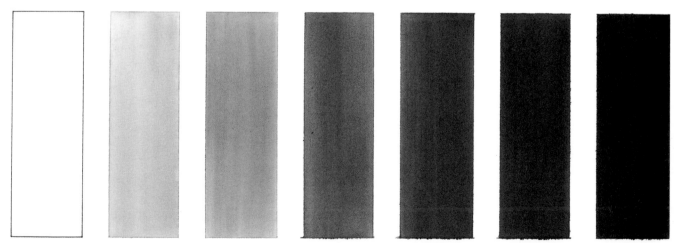

A value scale with white as the lightest value and black representing the darkest value.

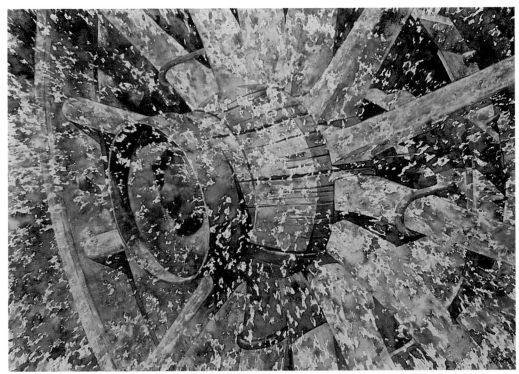

REAR WHEEL OF AN OAT SPREADER, watercolor, 24" x 34" (61.0 x 86.4 cm). Collection of Mr. and Mrs. James Nelson.

In this open composition, where you see only a part of the whole subject, I used a range of middle-value colors. The light of the ground surface is composed of light, middle, and middle-dark values of yellow, red, and blue to produce a myriad of purple hues.

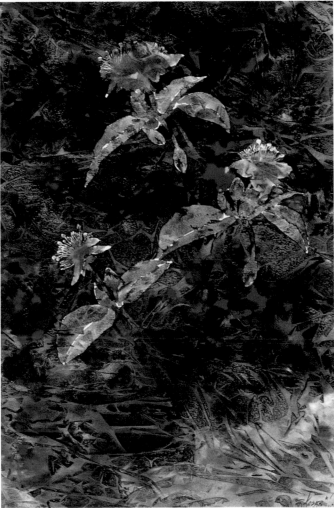

This painting holds to the scale of middle-dark to dark values. Though the primary colors were applied to a wet ground surface in copious amounts, the colors have a transparent quality when dry. There is a hint of light even in the darkest values. The flower petals catch a fraction of the sun's rays, giving the illusion of a late afternoon.

PATIO PATTERNS III, watercolor, 22" x 14" (55.9 x 35.6 cm). Private collection.

Balancing Values

I subscribe totally to the theory that we enjoy the world around us through the varieties of contrast. Color and size contrasts are visually stimulating. Similarly, you can organize values to enhance contrast and interest in your composition.

Try visualizing the following value distribution in your head. Imagine that you are evenly distributing a middle-value range of colors over a piece of white watercolor paper. The proportion of the middle values covering the page should about equal the amount of white (the color of the paper) saved. By painting out the white with middle values, you are creating shapes from the white of the paper as well as producing a proportionate light- and middle-value distribution. At this point the paper is half white and half middle valued. Now imagine that you are going to add dark values onto the paper, in proportionate amounts to the white and middle values—some white and middle-value areas must be used for the darks. The result is an evenly distributed, uncluttered, and organized composition—one-third light values, one-third middle values, and one-third dark values.

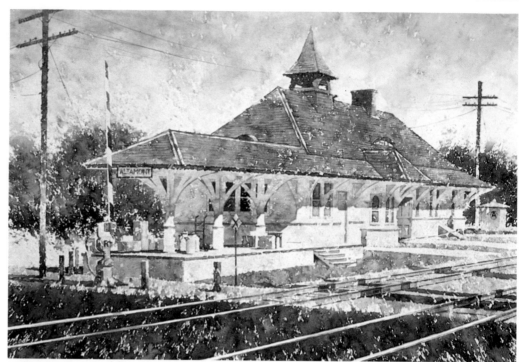

ALTEMONT STATION, watercolor, 21″ x 30″ (53.3 x 76.2 cm). Collection of Mrs. Dolores Beard.

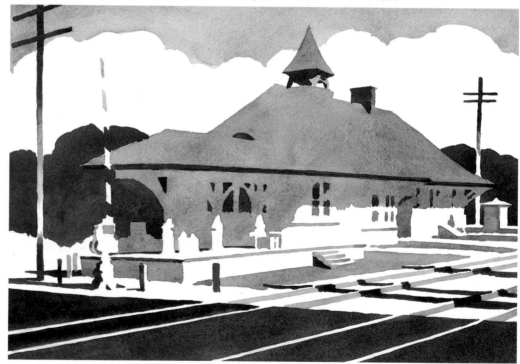

Altemont Station in the Catskill Mountains of New York State is a delightful relic of the past. At the turn of the century, when it was fashionable for middle- and upper-class families to take a summer vacation in the Catskills, the station received passengers from New York City. Today, after careful restoration, the station serves as a children's dental clinic. I felt this historical subject lent itself to a rather conventional value distribution. I placed the middle values at nearly regular intervals throughout the composition, leaving about half the page white (sky and building) and half the page a middle value (sky, middleground, and foreground). Then I introduced the darks to define the light and middle values. The end result is a painting that is approximately one-third light value, one-third middle value, and one-third dark value.

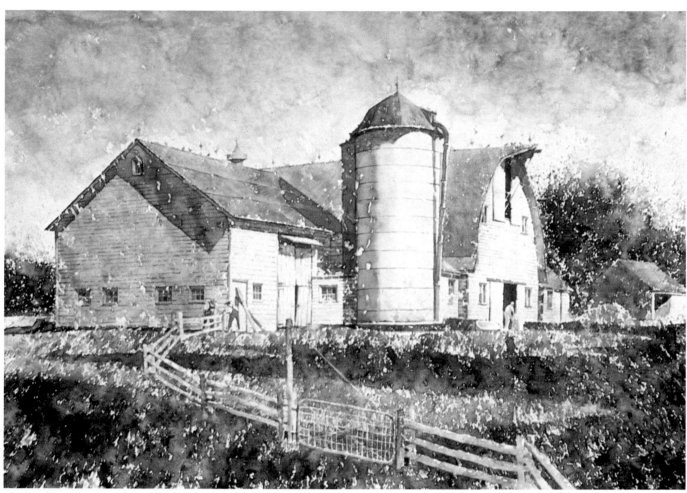

YAKIMA SUMMER CHORES, watercolor, 22″ x 30″ (55.9 x 76.2 cm). Private collection.

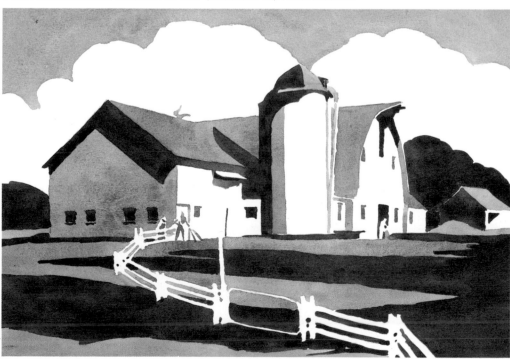

Using a middle value, I painted in a portion of the sky, building, and foreground. Then with about half the paper in white and the other half in a middle value, I distributed my dark values. Portions of the light and middle value areas had to be used for the dark values in order to balance the composition.

Creating a Focal Point with Values

You can establish a main point of interest, or a focal point, with the way you distribute values in your composition. Imagine that you are painting out the white of a sheet of watercolor paper with middle values, with the exception of three or four white shapes in various sizes. Next, you are distributing a small number of strong darks near the white areas—the darks should be in various sizes. By distributing the strong darks in close proximity to the whites, you are making the whites focal points—they become more vital. In such a value distribution a dramatic effect is established. The viewer's attention is drawn to specific areas with the contrasts of light and dark.

Here's another example. Imagine that you are painting out the white of the paper with middle values, with the exception of a specific single light or white.

Next, you are placing a dark value in juxtaposition to the white or light area. The concentration of a strong dark next to the only light area will draw the viewer's eye to this area.

The above examples not only demonstrate the impact of value distribution but also suggest the myriad of possibilities that are available as design plans. There is no one better than the other. Nothing is specifically right or wrong. However, in creating art, you should think about the use of design to carry paintings beyond the realm of mere reporting. The distribution of values can be a wonderful tool in turning reporting into exciting, imaginative, and creative story-telling. Expanding your awareness from pure objectiveness into the province of nonobjectiveness can be fun.

The assemblage of formats and compositional arrangements in this part represent a study guide. You should study and experiment with the numerous variations available. With practice you will develop a natural feeling for unity through line, shape, perspective, and value.

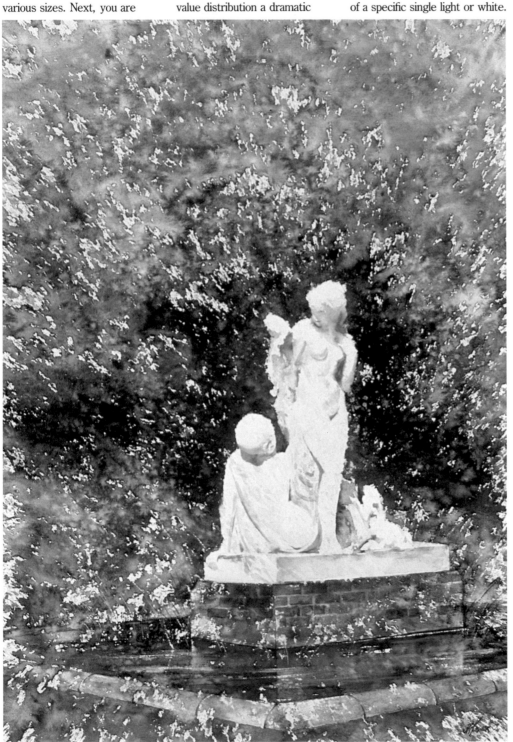

SECRET GARDEN, watercolor, 27″ x 19″ (68.6 x 48.3 cm). Collection of Mrs. Eileen Knourek.

I designed the value distribution in this painting to emphasize the beauty of the sculpted marble figures. The white of the paper forming the shape of the statue figures was "saved" with a piece of mat board cut to that shape. I developed the background area nearest the statue into an area of foliage shadow, which I used to contrast the strongest darks with the lightest lights. With the strongest contrast in this area, the statue becomes the focal point of the painting.

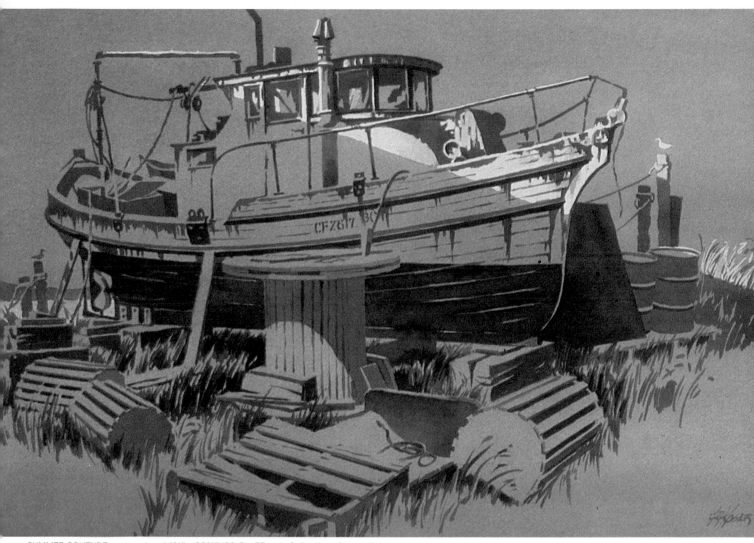

SUMMER SOLITUDE, watercolor, 14½" x 22½" (36.8 x 57 cm). Collection of the artist.

A haunting atmosphere of sunlight, coming from somewhere near the horizon, was created by painting out almost all of the white of the paper with transparent washes and glazes. A cluster of saved lights is scattered across the superstructure and hull of this Monterey fishing boat to add variety to the light of late afternoon. By positioning some of the strongest darks near the saved lights, I made this area the primary focus of attention for the viewer's eye. Your attention may roam to other areas of the painting, but it will always be drawn back to the point of strongest contrast.

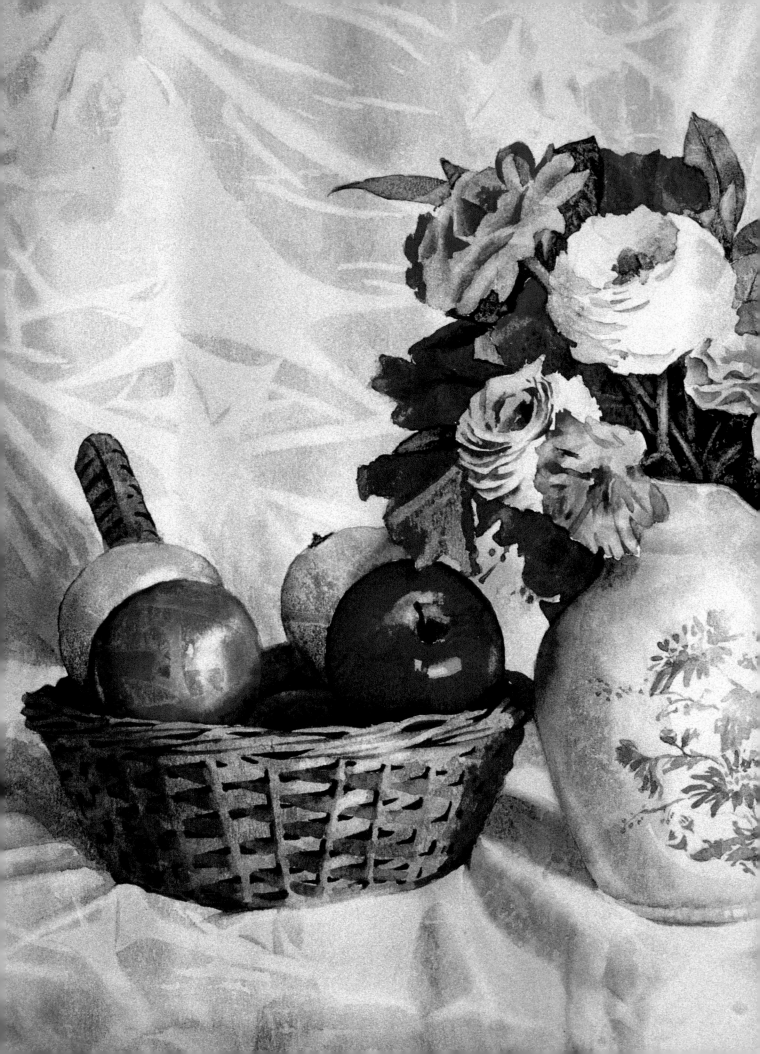

PART 3
COLOR AND TEXTURE
EXPLORING NEW FRONTIERS

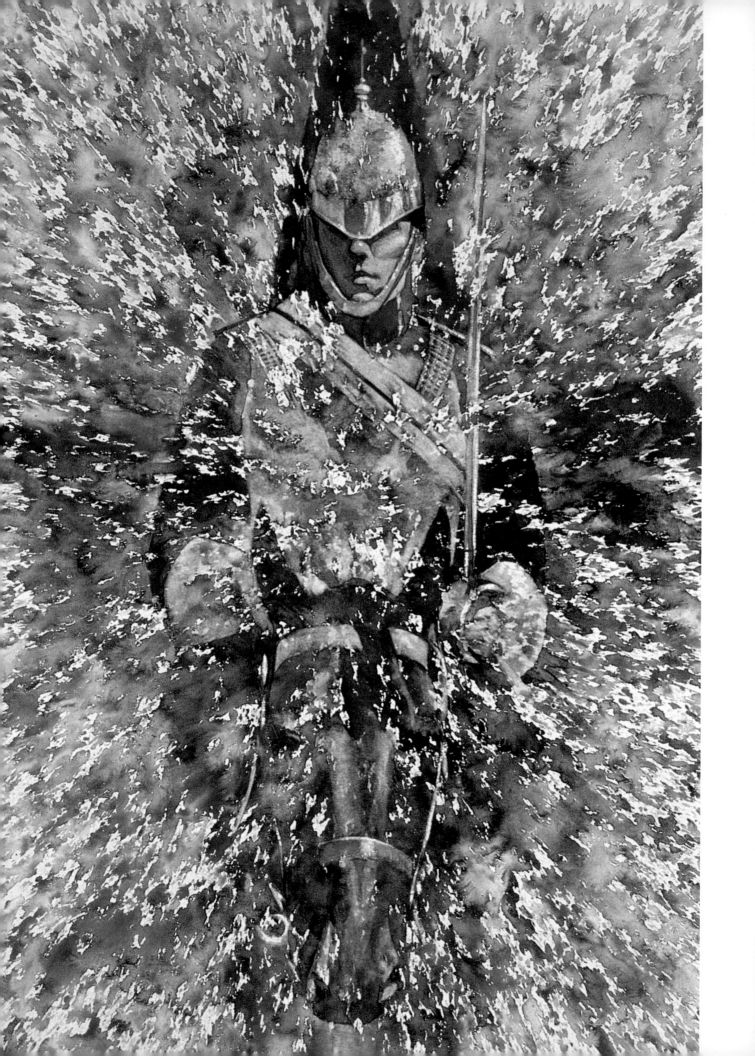

UNDERSTANDING COLOR

Color is a powerful tool for creativity. You will need to explore the possibilities and limitations of color before you begin painting.

Very often, color is what makes the first impact on someone viewing a painting. I believe your emotional reaction to color occurs before any other response you may have to the other design elements in a painting—color touches the emotions.

There are a number of factors you have to consider when working with color; in this part I will explain basic color terminology and simplify some of the processes for you. I will also discuss the physical properties of pigments and go into detail about mixing colors, specifically, a limited palette made up of the primary colors. You will learn how to select colors based on harmony or contrast—warm and cool, muted and intense, complementary and contrasting colors.

Understanding how color "works" is really a product of experience. You can develop your color intuition by painting regularly and finding a way to remember how results are achieved. Look at your color "disasters" as nothing more than rungs on the ladder to success, not lost causes. You can also learn from color wheels that show how the primary colors are mixed to produce secondary and tertiary colors.

As I try to share my feelings about color with you, I must caution you against copying the style of another artist. But it is wonderful to be influenced by others, to refer to many sources and to experiment with various media. Artists soak up and digest the world around them. The real danger is in becoming encumbered with too much knowledge; it can stifle the spontaneity of your art. You should set aside some special time each week to be "crazy." Color would be a wonderful place to start.

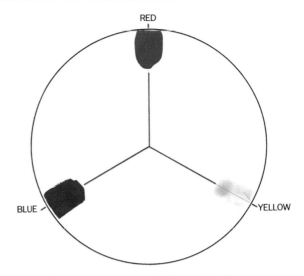

The primary colors: red, blue, and yellow.

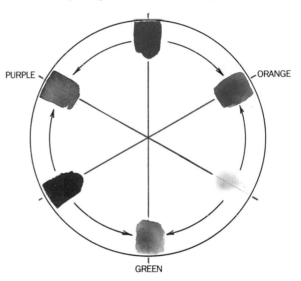

Secondary colors produced by mixing the primary colors.

QUEEN'S CAVALRYMAN,
watercolor, 27" x 18" (68.6 x 45.7 cm).
Collection of Mr. and Mrs. James Nelson.

Here I used a glorious explosion of color, a sea of color in light middle values. Water, then primary colors of yellow, red, and blue, were spattered onto the watercolor page with brushes in a variety of sizes.

Color Wheels: In these color wheels you can see the progression of primary color mixtures to produce secondary and tertiary colors. The colors that are in direct opposition to one another on the complete color wheel are known as *complementary contrasts.*

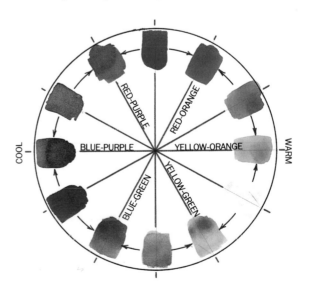

Tertiary colors produced by mixing the primary and secondary colors.

BASIC COLOR TERMS

Before you can understand how color functions in design, you must become familiar with some of the basic terms. Since everyone perceives color in different ways and in different degrees, it is essential to describe the properties of color and how colors interact with one another.

Hue: The hue (also referred to as the color of the object or area) is the type of light that reflects off an object or area.

Value: Value describes the amount of light reflected off an area. A value range means the degrees of lightness and darkness, regardless of hue or intensity, in a composition.

Intensity: Intensity (or saturation) refers to a color's strength or weakness. It describes the relative brightness or dullness of an object, regardless of its hue or value.

Complements: Complementary hues are complete contrasts; they are colors that are opposite one another on the color wheel. For example, the complement of red is green and the complement of orange is blue.

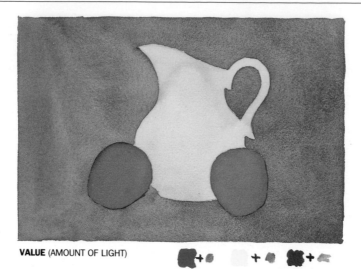

VALUE (AMOUNT OF LIGHT)

INTENSITY (SATURATION OF PURE PIGMENT)

RED YELLOW BLUE

GREEN PURPLE ORANGE

COMPLEMENTARY CONTRASTS

Neutrals: A neutral hue has a low intensity. By gradually adding a complement or black or white to a pure pigment, you can lessen its intensity and make it neutral.

Color temperatures: "Warm" and "cool" are the terms used to describe the temperature of a hue. If you look at the color wheel you will see that the yellow near the orange is warmer than the yellow near the green; or that the color violet is warmer near the red and cooler near the blue.

Primaries: Hues that cannot be produced by mixing other hues are called primaries (red, yellow, and blue).

Secondary colors: The secondary hues can be made by mixing two different primaries—red and yellow for an orange, yellow and blue for a green, and red and blue for a violet.

Tertiary colors: By mixing a primary and a secondary color, you can produce a tertiary color—red-orange, yellow-green, and blue-violet.

LOCAL AND REFLECTED COLORS

The true color of an object is referred to as its "local color"; for example, apples are red, bananas are yellow, the grass is green, the sky is blue, and so on. In painting you cannot limit your imagination to just the local colors without questioning the impact of the other surrounding objects that are reflecting colors onto the subject you are painting. The color of the environment as well as the color of surrounding objects are called "reflected colors." If you are painting a portrait, the underside of the model's chin will probably reflect the color of the garment he or she is wearing. A blue sky will turn green leaves blue-green and brown branches purple-gray.

SPRING FLOWER STILL LIFE, watercolor, 16″ x 24″ (40.6 x 61.0 cm). Collection of Mr. and Mrs. Douglas Tubbs.

Strong contrasting colors and values are the emphasis of this floral still life. Because the background is so dark, the flower petals could be filled with subtle color washes and still appear white. The colors in the tablecoth are reflected from the objects placed on it, creating an "anchoring" effect.

WARMS AND COOLS

Perhaps the most powerful ally I have to help capture a specific mood is color. In painting a mood is measured by the color's temperature. Warm colors—yellows, oranges, and reds—produce a festive mood, while cool colors—blues, greens, and purples—create a somber mood.

When working with warm and cool ranges, you should use the full range, which means working from the warmest cools to the medium cools to the coolest cools, and working from the warmest warms to the medium warms to the coolest warms. Working with the full range of warms and cools will help you avoid monotony in your painting. For example, let's say you want a warm temperature to be the dominant factor. You should use the full warm range and add cool colors sparingly in order to avoid monotony. You will notice that your warms will be enhanced by the contrast from adding areas of coolness to a predominantly warm painting.

A word of caution: When blending and mixing warms and cools, make sure your composition doesn't become a half-and-half painting; this conveys indecisiveness.

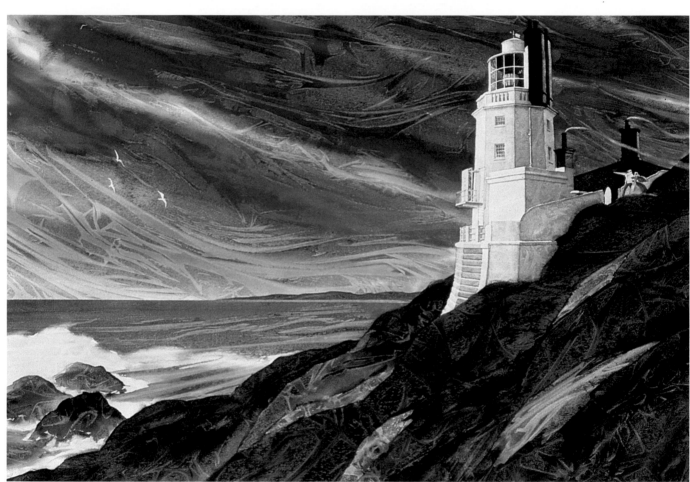

LIGHTHOUSE AT ST. MAWES, TRURO, CORNWALL, watercolor, 22½″ x 32½″ (57 x 82.6 cm). Collection of the artist.

For this cool dominance watercolor, I used a painting plan to design the values, silhouette combinations, and variety of edges. The soft edges of the clouds and surf are contrasted against the crisp masonry of the lighthouse.

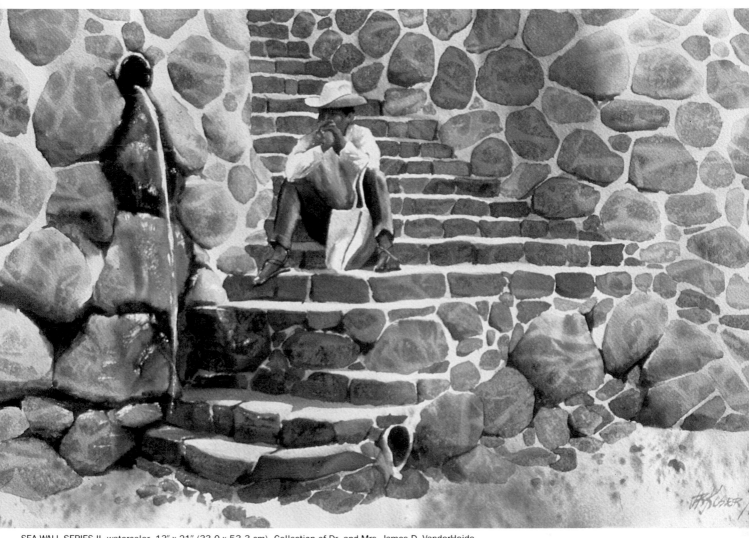

SEA WALL SERIES II, watercolor, 13″ x 21″ (33.0 x 53.3 cm). Collection of Dr. and Mrs. James D. VanderHeide.

My initial step, in this warm dominance painting, was to wet the entire paper and then paint the primary colors in broad vertical strokes. The edges of the underwash were soft and in a high-key value. When dry, the wash had a great deal of transparency and luminosity. By applying an underpainting of broad strokes of warm colors, I was able to unify the background, middleground, and foreground with a warm light.

HIGH KEY AND LOW KEY

Selecting a value dominance for your painting should be one of your main concerns. A "high-key value" refers to a color's lightness—leaning toward white on the value scale. A painting with a high-key dominance uses colors with light intensity.

A "low-key value" refers to a color's darkness—leaning toward the black on the value scale. A painting with a low-key dominance uses colors of dark intensity. You can add luminosity to a low-key painting by allowing some of the white of the paper to reflect through the dark-value colors. This will also lessen the tendency toward a muddy or lifeless painting.

In both high-key and low-key paintings, you can use numerous colors or a limited amount. The challenge is to make sure the values are in harmony. It is also important to emphasize that a high-key painting is not composed only with light values, or that a low-key painting is made up of only dark values. The scale of dominance is the choice of the artist. Success depends on your ability to produce a dominant high-key painting with the right amount of dark values, or a dominant low-key painting with the right amount of light values.

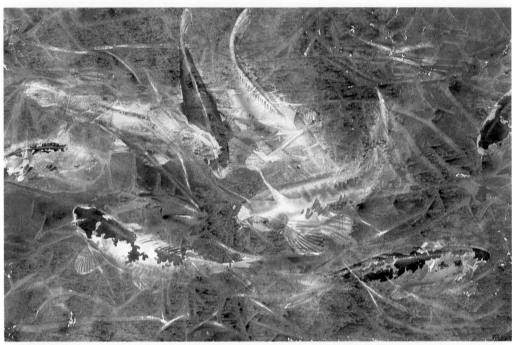

CALIFORNIA CARP I, watercolor, 20″ x 30″ (50.8 x 76.2 cm). Collection of Dr. and Mrs. Robert Baumhefner.

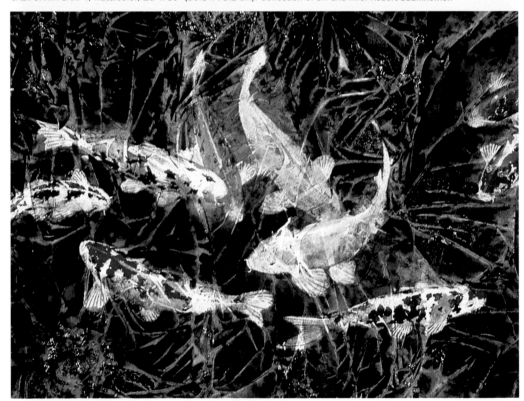

CALIFORNIA CARP II, watercolor, 24″ x 30″ (61.0 x 76.2 cm). San Bernardino County Museum, permanent collection.

In the high-key painting (top) a spatial illusion was created by using contrasting colors. Compare its mood with that of the low-key painting (above), which depicts the same subject matter. The dark value of the murky water pushes forth the light color of the fish. Both light and dark areas sustain each other at the opposite ends of the value spectrum. I produced the dark water by charging red, yellow, and blue into the wet surface of the watercolor paper.

CONTRASTS AND COMPLEMENTS

A simple way of examining color contrasts is to look at a color wheel. You will see that colors in direct opposition to one another on the color wheel, referred to as complementary colors, produce the most contrast—green against red is bold; orange bounces off of blue; and yellow and violet make a vibrant contrast. There are numerous contrasting colors; those that are in direct opposition on the color wheel contrast the most. Since there are slight variations to exact opposites on the color wheel, a broad range of contrasts is available, from the subtle to the harsh. The intensity of the pigment can also enhance the impact of contrast.

You can also create contrasts by working with the values of a color. In such a case, your opposites would be light or white and dark or black. The extreme contrast of white and black is comparative to the complementary colors of the color wheel.

By working with values and complementary colors, you can establish the most extreme contrasts with an infinite number of variations. The dominant theme of your painting could be contrasting colors and values with a subdominance of subtle color and value changes.

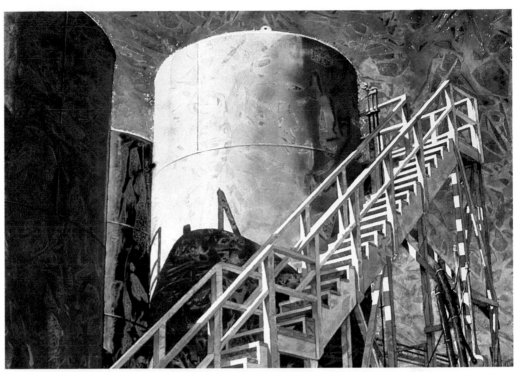

CITY SHADOWS SERIES V, watercolor, 22″ x 30″ (55.9 x 76.2 cm). Collection of the artist.

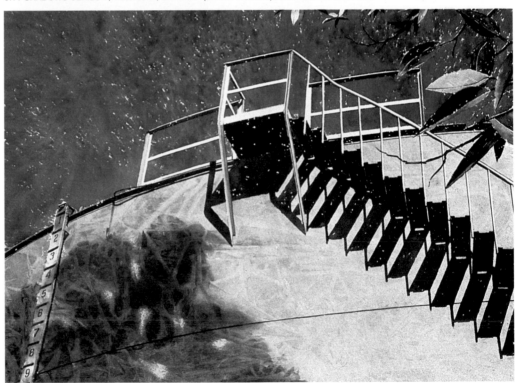

CITY SHADOWS, SERIES II, watercolor, 24″ x 28″ (61.0 x 71.1 cm). Collection of the artist.

Top: The green storage tank sandwiched between the yellow and ruddy red tanks becomes the color focal point in this cityscape. By placing strong complementary colors next to one another, I created a focal point to balance the busy design of the stairs, the railing, and the super-structure that supports the stairs.

Bottom: The dominance of blues in this painting of a winter morning in Fontana needed some contrast and relief. I introduced touches of warm color on the rusted sign on the water tank and the undersides of the rubber tree leaves, where the reds are slightly overstated to enhance the impact. By placing the warm colors near the periphery of the painting, I created a sense of balance.

MUTED AND INTENSE COLORS

Color can be muted, or it can be intense, meaning you have yet another option when you paint. When the character or mood of the subject is subtle, it suggests the use of muted colors. One of the most effective ways you can mute, or tone down, a color is to mix it with its complement. The degree of change in the color will be proportionate to the amount of complement you add to it. There are numerous muted (neutral) colors that are manufactured for sale, but you will find that you will be limited in the variations you can create with a single muted color. When you mix complementary colors, the varieties or changes are less predictable and have greater diversity.

If subtlety is not a part of your painting plan, you may want to try intense colors, which will emphasize bold, dramatic breaks in color. The closer the color is to the primaries on the color wheel, the more intense it is. When intense colors are dominant in a painting, you will see strong values and contrasts. You will also notice that shapes usually have hard edges. It is an excellent form of simplification when handled with skill and creativity.

By using somber, muted colors, I was able to convey a sense of stability and antiquity in this neighborhood cityscape. All the colors were muted with their complementary colors. The subtle changes in the brickwork, facade, sidewalk, and tree bark were achieved by varying the proportions of the complementary colors mixed. For example, the golden yellow of the wooden doors was muted with blue to unify it with the environmental light. The white cat animates the scene and balances some of the weight of the silhouetted tree in the foreground.

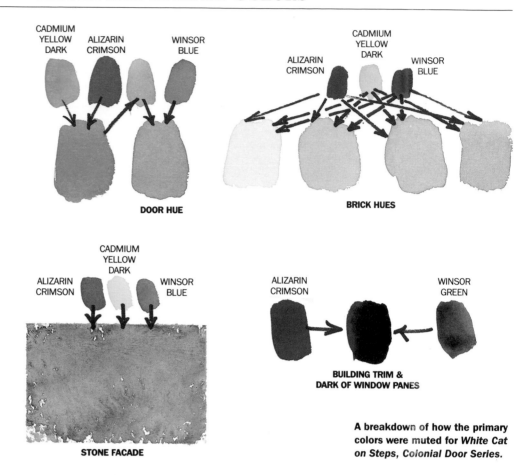

CADMIUM YELLOW DARK ALIZARIN CRIMSON WINSOR BLUE

DOOR HUE

ALIZARIN CRIMSON CADMIUM YELLOW DARK WINSOR BLUE

BRICK HUES

CADMIUM YELLOW DARK

ALIZARIN CRIMSON WINSOR BLUE

STONE FACADE

ALIZARIN CRIMSON WINSOR GREEN

BUILDING TRIM & DARK OF WINDOW PANES

A breakdown of how the primary colors were muted for *White Cat on Steps, Colonial Door Series*.

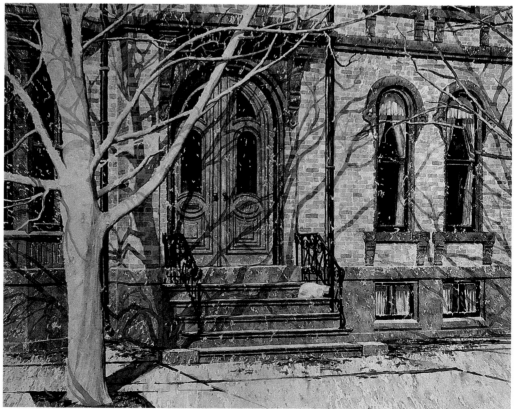

WHITE CAT ON STEPS, COLONIAL DOOR SERIES, watercolor, 20″ x 25″ (50.8 x 63.5 cm). Collection of Dr. and Mrs. Kaplan.

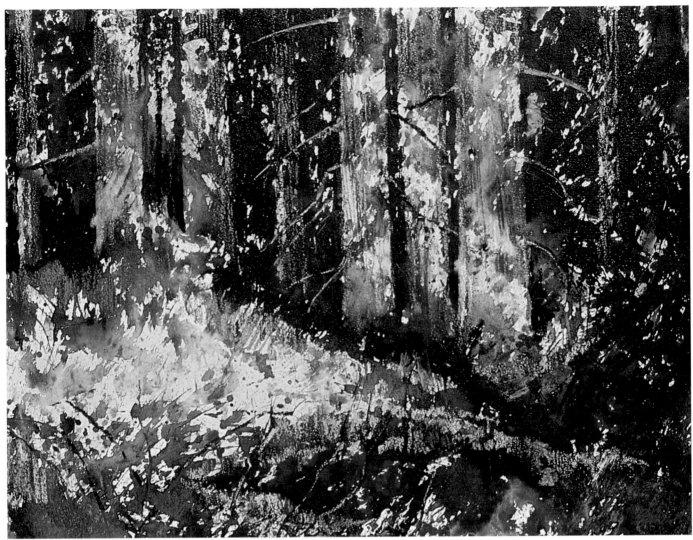

PRAIRIE CREEK REDWOODS, watercolor, 14" x 20" (35.6 x 50.8 cm). Collection of Mr. and Mrs. William Butler.

Strong value, contrast, and intense color characterize this painting. The predominantly hard edges convey the brilliance of the outdoor light and contrast well with the deep, color-filled shadows. This is a predominantly warm painting, but the warmth is given relief with the introduction of some muted greens in the foreground. I was able to test these color relationships by making trial patches as shown below.

Trial patches for *Prairie Creek Redwoods.*

USING A LIMITED PALETTE

A limited palette refers to the number of tube colors being used—usually two, three, or four colors. Though your palette may be limited, you will find that you can combine a few colors in numerous ways to establish strong or subtle contrasts, muted or intense hues, warm or cool temperatures, or high-key or low-key values. When you are experimenting with a limited palette, look to nature for inspiration and points of departure from the ordinary. See how unpredictable color can be, how exciting and full of emotion.

A limited palette also brings unity to the painting. The fewer tube colors used, the better (for unity's sake). For example, if you select the three primary colors, then all the secondary and tertiary colors can be produced from the primaries. Greens, oranges, and purples will have a common bond with the primaries. All grays produced by mixing the three primaries will be influenced by the dominant primary—a yellowish gray, a reddish gray, or a bluish gray. The dominance of the chosen primary will determine whether the painting will have a cool or warm mood.

Unity is also enhanced with a dominant warmth or coolness in the painting. A cool dominance with a relief of warms, or a warm dominance with a relief of cools, allows you to add variety to your composition.

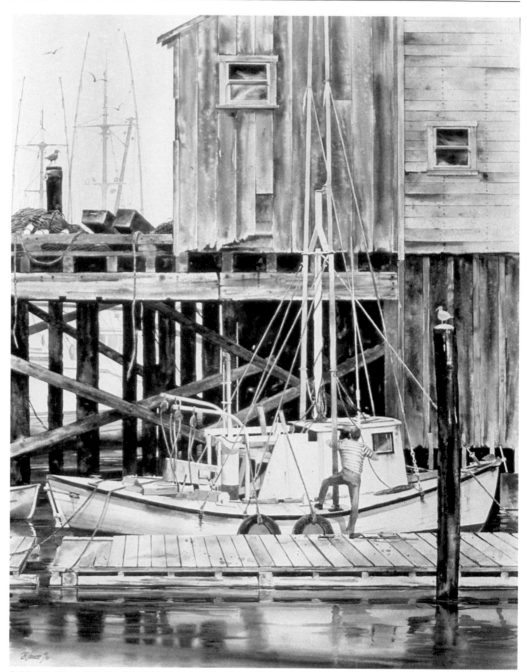

CARE AND FEEDING OF A FISHING BOAT, watercolor, 29" x 23" (73.7 x 58.4 cm). Private collection.

I used a limited palette of ultramarine blue, burnt sienna, and yellow ochre to produce the atmosphere of this salty, wet waterfront. My limited palette was used with an option of muted hues. No pure red, yellow, or blue was used in this painting. The painting is a carefully constructed group of push-and-pull value patterns, which I felt was the most effective way to convey the character of this waterfront.

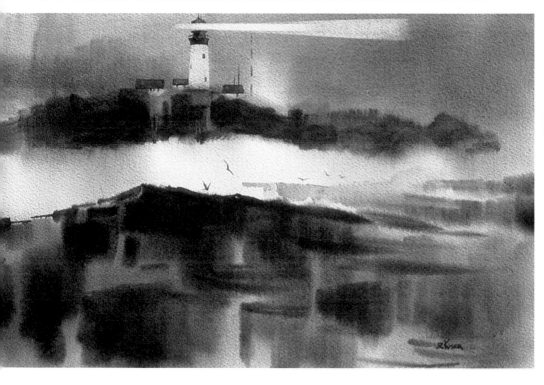

I chose the pigments burnt umber and ultramarine blue to create the mood of this seaside scene. First I wet the entire surface of the watercolor paper, then I applied a high-key valued underpainting, taking care to save the white of the breaker shape. By using two colors similar in intensity (one warm color and one cool color), I was able to produce a spacious mood. This palette is well suited for paintings of seacoasts and snowy landscapes, which usually have a blue-gray or leaden sky.

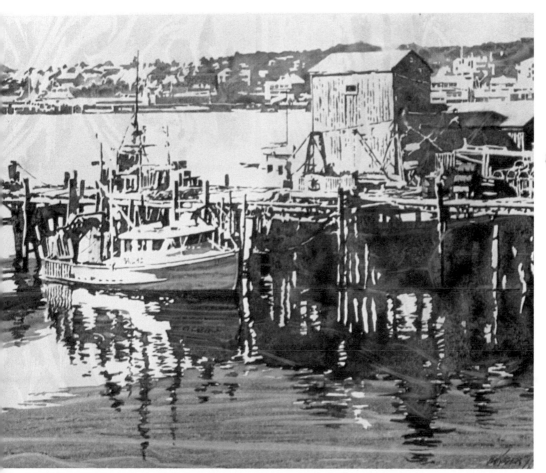

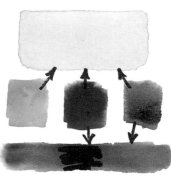

In this painting the tube colors alizarin crimson, Winsor green, and Indian yellow make up my limited palette. I wanted to create an atmosphere of hazy sunlight and salty air, so I tested the colors on a trial patch. The high-key wash of green and red was cooler than I desired. I couldn't feel the sunlight, so I added some Indian yellow. I enhanced the patterns of the water reflections by using the kitchen wrap monoprinting technique (see pages 98–99).

LANDING PATTERNS, watercolor, 16″ x 20″ (40.6 x 50.8 cm). Collection of Mrs. Dolores Beard.

PHYSICAL PROPERTIES OF PIGMENTS

There are hundreds of watercolors manufactured in tubes that are available to the artist. In my studio I have posted to the wall two color charts published by commercial manufacturers of watercolor pigment. There is really no need for a hundred tubes of color in one painting. The challenge is to make beautiful visual music within the framework of a few exciting colors, to find the right combination that will work for each individual's creative psyche. The artist's palette should be as personalized as the character of one's handwriting. The colors on your palette should be the result of constant experimenting and searching, of months or years of painting experience.

The following are some basic points about the physical make-up of pigments that will be useful to you when selecting palette colors. One main consideration will be the staining quality of the colors you select. Staining colors are very transparent and will penetrate deep into the fibers of the paper. The color will not lift off or wash out once it has been applied to the paper's surface. Staining colors will also affect or stain other pigments that were applied previously. When dry, staining pigments offer a great deal of luminosity. Two examples of strong staining pigments are phthalo blue and alizarin crimson.

At the opposite pole are the nonstaining pigments, which are characterized by their opaqueness. Because of their opaque quality, nonstaining pigments seem to dry on the surface of the paper with only slight penetration of the paper fibers. Nonstaining pigments are quite effective in the glazing technique because they lie over rather than obscure the underpainting. Two good examples of nonstaining pigments are burnt sienna and manganese blue.

The broad range of manufactured pigments available to the artist is the result of many colors produced by the mixing and blending of both staining and nonstaining base pigments. Such refinements in the production of tube paints have added variety to the subtleties and physical characteristics of the colors, such as moderate staining, slightly staining, nonstaining, slightly opaque, moderately opaque, and totally opaque qualities.

STAINING
(TRANSPARENT)

NONSTAINING
(OPAQUE)

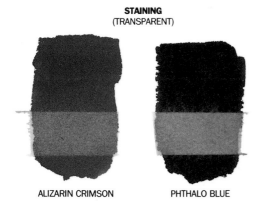

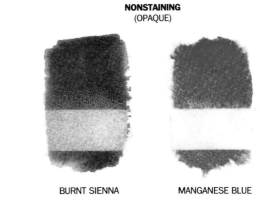

ALIZARIN CRIMSON PHTHALO BLUE

BURNT SIENNA MANGANESE BLUE

PHTHALO BLUE GLAZE

ALIZARIN CRIMSON GLAZE

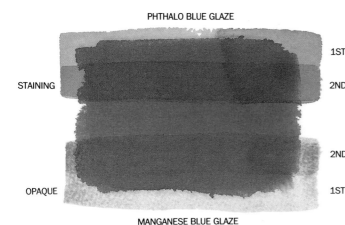

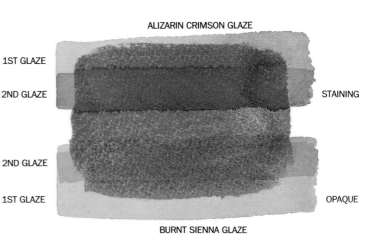

1ST GLAZE

STAINING 2ND GLAZE STAINING

2ND GLAZE

OPAQUE 1ST GLAZE OPAQUE

MANGANESE BLUE GLAZE

BURNT SIENNA GLAZE

Examples of staining and nonstaining pigments.

POTENCY FACTOR OF PIGMENTS

Before exploring specific colors and various combinations, you need to understand the potency factor of manufactured pigments. In my color arsenal, I refer to them as "heavyweights," "middleweights," and "lightweights." The following are some examples of the primary colors in each category.

Heavyweight: Blues—phthalo blue, indigo, and Prussian blue. Reds—alizarin crimson and cadmium red. Yellows—cadmium yellow and cadmium orange.

Middleweight: Blues—ultramarine blue and cobalt blue. Reds—vermilion and burnt sienna. Yellows—Indian yellow and yellow ochre.

Lightweight: Blues—cerulean blue and manganese blue. Reds—rose madder and cadmium scarlet. Yellows—lemon yellow and aureolin.

Remember, these are just some of my examples; you may want to refer to your own color charts for a personal comparative analysis. Knowing the weights of pigments will help you arrange compatible palette colors as well as understand how colors will act when they are mixed.

HEAVYWEIGHT

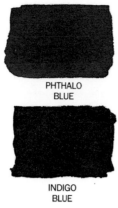
PHTHALO
BLUE

WINSOR RED

CADMIUM
YELLOW

INDIGO
BLUE

ALIZARIN
CRIMSON

CADMIUM
ORANGE

MIDDLEWEIGHT

COBALT
BLUE

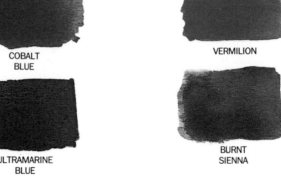
VERMILION

INDIAN
YELLOW

ULTRAMARINE
BLUE

BURNT
SIENNA

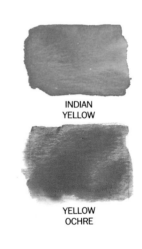
YELLOW
OCHRE

LIGHTWEIGHT

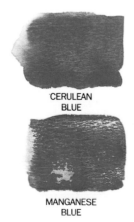
CERULEAN
BLUE

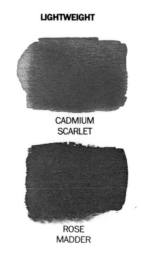
CADMIUM
SCARLET

LEMON
YELLOW

MANGANESE
BLUE

ROSE
MADDER

AUREOLIN

The primary colors in different weights.

Now, I would like to encourage you to experiment with some colors that are compatible in terms of potency. Try mingling a heavyweight blue like phthalo blue with a strong heavyweight yellow like cadmium yellow deep. Instead of mixing on the palette, wet some watercolor paper and apply these colors in equal amounts into the wet surface. Allow the colors to mingle on the wet paper, and then charge the edge of the wet area with cadmium red or alizarin crimson. Doesn't the red hold up well in the presence of the yellow and blue? I find that the red imparts a new ingredient of color to the blue and yellow, but is still able to hold its own integrity.

Next, try mingling some middleweight pigments—ultramarine blue, burnt sienna, and yellow ochre—on a wet watercolor paper surface in approximately equal amounts. Don't place one color on top of the other; place them in proximity so that they will mingle on their own. You will see the secondary and tertiary colors forming; notice how well they hold up when thrust into color "combat" on the same page.

To complete the experiment, you may want to try mixing some lightweight pigments like lemon yellow, rose madder, and manganese blue. By mingling these colors together, you will discover a new three-color, high-key limited palette for your next painting.

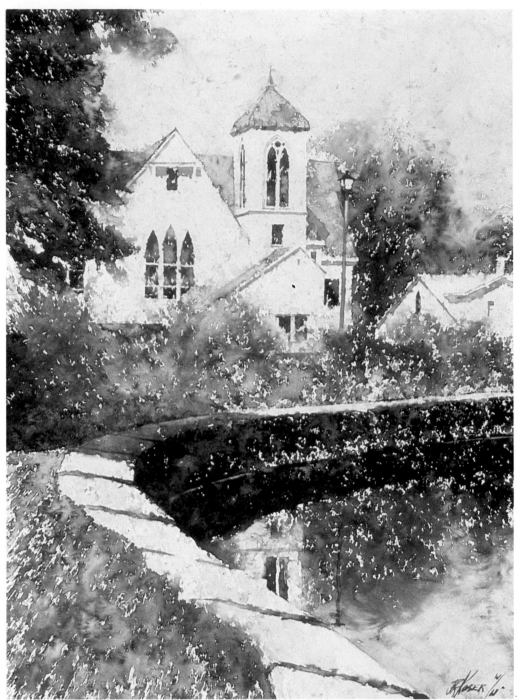

REFLECTIONS IN A CATSKILL CREEK, watercolor, 19″ x 14″ (48.3 x 35.6 cm). Collection of Mrs. Eileen Knourek.

For this painting, I used lightweight, middleweight, and heavyweight pigments to clarify and define specific areas. The contrast of the different weights is most evident in the stone wall bordering the creek and in the foliage against the building.

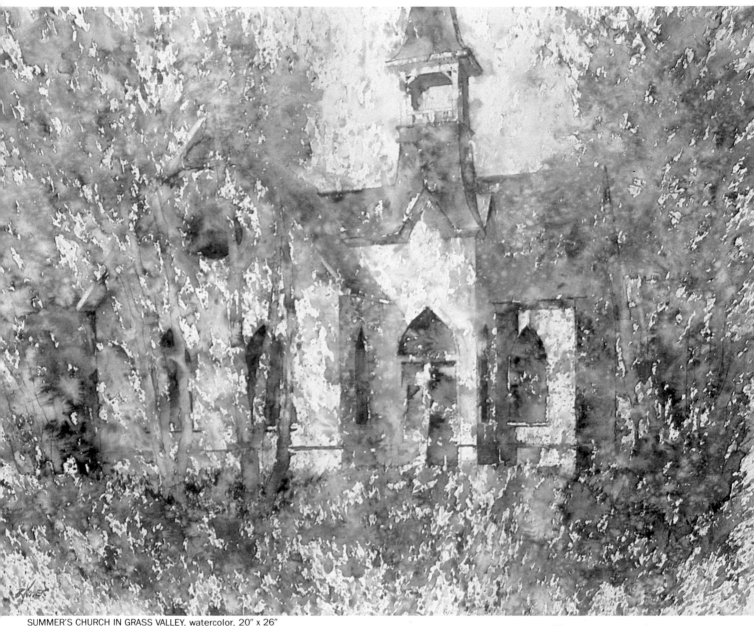

SUMMER'S CHURCH IN GRASS VALLEY, watercolor, 20" x 26"
(50.8 x 66.0 cm). Collection of Mr. and Mrs. Albert Ciampitti.

The transparency of the lightweight pigments used in this painting sets the mood of this summer day. The foliage seems washed out and blends into the atmosphere.

WORKING WITH PRIMARY COLORS

My philosophy in color selection emphasizes simplicity. "Keeping it simple" will be a worthwhile subgoal in all techniques and will be helpful in your selection of colors. But the end results need not be a simple painting.

I believe the backbone of a working palette is made up of primary colors. By using a limited palette of primary colors, you can avoid many color "mistakes" and benefit by working effectively with values. Occasionally you can incorporate a secondary color,

like green, for convenience; for example, phthalo green mixed with alizarin crimson makes a vibrant "black." Working with greens can be nightmarish without care and some experience. If you use a tube green for the "local" color of landscape foliage, you will discover that the color will seem flat and lifeless. If you want to paint an exciting foliage full of life, try using yellow, red, orange, and blue to support a small matrix of pure green. There are also tube

colors that can be used effectively to accentuate secondary or tertiary colors produced from the primary colors.

My working palette is composed of three yellows, two reds, and three blues. The number of these primaries may change somewhat over a period of painting endeavors, but rarely is the change radical. The two reds I use (see color wheel below) are alizarin crimson and cadmium red medium. They represent a cool and warm red of

about the same potency. I can use them alone or together to develop a wide range of red hues.

The yellows on my palette consist of cadmium orange, cadmium yellow medium, and lemon yellow. I use cadmium orange as my warm yellow because it works well with the cooler cadmium yellow medium. Lemon yellow provides a lightening effect when mixed with other primary colors. If I need a warm yellow, all I have to do is dip into the cadmium orange.

ALIZARIN CRIMSON CADMIUM RED MEDIUM

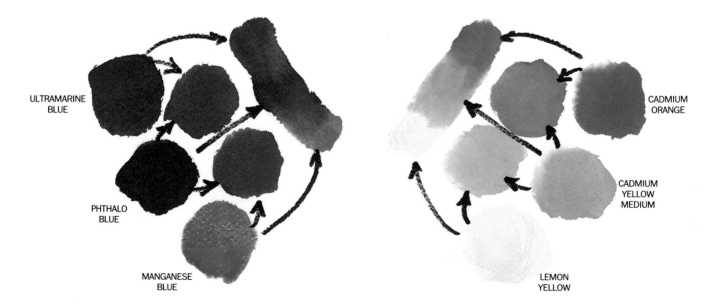

ULTRAMARINE BLUE

PHTHALO BLUE

MANGANESE BLUE

CADMIUM ORANGE

CADMIUM YELLOW MEDIUM

LEMON YELLOW

A color wheel of the primary colors in different weights.

To control the warmth, I add cadmium yellow.

Phthalo blue, ultramarine blue, and manganese blue are the primary blues I use on my palette. Phthalo blue leans in the direction of green or cool. Ultramarine blue leans toward the reds of the color wheel. The use of either one or the other of these blues imparts a different quality to the secondary and tertiary colors formed as they mix on the ground surface with yellows and reds. Manganese blue is a gaudy, bright, and opaquish blue with wonderful granulation characteristics.

I would like to reemphasize the fact that there are physical differences in each of the colors I mentioned above that need additional consideration. An excellent example is the staining quality of phthalo blue and the opaque quality of ultramarine blue and manganese blue. When you blend opaque and staining colors on wet paper, the various mixtures yield a wide range of effects, from very intense staining with only slight granulation to very opaque and granular with only slight staining.

In addition to stressing the importance of keeping the palette simple, I would like to encourage you to be generous. Have more than enough pigment available on the palette. A "stingy palette" will produce a stingy painting. The best color combinations die a natural death without generous amounts of color available for use. Also remember to use plenty of water for all techniques, except for the drybrush. A slogan worth pinning up in your studio is: "If it looks right wet, it's probably wrong." Be prepared to "overstate" in color and value. As watercolor dries, changes in color and value will occur.

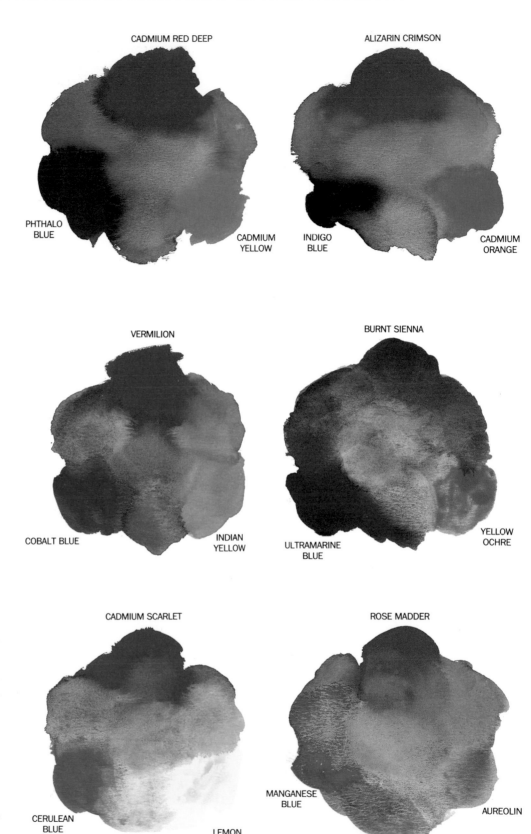

A variety of primary pigment mixtures.

MIXING COLOR DIRECTLY ON THE PAINTING SURFACE

I love color wheels. I think of them as rainbows, full of hope, no two exactly alike, representing an infinite number of possibilities. I must function within the wheel of color if I am to work with color at all.

During the course of my struggle with watercolor, I became aware of a simple but startling fact: I often found more "color excitement" in my large plastic palette surface than I found in my painting. For example, I would mix yellow and red together on the palette to get a secondary orange. Then I would tone down the orange's brashness with a touch of blue and carry the mixture on my brush, to the surface of my painting. But in the process I left behind the excitement of the remnants of the primary colors that were hinted at in the secondary and tertiary colors. The hints of those primary colors were found on my palette, not in the painting. Occasionally I might add a bit of orange to a blue shadow by mixing the pigments on the painting surface, but that was a small exception to my rule of procedure. At that point I found my color statements rather dull and lifeless, and I'm sure the public viewed my work the same way.

Out of a gradual self-assessment and critiquing grew an attitude about color "mixing" that I now hold to with a fair amount of regularity. I like to mix my colors directly on a wet or damp surface. I keep my reds, yellows, and blues segregated on the plastic palette, and I'm careful not to let them blend on the palette. With this technique, you can see the presence of some of the primary colors showing through in the dominant secondary or tertiary colors within my painting. The color excitement that was once found only on my palette can now be found, to a degree, in my finished painting.

I produce greens by mixing and blending yellows and blues right on the wet surface of my painting. For a sunny green, I add a bit of red and sometimes a fresh yellow, which I can cool with a bit more blue to produce a shadowy effect. When the painting dries, I will find hints of some of the primary colors in the secondary color.

For the painting at right, I blended the following colors directly on the ground surface: Indian yellow and gamboge, alizarin crimson and Winsor red, and ultramarine blue and Winsor blue. I wet the areas to be painted first by flecking and spattering clean water onto the surface at random, which left sparkling islands of dry white paper. Then I applied the primary pigments in the same manner. I usually start with the yellows, followed by the reds, and then the blues, working quickly to take advantage of the wetness. It is the mixing of primary pigments that produces such a variety of greens, oranges, and purples. There are always touches of the primary colors sparkling through. To test my color mixtures for a painting, I make several trial patches like those shown here.

SUNLIT PORTION OF BRIDGE
WITH DARK FOLIAGE
AND SUNNY FOREGROUND

SHADOWY PORTION OF BRIDGE

HEAVY SHADE ON BRIDGE—
TREE TRUNK SHADOW CAST
BY TREE ON FOREGROUND

Trial patches for Bridge on Gladstone Road.

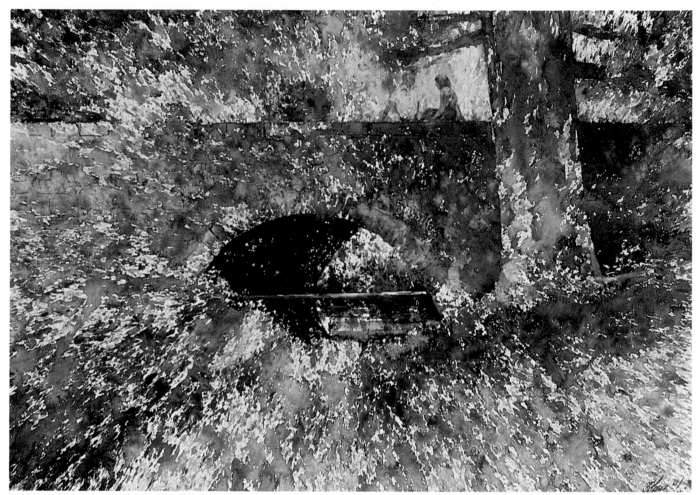

BRIDGE ON GLADSTONE ROAD, HUNTLEY, SCOTLAND, watercolor, 19" x 27" (48.3 x 68.6 cm). Collection of Dr. and Mrs. Morris B. Gluck.

SUNLIT FOREGROUND

FOLIAGE AND BRANCHES

NON-CONTACT METHOD

The concept behind the non-contact technique is to spatter and fleck water and pigments into designated areas of the painting surface—building up the composition one area at a time. While you are applying pigments in one area, the other areas of the paper are covered with mat board cutouts, called resists, or liquid frisket to keep them clean.

To begin I usually have a 35mm slide made of the drawing I want to make into a watercolor, and project the image onto my painting surface. I then draw in the basic shapes and areas. Once I am satisfied with the composition, I make a tracing of the drawing to construct my mat board resists. The tracing is composed of the basic painting areas—for example, the main shapes, the foreground, the middleground, the background, and so on. Next, I need to transfer the tracing onto a piece of mat board. After rubbing the back of the tracing with graphite pencil, I place the tracing, graphite side down, onto a piece of mat board and draw over the lines of the tracing with a pen. Then I cut out the mat board shapes, bevel the edges, and waterproof each piece with acrylic spray.

I assemble the mat board resists onto the painting surface, except for the area I want to paint first. Using a natural bristle toothbrush, I fleck and spatter water onto the exposed area. Immediately afterward, I begin applying the pigments with different size brushes—the toothbrush, a 1″ aquarelle, and a 2″ Sky Flow—in spattering and flecking motions. I usually apply my pigments in the same color sequence: yellows, reds, blues.

After an area is finished, I wait for the paint to dry before I remove all the resists to evaluate the painting. Then I proceed with the next area in the same manner. (See *Early August on Elk River Road* on pages 118–123 for a detailed demonstration.)

Working with the three primary colors in the non-contact technique, you can obtain the secondary colors in a wide range of values. In the section below, I will demonstrate some of the primary color mixtures that you can obtain with this unique method.

Mixing Greens

You may want to try the following procedure as you read along. With a natural bristle toothbrush,

I fleck water onto a patch of paper. Next I use the toothbrush along with 1″ and 2″ flat brushes to fleck and spatter yellow pigment onto the wet area. Immediately afterward, I rinse out the same brushes and then dip them into my blue pigment to spatter on top of the yellow. From this random paint application, you can see that where equal amounts of yellow and blue mix, a green is formed. Where only a small amount of blue reaches a spot of yellow, the green is warm and yellow. Where there is more blue than yellow, the green is a coolish blue. There will be some areas of pure yellow and blue that enhance the surrounding color. If a pinch of red is spattered onto this wet surface, some new effects will be produced. Where the red touches a green, it will mute the green from a Kelly or emerald green to a more natural green. And where a little pure yellow is touched by the red an orange is created; where pure blue is touched by the red a purple is formed.

Mixing Oranges

Using the spattering and flecking technique, I wet a patch of paper with water and then immediately

spatter yellow pigment into that same area. While the yellow is still wet, I spatter red into the yellow area. You can see an orange hue where equal amounts of yellow and red mix. Where minute amounts of red join large islands of yellow, the orange is a yellow-orange. Where large amounts of red mix with yellow, the orange is a red-orange. A small amount of blue can be added to tone down the brashness of the orange. When the blue touches a pure yellow it creates a green cast, while the blue that mixes with a pure red produces a purple.

Mixing Purples

After spattering a patch of paper with water, I apply reds and then blues into the wet surface. Where equal amounts of red and blue blend, a purple is formed. Where only a small amount of red touches a blue, the purple will be a cool bluish purple. Where only a small amount of blue touches a red, the purple will be a warm reddish purple. A minute amount of yellow added to an area of red will cast an orange tone, and a minute amount of yellow added to an area of blue will create a green tone.

Blending primary colors directly on the painting surface to produce greens, oranges, and purples.

MIXING GREENS

INDIAN YELLOW

INDIAN YELLOW + PHTHALO BLUE

INDIAN YELLOW + PHTHALO BLUE
+ ALIZARIN CRIMSON

MIXING ORANGES

INDIAN YELLOW

INDIAN YELLOW + ALIZARIN CRIMSON

INDIAN YELLOW + ALIZARIN CRIMSON
+ PHTHALO BLUE

MIXING PURPLES

ALIZARIN CRIMSON

ALIZARIN CRIMSON + PHTHALO BLUE

ALIZARIN CRIMSON + PHTHALO BLUE
+ INDIAN YELLOW

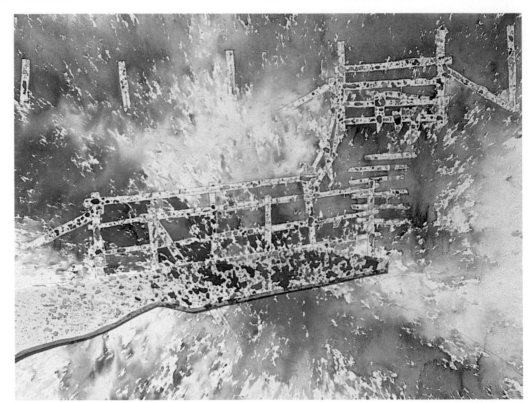

This sequence demonstrates how I put the non-contact painting process into practice. In this stage the fencing and bridge are protected with liquid resist, and the pathway is protected with a mat board resist. Then I gradually began building up the color, using the non-contact method over the entire painting surface.

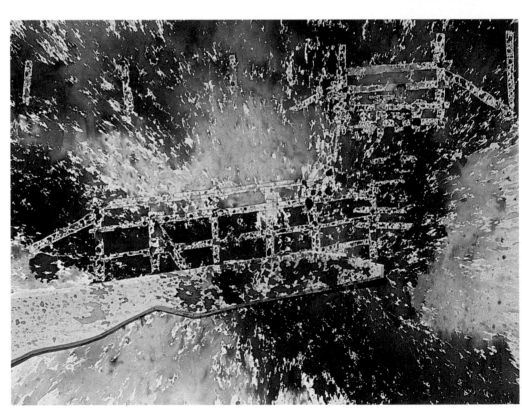

Greater value and pigment concentration is attained gradually.

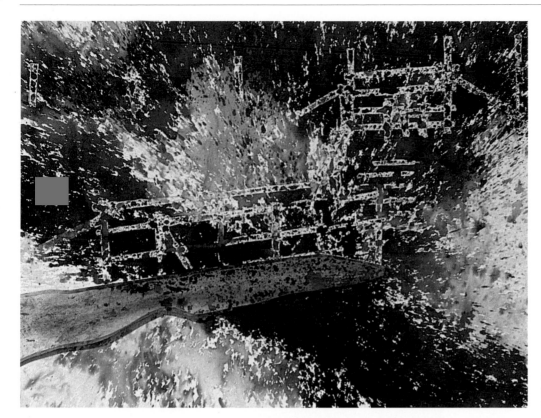

Here is the final stage, where I felt satisfied with the value and pigment concentration.

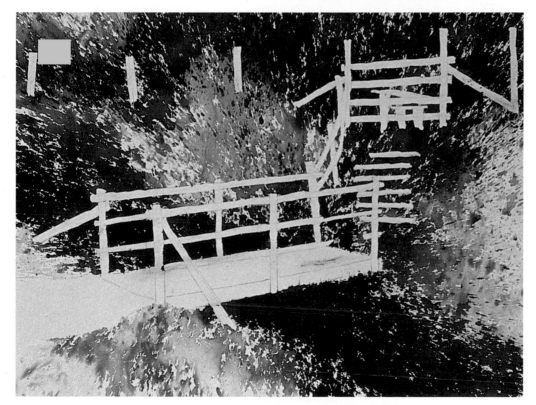

I removed all the resists to reveal the white shapes.

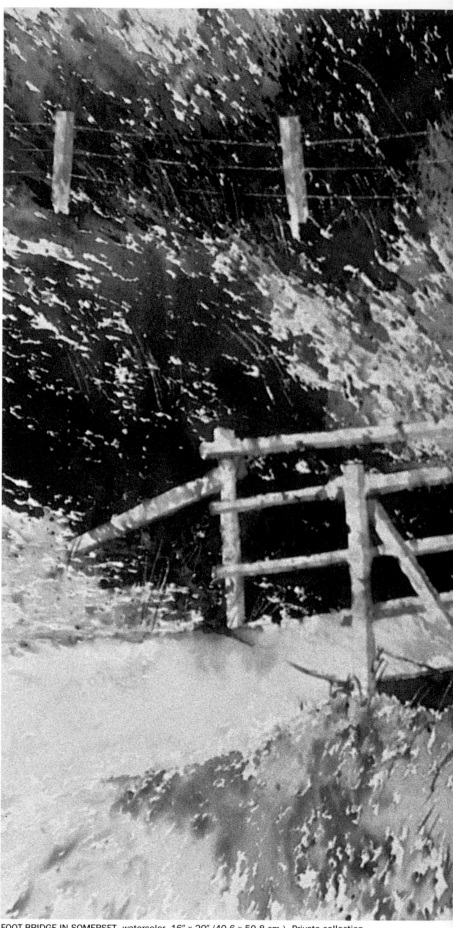

When the last paint application was dry, I developed the fence and bridge areas. To suggest shadowy patterns on the fence and bridge, I dry painted those areas with primary colors using a small round brush. Then I used a sharp knife point to scratch in the fence wire and to suggest the grass in the foreground.

FOOT BRIDGE IN SOMERSET, watercolor, 16" x 20" (40.6 x 50.8 cm.). Private collection.

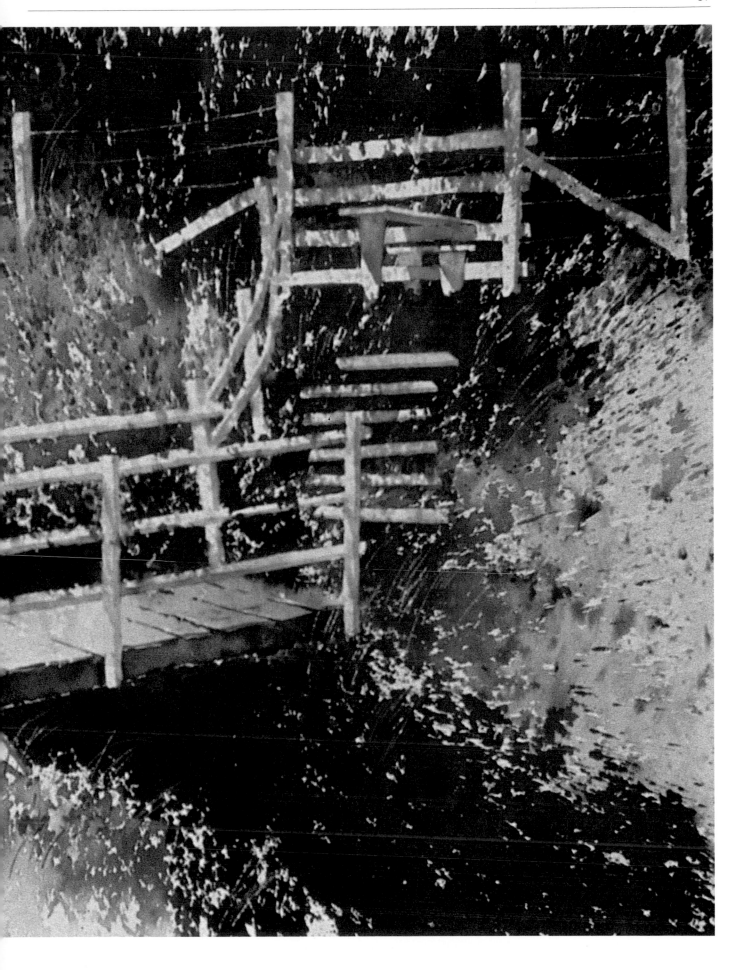

REGULATING PAINT FLOW

Watercolor painting demands that you work rapidly so that you can take advantage of the variety of effects obtainable while the paper is wet. It's easy to suffer an anxiety attack when you have to adjust values in different areas, control color dominance, and try to produce a pleasing variety of edges between shapes all at the same time.

Painting with watercolors for many years has taught me to look for ways to "bite off" only what I can chew. For instance, let's say I want to paint an entire page with some abstract design elements and textures as an underpainting. In such a case I would paint in a light value for the underpainting. By leaving some light areas, even some white of the paper exposed, I will produce a transparency and luminosity as the rest of the painting progresses. As I continue to layer images and shapes on the ground surface, I can select and concentrate on smaller areas to develop.

I love to paint on wet surfaces; it's a wonderful control device. When I charge pigments onto a wet area, the pigments will not go beyond the wet boundary. I can actually regulate my paint flow by simply controlling the wetness of the paper.

In this painting I regulated the paint flow by only wetting the area I planned to work on first. For the sky, I wetted the area with a flat 1″ aquarelle brush, outlining the church and mountain shapes. Then I added my pigments to that area while it was still wet. The paint pigments only flowed into the wet areas, not beyond.

SUMMER SUNDAY, MEXICO, watercolor, 14½″ x 21½″ (36.8 x 54.6 cm). Collection of the artist.

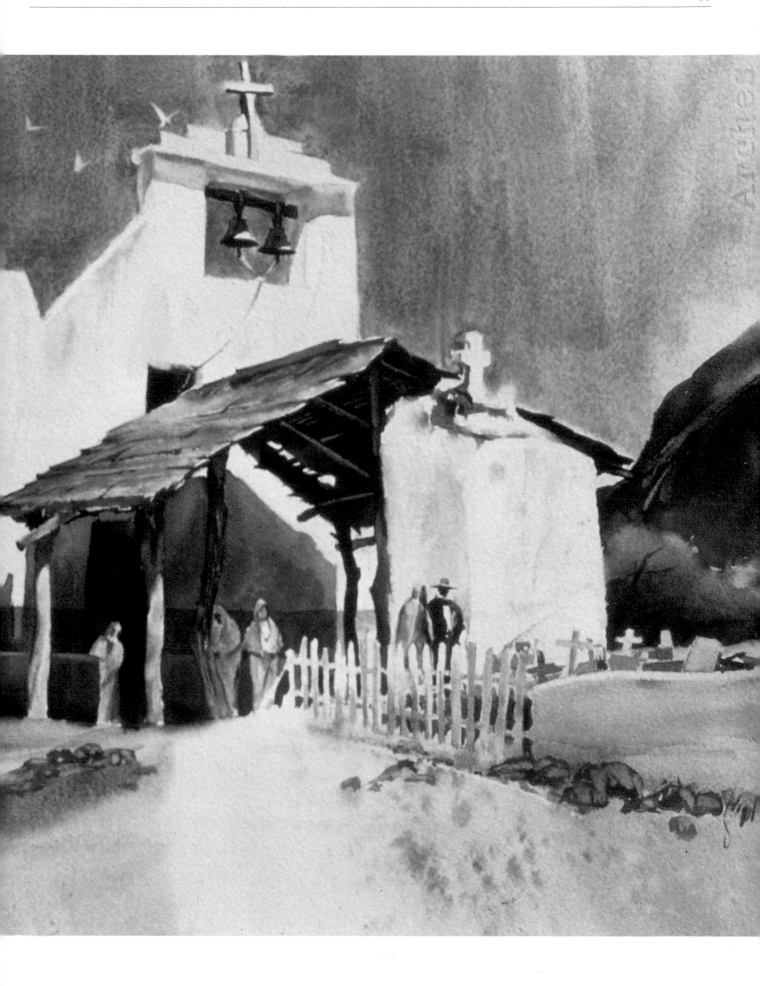

ADJUSTING COLOR: GLAZING

In order to adjust the value or temperature of a watercolor painting, you need to know about glazing. Solutions used for glazing should be composed mostly of water with small amounts of pigment. Opaque paint is easy to glaze with because the pigment lies on the paper's surface. The glaze does not actually alter the pigment underneath it; you will see the color and value of the underpainting reflecting through the glaze.

Any paint pigment can be used for glazing if a couple of precautions are followed. First, you must work slowly. Only slight changes are necessary with each glaze application, so make your change in gradual degrees. Mix your glazing solution of water and pigment, then test the potency on a small piece of the same kind of paper you plan to work on, which I call a "trial patch." You should paint only one application or layer at a time. Allow the paint to dry completely between applications. You can judge the success of an application only when it is dry.

For the sea wall, I brushed in the mortar first. When that area was dry, I developed the stones; next I began glazing the wall with red (alizarin crimson). A very diluted mixture of pigment with water was brushed over the wall area. One brush-filled swipe was made between the drying period to prevent any dissolving of the transparent watercolor of the stone wall. This also helps keep close control of the value.

Then a diluted mix of water and green (Winsor green) was brushed lightly over the area glazed by the red.

After building up the glazes to the degree that the stone wall looked wet and mossy, I painted in the darks around the rock shapes, indicating the gradual dissolving of mortar. The value of the glazes "pushes" the boat to the foreground.

LOW TIDE AT PORTSOY,
watercolor, 19" x 14" (48.3 x 35.6 cm).
Collection of Mrs. Dolores Beard.

Because the sea wall was usually submerged in water, the stones had a variety of deep greenish red colors that made a perfect subject for glazing.

WARMING UP

There is a great deal of coordination required to handle watercolor—you need a combination of physical dexterity and mental adaptability to the unexpected. We all need a "warm-up period" when performing a skill that involves our physical and mental expertise. I usually have a warm-up before each painting session. In my warm-up I test out my ideas on small areas of watercolor paper that I call "trial patches." The patch size is small for convenience and always on a ground surface that I plan to work on that day.

A warm-up period allows me to test my color combinations, the order in which I want to introduce my primary pigments, and the saturation of each pigment, and sometimes I will explore ways of texturing the painted surface. There is little anxiety over the outcome. Warm-ups help me to be more daring and inventive rather than playing the "pat hand" of some techniques I'm very familiar with. Remember, nothing ventured, nothing gained. The warm-up period and trial patches are great for breaking out of old habits. I have pages and pages of trial patches labeled for reference so I can, if need be, find some record of a particular technique or color combination that I wish to review.

Water and sky trial patches.

Trial patches for foliage, using the non-contact method.

LIFTING COLOR AND USING RESISTS

Watercolor can be lifted or scrubbed out. Before lightening or lifting an area, you must make sure that the area is wet. This softens the paint and loosens the paper's fibers only in the area needing the adjustment. (Drafting tape may be used to mask off the area needing adjustment.) Using a napkin, paper towel, rag, or wet sponge, you can gently rub or scrub the surface. Be patient. Let the water soak in and do its job. More than one lifting process may be necessary in order to reach the desired value and shape. Easy does it!

If you want to save the white of the paper, you may want to use a resist. There are some products on the market such as masking fluid, liquid frisket, and maskoid. You can also use masking tape to stop the flow of the paint from entering a specific area.

In the demonstration shown here, I used lifting *and* masking techniques. It's a matter of preference.

These are just some of the methods available for making adjustments in watercolor. I hope the techniques suggested in this section will enable you to use color more effectively in your next painting.

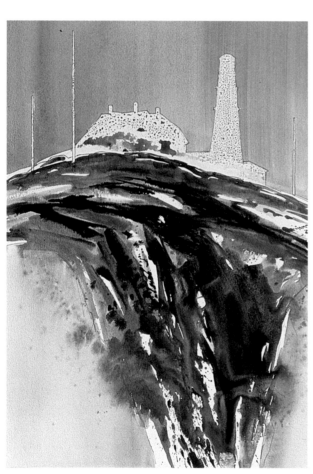

USING A LIQUID RESIST

In this stage, you are looking at a painting that was developed with the wet-into-wet technique. I saved the white area of the lighthouse and utility pole by covering those areas with a liquid resist before I began painting.

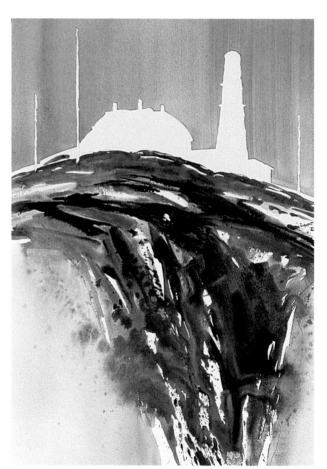

When the painting was completely dry, I removed the liquid resist by brushing it away with my fingers and a soft eraser. The white of the paper is revealed and the edges are crisp and sharp. I must now develop this area and incorporate it into the rest of the painting.

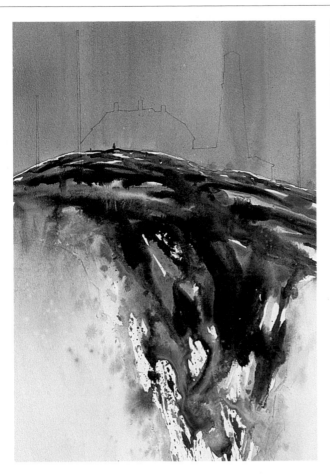

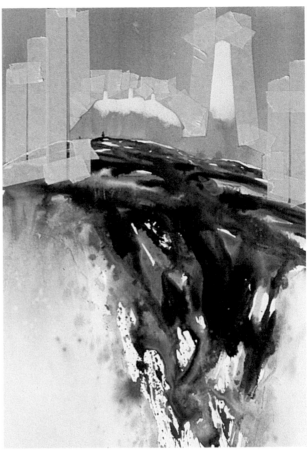

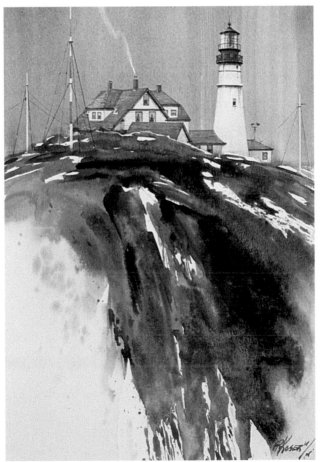

LIFTING COLOR

In this procedure I did not cover the lighthouse area; instead, I painted in the entire sky and foreground, using the wet-into-wet technique.

When the painted surface was completely dry, I used drafting tape to outline the lighthouse and utility poles. Once I had all the tape down, I used a moist sponge to lift the areas within the tape outline. The moistening softens the paint particles and leaves the area light but not a pure white.

After lifting the desired amount of paint, I removed the tape and developed that area so it would become a part of the painting.

LIGHTHOUSE SERIES XXI, watercolor, 16" x 11" (40.6 x 27.9 cm).

CREATING TEXTURES

As I mentioned earlier, I consider texture a microdesign element. This is not to say that texture is of lesser importance; in fact, it adds quality to the spaces within the painting—a design within a design. As with color, texture can be emotionally stimulating. In watercolor the physical properties of the pigment and the variety of paper surfaces offer a broad range of textural possibilities. These are explained in the following section.

As a design element, texture can be a strong factor in unifying a composition. With textures, you can connect specific areas of a painting. For example, you can unite the foreground to the horizon with a variety of textures. Depending on your subject, textures can be subtle or bold. You can produce an illusion of detailed rendering in a tree trunk by varying your brushstrokes. Lines can be used to create direction and tension. The viewer's eye will be drawn to a textured area of a painting because it's where activity prevails.

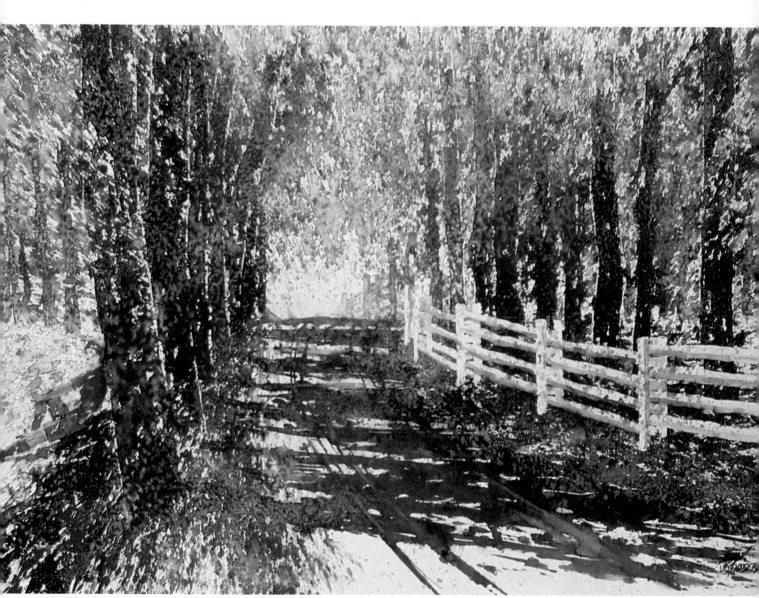

COUNTRY ROAD IN AUTUMN, watercolor, 21" x 30" (53.3 x 76.2 cm). Collection of Mrs. Dorrie Hardin.

I used the non-contact technique as the initial step for this painting. A liquid resist was used to preserve the white fence during paint application. The foliage called for some strong and vibrant colors so I selected a "heavyweight" yellow (cadmium orange), alizarin crimson, and Winsor blue. These vivid staining colors held up well in the presence of each other and reflect the gaudiness of the leaves after autumn's first hard frost.

PAPER AND PIGMENT TEXTURES

Watercolor papers come in different textures: rough, cold-press (semi-rough), and hot-press (smooth). They also come in different weights. The average selection is 72 lb., 90 lb., 140 lb., 200 lb., 300 lb., and 400 lb. weights. (The weight of the paper refers to the weight of a ream—usually 500 sheets.)

Each type of paper accepts pigment somewhat differently. The sizing (usually a gelatin or animal-hide glue preparation) that is applied to paper during manufacturing also influences the way pigment and paper interact. Sizing controls the absorbency of the paper; for example, a highly sized paper won't accept watercolor at all.

There are also staining pigments, which penetrate deeply into the fibers of the paper, and there are opaque pigments, which tend to remain on the surface. In addition to these properties, pigments have texture: smoothness or graininess, depending on chemical makeup.

Granular pigments, such as burnt sienna and cerulean blue, leave behind a grainy sediment when they dry, whereas smooth pigments, such as Winsor blue, do not. Experiment with smooth and grainy pigments on different paper textures to see the different effects they can give you.

OPAQUE **STAINING**

HOT PRESS

COLD PRESS

ROUGH

MANGANESE CERULEAN ULTRAMARINE BURNT SIENNA YELLOW OCHRE CADMIUM YELLOW DARK ALIZARIN CRIMSON PHTHALO BLUE PHTHALO GREEN

Opaque and transparent pigments on different paper surfaces.

MONOPRINTING

A large number of textural designs can be produced by a stamping technique called monoprinting. In this method watercolor pigment is brushed onto a textured surface—a leaf, a piece of cardboard—to be used as an applicator, which is then pressed onto watercolor paper. Pigment transferred onto paper in this manner will give you some sense of the actual texture of the applicator.

When you use this process, the paper can be wet or dry or a combination. Wetting the paper is best accomplished with a large flat brush such as a 1″ aquarelle or a 2″ Sky Flow. The wetness of the paper will also affect the type of patterns that will develop. For instance, soft, diffuse patterns are produced when monoprinting is done on a wet surface. If the watercolor paper is dry, the texture will be firm and crisp. A variety of patterns can be obtained when the watercolor paper has both wet and dry areas.

The textured surface of your applicator can produce a variety of abstract patterns. For instance, interesting monoprinting textures can be made with corrugated cardboard or matboard (in different sizes and shapes), leaves, and screen mesh. You can waterproof the matboard or cardboard with acrylic spray, which means it absorbs less pigment itself and transfers more pigment to the paper. Conversely, a more absorbent applicator transfers less pigment to the paper.

You can also create monoprints with objects such as pen caps, bottle caps, rubber erasers, or any small object. Just dip the object into paint and stamp it onto the paper in a repetitive motion to create a series. Many textured objects can be used; experimentation will initiate the best results.

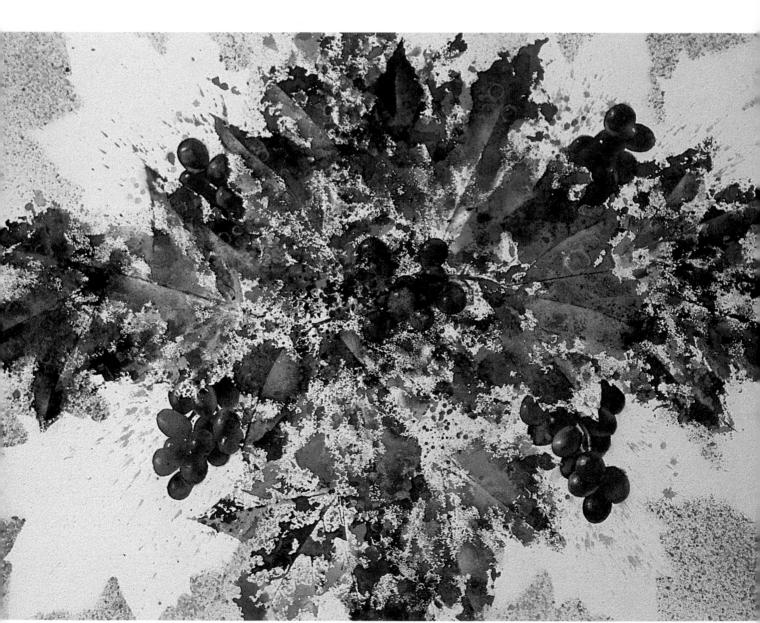

SONOMA SUMMER, watercolor, 16″ x 24″ (40.6 x 61.0 cm). Collection of the artist.

With a paintbrush, I applied yellow pigment to a leaf.

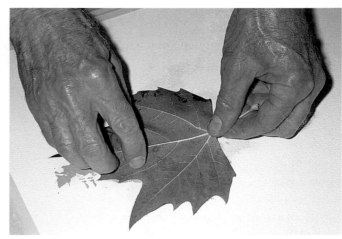

Then I pressed the painted leaf face down onto a sheet of watercolor paper.

When I lifted the leaf off the paper, its imprint remained.

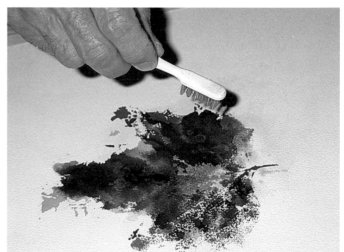

While the yellow area was still wet, I added blue pigment using a small piece of matboard as an applicator. I pressed the blue matboard onto the yellow area of the paper, creating a variety of greens. Then, while the painted areas were still wet, I added minute amounts of red with a toothbrush. This enhanced the other hues and created some new ones.

I used a cruciform format for this monoprint painting. Grape leaves were used instead of a paintbrush as the applicator, and I applied the primary colors in sequence—yellows, reds, blues—building up this cool dominance painting.

NONABSORBENT WRAPPING PAPER FOR MONOPRINTING

Plastic wrap, wax paper, and aluminum foil are good examples of nonabsorbent papers that can be used for monoprinting. For the best results, you must press the wrapping paper onto the watercolor painting while it is still wet or damp. By stretching the wrapping paper out onto the wet watercolor surface, you can obtain irregular lines. The random wrinkles of the wrapping paper will reposition the wet pigment.

You can also vary the degrees of wrinkles in the wrapping paper. For example, if the wrapping paper is crumpled and pressed onto the wet watercolor, you will have a dense area of textures. Whereas when the wrapping paper is crumpled and straightened out before being pressed onto the wet surface the textures will be subtler.

The nonabsorbent wrapping papers are most effective when left in place until the wet watercolor surface is dry. If you remove the wrapping paper while the watercolor is still wet, you will lose most of the texture and excitement. Even though these "kitchen papers" are nonabsorbent, some pigment will lift off when the wrapping paper is pulled off. The amount of paint is minuscule, but it adds a fine-grain texture that enhances the overall design.

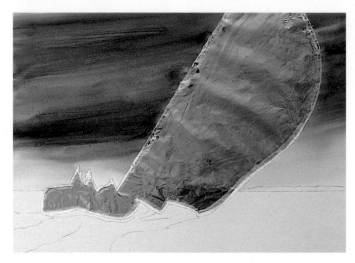

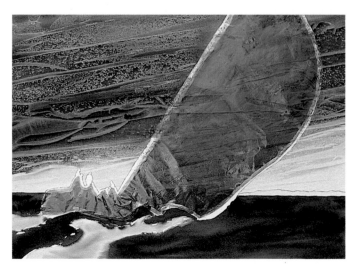

At this stage, I preserved the white of the boat and sail by making a resist from aluminum foil. I made a quick outline tracing of the area to be saved and laid this tracing onto aluminum foil. With a ballpoint pen, I traced the shape to produce a mark on the foil. Then I cut the shape out and placed it on the paper. I made sure there was about 1/8" of space between the foil and the pencil line on the watercolor paper. I used that 1/8" of space to seal the foil to the paper with a liquid resist. Once it dried, I did a second application of resist. Then I wet the sky area and applied broad strokes of yellow, followed by some red, then some blue to introduce the cloud movement, and finally a bit of green.

I monitored the drying process of the sky and allowed the surface to change from a sloppy glisten to a moist satin surface. Then I stretched a sheet of plastic kitchen wrap to introduce stress lines and pressed it on the wet paper surface. I allowed the paper to dry completely before removing the plastic wrap, which produced directional lines and textures.

Next, I wet the water area, painting around the wake of the boat hull. The shape of the wake was wet but I kept it separate from the large area. Then, I charged the larger area of sea with the same colors I used in the sky. Some very diluted green and yellow was introduced into the wake. When this surface reached a moist, satin finish I joined some of the areas of the wake and the sea with a damp brush. Then I placed some stretched plastic wrap over the wet area. When the paint was completely dry, I removed the plastic. The tension and texture is compatible with the sky. The small strip of shoreline was rendered in the same manner as the sky and ocean foreground.

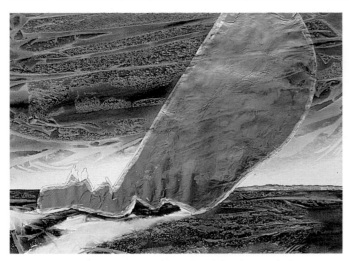

Here, all the plastic wrap was removed and the three painting areas were evaluated.

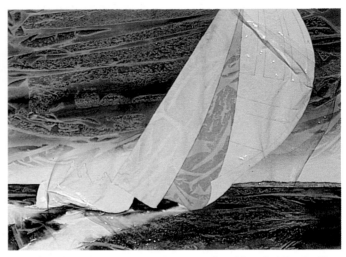

The ship and sail resist were easily removed and I peeled the drafting tape from the outer margins to provide a finished edge. Then I wetted and charged portions of the sail shapes with diluted amounts of yellow, red, blue, and green. I lightly spread plastic wrap onto the moist surface. When dry, varied textured patterns were produced within the sail boundaries.

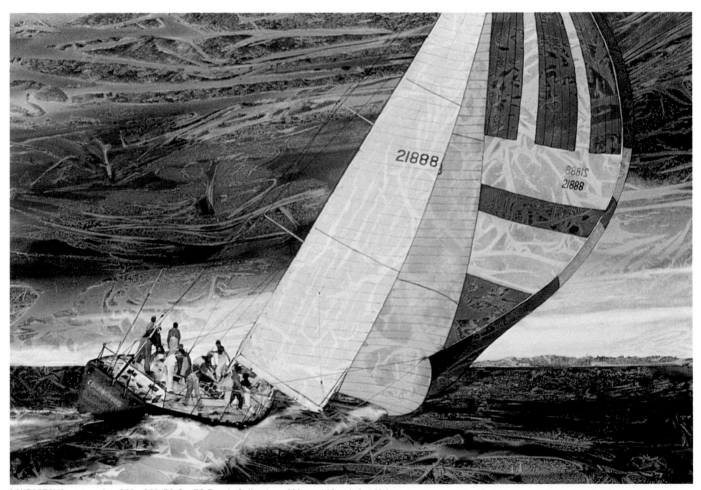

COURAGEOUS, watercolor, 20" x 29" (50.8 x 73.7 cm). Collection of Mr. and Mrs. Arthur Nelson.

In this completed painting you can see I added figures in the boat and did some minor adjustments.

OTHER TEXTURING TECHNIQUES

Let's review some texturing options that involve adding something besides paint to the surface of the paper. Trial and practice will also help you realize the full potential of each technique. The degree of wetness of the watercolor paper will have a strong effect on the results of each of the following techniques:

● Applying drops of water onto slightly damp areas of a painted surface will produce large water blooms, which create exciting edges resulting from the water pushing the pigment.

● Fresh water spattered from a brush or your fingers onto the damp pigment on the paper will also produce random texturing as it dries. You can control the size of the textures by the size of the water spatter droplets as well as the degree of wetness of the paper.

● Spattering alcohol onto a damp watercolor surface will produce a spotted texture with a pigmented residue when the paint has dried. You can also spatter pure pigment onto the watercolor page to produce interesting patterns of texture and color. The softness or crispness of

patterns will depend on the wetness of your paper and can be spattered onto a painted or unpainted surface with any size brush. The brush bristles will control the size of the spatter—a toothbrush is very useful in this technique.

● Sprinkling salt onto the damp surface of your watercolor will cause the pigment to be absorbed by each grain of salt, producing a crystalline surface texture. Fine sand or gravel sprinkled onto a wet wash will also cause the pigment to be drawn to those particles. After the watercolor is dry, you can brush off the loose sand or gravel. The result is a surface texture composed of islands of concentrated pigment in various sizes and shapes.

Perhaps the most important emphasis in texturing should be placed on each artist's inventiveness and special design sense. At the same time you must be careful that textures don't become "add ons" to every painting. Regardless of how inventive and exciting textural elements are, they need to be supported by all the design elements for it to become a successful composition.

Three patches of primary colors mingled together that were treated with different materials— salt (top), water (middle), alcohol (bottom)—during the drying period to produce unique textures.

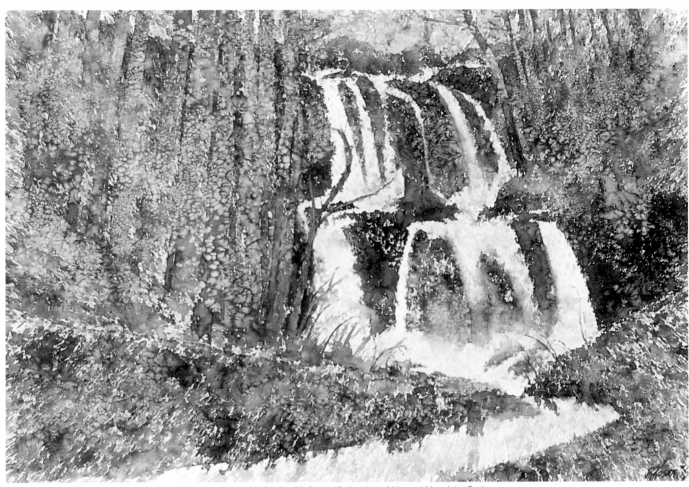

CHANGE OF SEASON, BLENHEIM FALLS, watercolor, 20″ x 29″ (50.8 x 73.7 cm). Collection of Mr. and Mrs. John Burk.

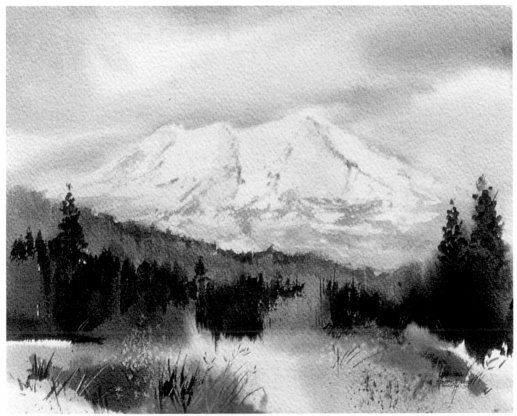

SLEEPING LADY, watercolor, 10″ x 14″ (25.4 x 35.6 cm). Collection of Mrs. Florence Koser.

I wanted the textures to portray the sunlight reflecting off the golden autumn leaves along the banks of this waterfall and stream near Blenheim in Upstate New York (above). The light and luminosity of the colored trees were produced by introducing salt into the moist watercolor. When dry, the imprints left by the salt created smaller light areas with crisper edges than those produced with water droplets.

The foreground texturing (left) was done by splashing pigments onto a wet and dry surface, adding a subtle degree of variety. I stayed away from details in this painting and focused on the spattering of pigment and some limited calligraphy to suggest the details of this landscape.

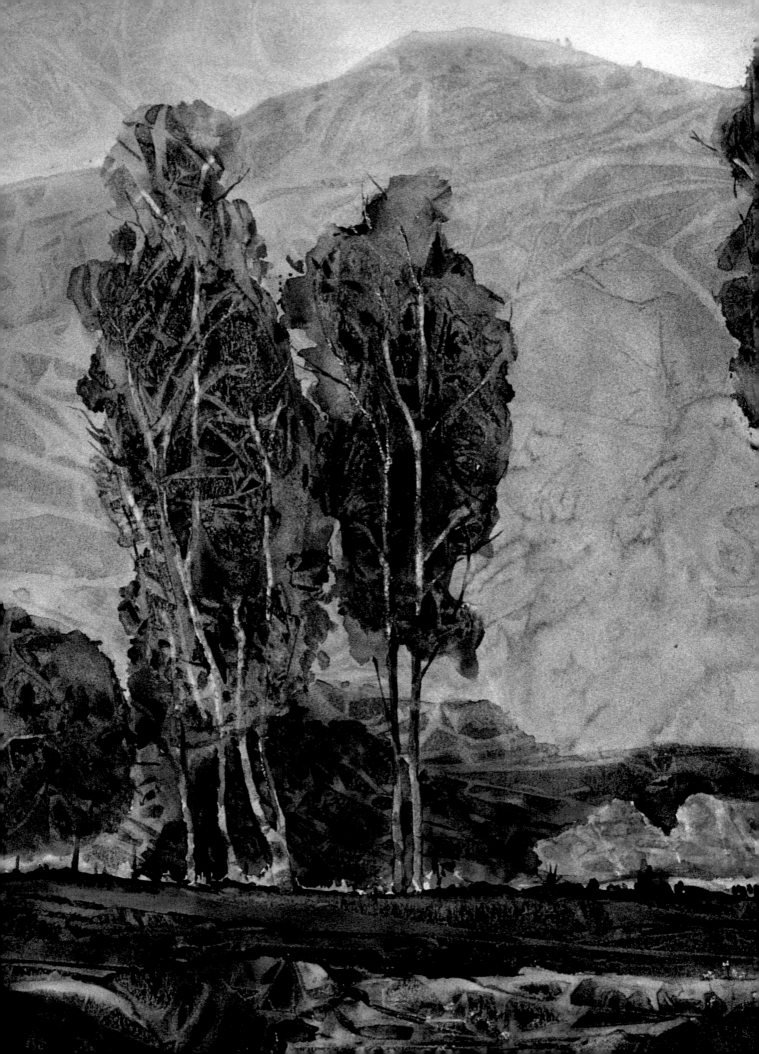

PART 4

TECHNIQUES

EXPERIMENTING WITH COLOR, TEXTURE, AND MIXED MEDIA

APPROACHING NEW TECHNIQUES

All techniques require that you make some basic decisions before you begin painting. For some techniques, you may need a painting plan to guide you, or you may need to use a resist for some paint applications to save the whites. The choice of colors and pigments as well as the design of your composition are all important considerations to the technique you select.

I believe that a technique's effectiveness also depends on such things as the subject you select and how you plan to handle the form and content. Just as important is searching your emotional and psychological self so that the total potential of your creative soul will be reflected in your art.

My technique for interpreting the essence of the subject before me—what I see—is most effective when I have drawn from the actual source. Spending time sketching and observing the subject in its environment will only bring greater understanding to what technique is best suited for interpreting and depicting it. By taking the time to absorb the essence of your subject, you will

be able to convey its true nature through shape, value, and the way you apply the paint onto the paper's surface.

Once you have established a strong visual grasp of your subject, try to simplify or get to the heart of the matter by eliminating the minor details. In fact, you can actually strengthen the overall composition of a painting when you force the viewer to *feel* the subject rather than just see it. Simplifying or editing what you actually see will help you express the subject's nature and spirit in a way that will engage the viewer's imagination. If you succeed, the viewer becomes an active participant in the picture process.

I am constantly probing, searching, pushing methods I have learned in some new direction, or refocusing on something from a past experience. I play no "pat hand." Joyously, I try to match my wits with the challenge of each new inspiration. I hope the techniques discussed in this chapter will inspire you to digest, use, and, most important of all, build on your own imagination and ideas.

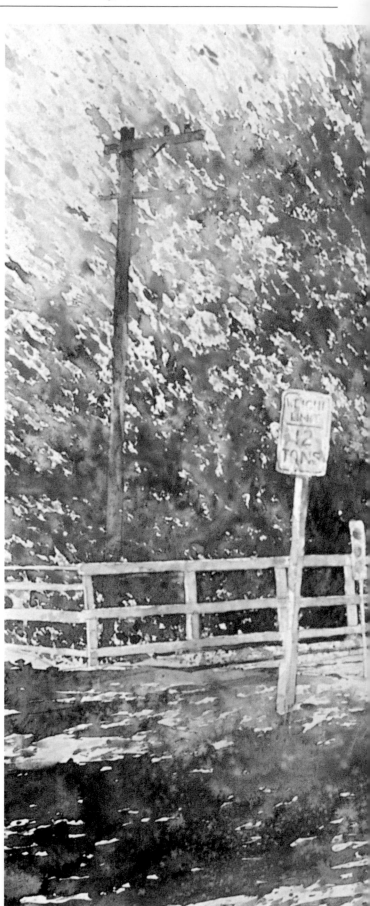

COVERED BRIDGE ON ELK RIVER ROAD,
watercolor, 19" x 28" (48.3 x 71.1 cm).
Private collection.

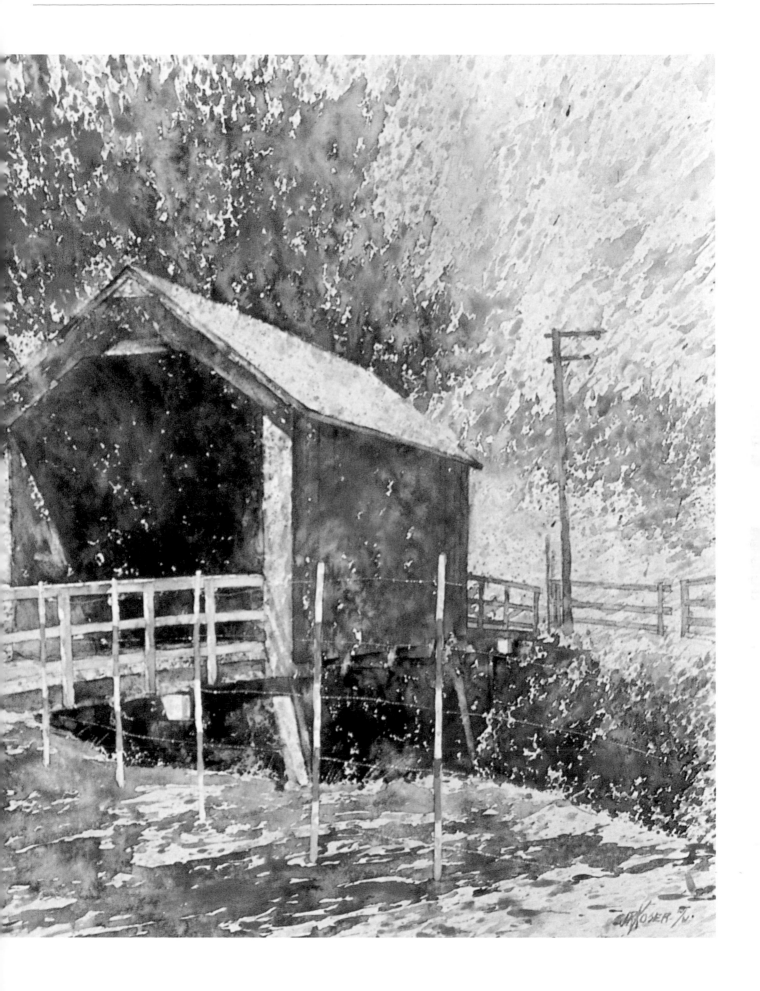

ROOTED IN THE PAST

The impact of the late afternoon summer sunlight on some outcroppings of rock, in juxtaposition with the roots of a tenacious pine tree, captured my fancy; the combination made for a strong composition.

The composition was exactly what I wanted for a watercolor painting, so I returned to the site several times to complete my drawing. In order to transfer my drawing onto my painting surface, I took a 35mm slide transparency of the drawing. When the slide was developed, I projected the image onto the surface I intended to paint on and drew in a sufficient number of lines to allow me to begin painting immediately. The slide transfer process eliminates any unnecessary pencil lines so you will not need to erase. I do not use an eraser on watercolor rag paper when I apply washes or glazes. Erasing distresses the paper enough to interfere with the pigments drying on paper.

Before I started painting, the watercolor paper was soaked thoroughly, stretched, and dried. This procedure assures me that when I wet the paper before applying the first wash, the paper will not wrinkle or buckle and will be far more efficient in producing the effects I want. Then I used a small round brush to apply a liquid resist in the areas that I wanted to portray as being illuminated by the sun. When the resist was dry, I wetted the entire paper thoroughly with a 2″ Sky Flow brush before applying my first wash. My colors consisted of cadmium orange, alizarin crimson, and Winsor blue.

Drawing from nature offered me a chance to get outside after a long day of studio watercolor classes. I used marker for this sketch. I needed to return to the site several times to complete the drawing because the light did not remain in the position that I wanted it for very long. The rocks weren't as close to the tree as you see in the drawing and much of what I recorded was simplified. Even as I stood in the evening shadows drawing in colorless values, I was in the process of "painting" my watercolor.

After transferring my drawing onto watercolor paper, and applying the liquid resist to the sunlit areas, I taped the edges of the paper with drafting tape, two inches all around, to keep the margins from getting wet.

I wet the entire paper with a brush and applied a cadmium orange wash, from top to bottom in a horizontal motion. (The orange was intense at the top of the paper and almost paper white at the bottom.) Then I immediately applied an alizarin crimson wash, from top to bottom, in the same manner. While the paper was still wet, I brushed on a Winsor blue wash, from top to bottom.

Turning the board upside down, while the page was still wet, I applied a yellow wash, from top to bottom. Then I followed it with a red wash. The purple was most intense at the top portion of the painting, and the orange was most intense at the bottom portion of the painting. The band of color in the middle of the paper was discernibly lighter.

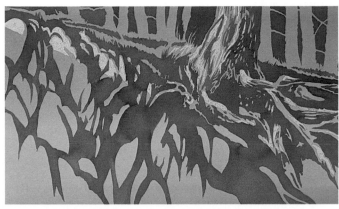

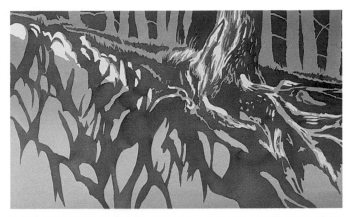

I turned the painting back to its right side. Using a #7 round brush, I mixed the three primary colors with generous amounts of water. The purples produced varied in range from a warm to a cool purple. Following the pencil guidelines, I applied the middle-dark valued purples. I brushed the paint rapidly within the pencil lines, making sure the brush was always loaded with pigment so that no area had to be repainted.

At this stage I removed the liquid resist, covering the sunlit areas of the landscape. Using a 2″ Sky Flow brush, I wetted the entire page with water, from top to bottom. Because of the staining quality of the pigments used and their penetrative characteristics, little paint was dissolved with this simple brushing. But the small amounts of color that were dissolved helped to tint the white areas that were preserved by the liquid resist.

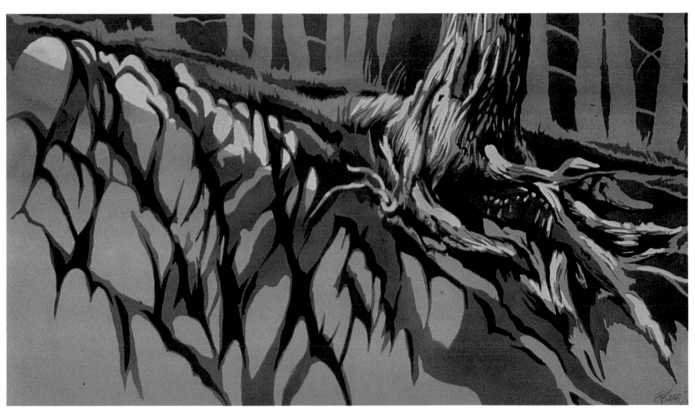

ROOTED IN THE PAST, watercolor, 18″ x 32″ (45.7 x 81.3 cm). Collection of Mrs. Wanda Tonnemacher.

In this final stage I introduced the darkest purple values to complete the painting.

PACIFICA SERIES VII

The theme for this watercolor was inspired by a seascape painting by Jack Wilkinson Smith, a picture I first viewed at an art exhibit entitled "Early Artists of Laguna Beach—The Impressionists," curated by Janet Blake Dominik. Besides the fascinating use of the S-format for design, the painting had areas of intriguing negative space that I wanted to experiment with in watercolor. The painting also reminded me of an ocean front I had once painted just north of Trinidad, California.

Once I had rendered a drawing in marker pen from the seascape painting at the museum, I was ready to proceed with my painting. First I made a 35mm slide of my drawing. Then I thoroughly wetted and stretched a piece of 240-lb. rough watercolor paper. When the paper was dry, I projected the slide onto the paper to draw in the guidelines for the sky, surf, and rocks with a 3B pencil. I used a small round brush to apply a liquid resist to the seagulls. When the resist was dry, I brushed a portion of the paper with water, using a 2″ Sky Flow brush before applying my first wash. The painting was done with transparent watercolor and no opaque whites so the white of the paper represented the powerful white of the surf.

The palette I chose to work with was a simple triad of cadmium orange, alizarin crimson, and Winsor blue with the addition of Winsor green. In order to control the edges and values of such a large painting, I worked with controlled washes in selected areas. Working from the sky to the foreground, I used plastic wrap for texturing.

This pen marker sketch was my value guide, which I followed very closely in my painting. I rendered this sketch from a Jack Wilkinson Smith seascape painting at the museum.

First, I mixed trial patches to create the warm purple gray value of the sky. I wet the sky area and then charged it with yellow, red, and blue, in minute amounts. When the area lost some of its glistening wetness, I added blue pigment to enhance the color of the sky. Next, I stretched and pressed plastic wrap over the wet sky area. The plastic wrap will create an illusion of motion and will add unique surface textures to the sky area.

When the sky area was dry, I removed the plastic wrap and started working on the most distant band of surf, or wave line. I wet that area, except for the white breaker, and I charged it with yellow, red, blue, and green. As the paper began to lose some wetness, I wetted the white surf area and softened the edges with the pigmented areas using a brush. Then I stretched plastic wrap over the damp area and allowed it to dry. The next band of surf was handled the same way.

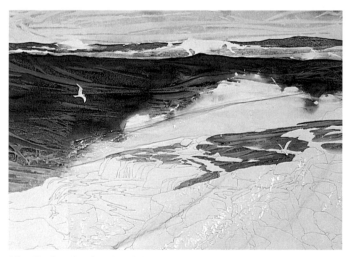 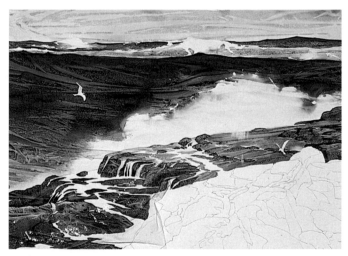

After the bands of surf had dried and the plastic wrap was removed, I worked on the large wave shape in the middleground and the white breaker crashing onto the rocks. The sea gull shapes were protected with a liquid resist. I wetted this large area with a 2″ Sky Flow brush and kept the surf and white breaker areas separate with a ¼″-⅛″ of dry paper space between them. Into the cresting wave I charged yellow, red, blue, and green, allowing the colors to mix on the wet watercolor paper. The white foam of the crashing wave was also tinted with diluted amounts of primary colors, otherwise it would have appeared as a flat, lifeless white paper cutout. As the paper dried to a satin finish, I used a damp brush, in a random fashion, to join the dark edge and the white edge. Then plastic wrap was stretched over the entire wet area and the surface was allowed to dry completely.

The foreground rocks were divided into workable areas. The white areas were saved by painting around them. All the primary colors were used for the rocks. If you look ahead at the completed painting, you will see that the immediate foreground was developed with the same four pigments as the rest of the painting. The dominance of yellow and red over the blue and green makes the rock shape move visually forward and pushes the cooler parts of the painting back. The warm hues of the forms in the foreground support the perspective of the painting. As each area was completed, I laid plastic wrap over the fresh paint and allowed it to dry completely. In the final stage, I removed the resist from the sea gull shapes and carefully reworked the edges to modify the shapes so I could incorporate the motions I wanted.

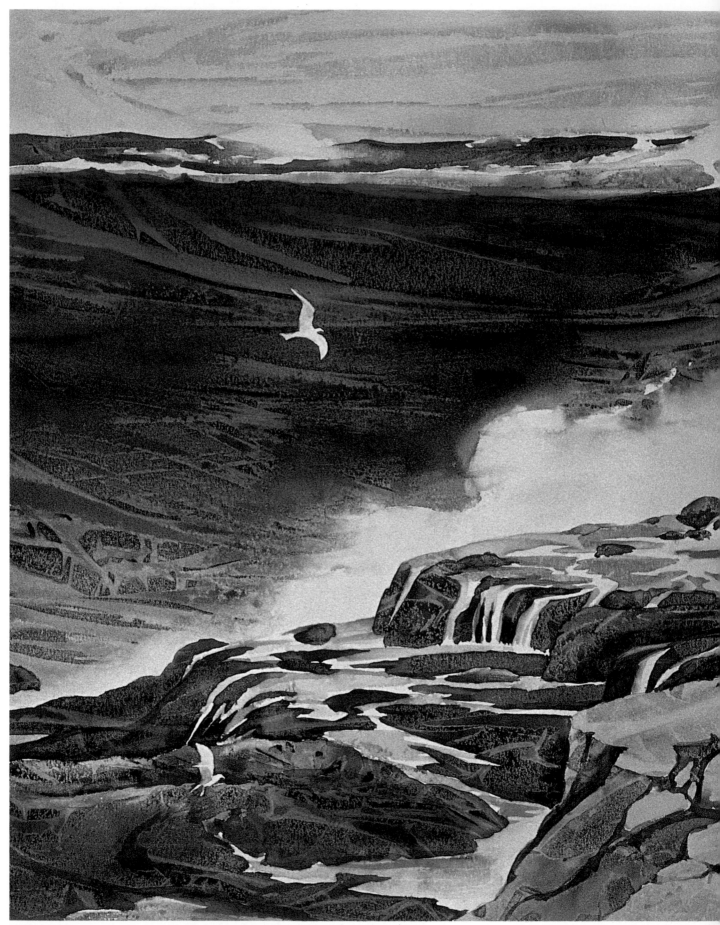

PACIFICA SERIES VII, watercolor, 23″ x 33″ (58.4 x 83.8 cm). Collection of Dr. David P. Tonnemacher.

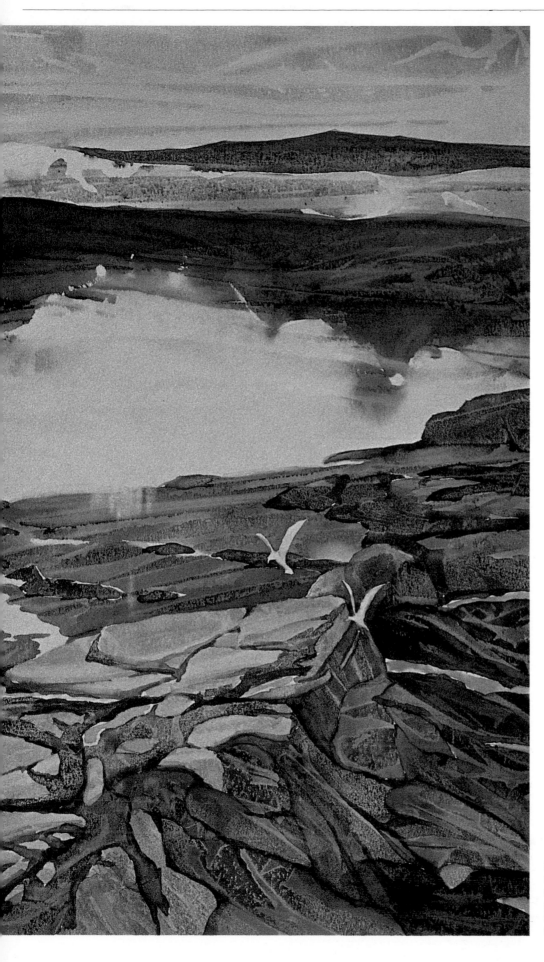

Because the staining colors I used in this painting did not lift off easily I had to start this painting a number of times when things did not go in the direction I wanted.

TINA'S COTTAGE

Tina's Cottage depicts a wonderful slice of life along the Northwest Pacific Coast between Eureka and Crescent City, California. Houses and cottages hang tenaciously to the rugged coastline. The view is awesome, filled with big sky, ocean, and a preview of the weather as it sweeps down from the Aleutian Islands. Tina's cottage is also located within a seashell's toss of Rocky Point, where the wind is constant.

From my sketch, which I drew on site, I made a careful tracing of the buildings. Then I rubbed graphite onto the back of the tracing, placed the tracing over my painting surface, and used a ball-point pen to draw over the tracing to transfer the graphite line to my watercolor board. In freehand I drew in the guidelines for the trees in the background, the distant shoreline, the area of sand and vegetation, and the smoke from the chimney. (Specific details are given in the captions.)

I did the painting on a cold-press watercolor board that had a fairly smooth, nonabsorbent surface. Because there was practically no "tooth" to the paper, no paper texturing could be produced, even with granular pigments. On such a surface the pigment will dry without texture. Water stays on the surface of the board for the most part. The smooth surface works well for detailed rendering. Using a horizontal format, I selected a palette of tube colors—cadmium orange, Winsor green, and Payne's gray—based on the hues of what I had actually seen.

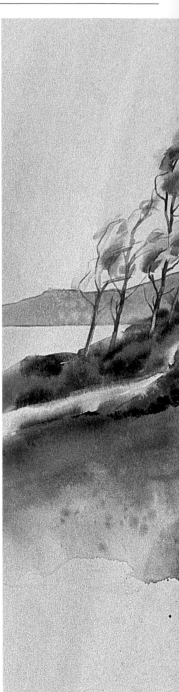

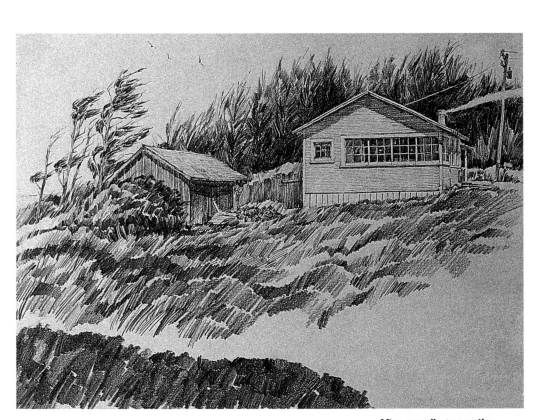

After spending an entire afternoon sketching Tina's cottage, I had enough information for a painting plan that I was able to use several months later to re-create this coastal environment in watercolor in my studio.

TINA'S COTTAGE ON BIG LAGOON, watercolor, 16″ x 21″ (40.6 x 53.3 cm). Collection of Mr. and Mrs. Fred G. Lake.

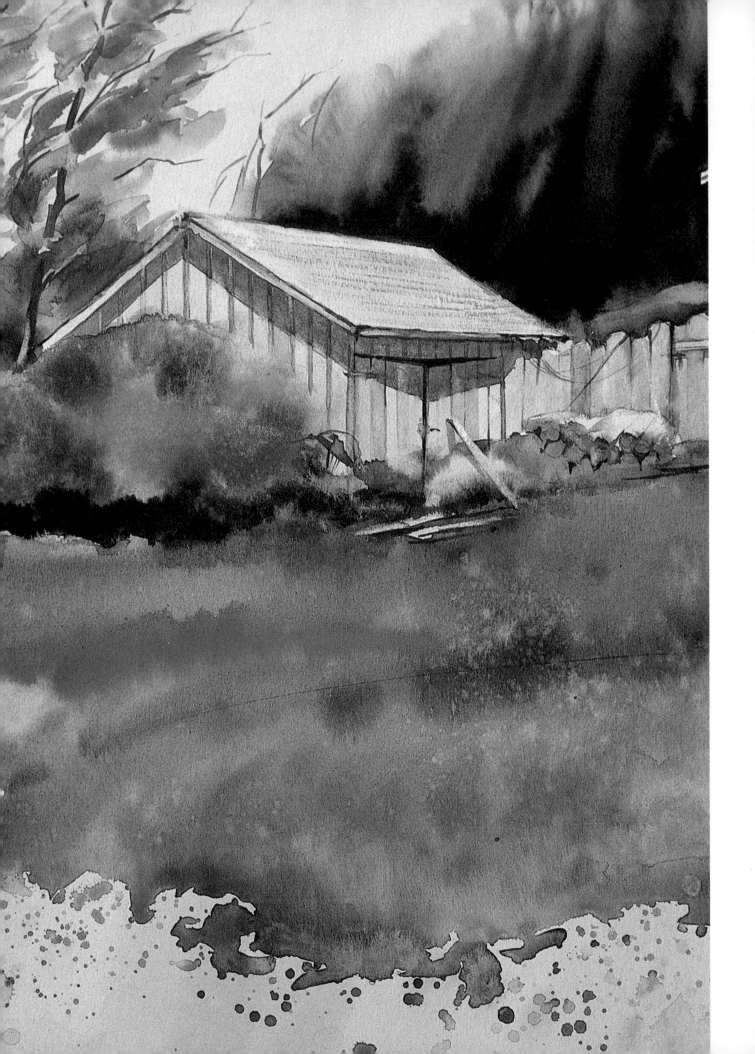

The following is an overview of the process I used for this painting. I wet the entire watercolor board with water, using a 1½″ Sky Flow brush. Then to provide a unifying element, I brushed wide vertical bands of the diluted tube colors that I planned to use in the painting. This was then allowed to dry. I did not use any kind of liquid resist to save whites.

No opaque white is used in the painting. I simply painted around all the whites. Using a #7 round brush, I applied water into the area of trees that border the roofline, the smoke, the telephone pole, and the mailbox. Then working rapidly, I charged the unmixed tube colors into the wet area. The paint remained within the wet areas and the margins that needed to be crisp and delineated were preserved, thus saving the light areas.

After some initial drying, I brushed the area of sky above the trees with water and blended the wet sky with the moist tree area to allow a bleeding of the paint into the sky. This produced a variety of edges for the background trees. The edges of the smoke shape were handled in a similar manner. The telephone line was scratched in with a knife after the paint was dry.

For the foreground, I wet the grassy area with water and charged it with the tube colors—orange, green, and gray—allowing them to mingle on the paper. Specific areas were accentuated with more color to enhance the horizontal bands. I touched the areas along the bottom edge with water to add variety to the edges.

Late in the drying process, water was spattered with a brush into the semiwet paint of the grass area, creating subtle textures. After the foreground paint was dry, additional texturing was achieved by spattering paint into the negative space.

I used a controlled wet-into-wet blending of colors to create the shadows of the trees and the eaves of the roof.

In the final stage I painted in the lines of the trees and the buildings, using a semidry brush technique.

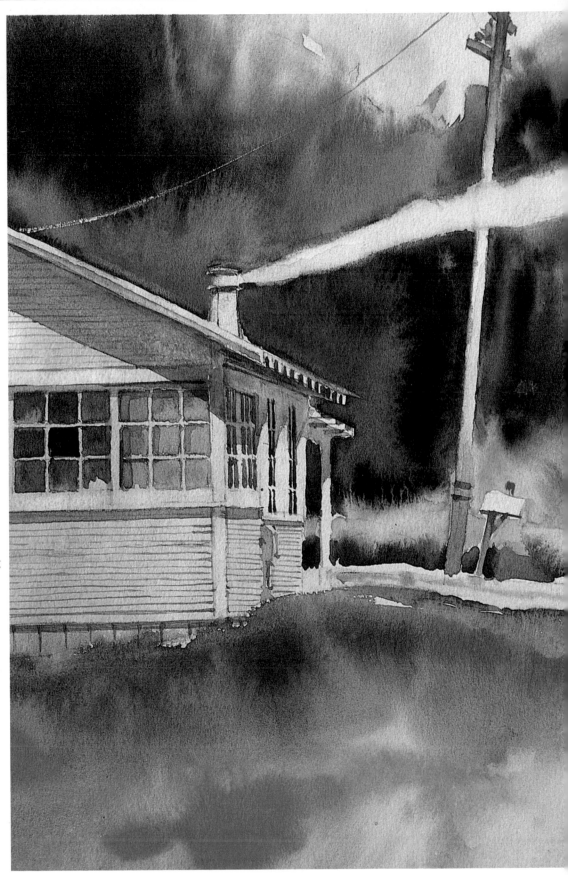

EARLY AUGUST ON ELK RIVER ROAD

Humboldt County in Northern California has offered me many stimulating points of interest for my paintings. The Elk River, though not large, snakes down through a valley that has provided grazing land for cattle for many years.

In many of my paintings I've used the covered bridges found in this area as my subject matter. I've been told that it is easier to herd cattle across a covered bridge. I also try to capture the light, temperature, color, and mood of the day and the season. August is a time of contrast—the warmth of the sun and the coolness of the shade. In this painting the effect of the long summer days has begun to tell on the foliage of the trees and the color of the wild grasses.

For my painting surface, I used a piece of watercolor board (100% rag paper bonded on pH-negative four-ply cardboard). My palette colors were Indian yellow, burnt sienna, ultramarine blue, and Winsor blue.

I wanted to render this pastoral landscape scene in a non-contact method, which I devised for myself, to produce an impressionistic feel to the flow and the line of the scene. In the non-contact technique, paint is applied by spattering and flicking brushes loaded with pigment onto the painting surface. The following pages include a step-by-step, reconstructing how this painting was made.

I drew, redrew, adjusted, and readjusted the major shapes of the foliage, shadow, roof, road, and fencing until they developed into a workable painting plan.

This pencil sketch on watercolor paper was made from a projected image of the original sketch. I also laid drafting tape 2″ around the edge of the board to prevent wet margins. Then I applied an underpainting of washes made up of the primary colors in very high-key values (Indian yellow, burnt sienna, ultramarine blue, and Winsor blue). When the washes were dry, I applied a liquid resist to the fence.

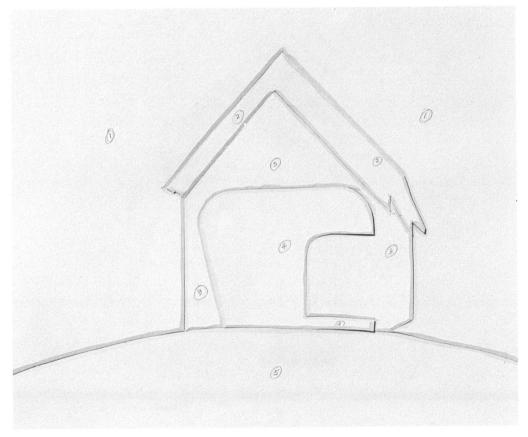

For this stage, I needed to construct the mat board resists. A tracing was made of the drawing on the watercolor paper. Then the tracing was divided into workable painting areas. The tracing of the painting areas was then transferred onto mat board (by rubbing the back of the tracing with graphite and then drawing over the front of the tracing with a ball point pen). Using a mat knife I cut the mat board shapes, which became cutouts, or movable resists. I beveled the edges of the resist shapes with a razor blade and waterproofed them with a clear acrylic spray. Then I assembled them onto the watercolor surface, corresponding to the pencil drawing.

I removed the resist shape from the area I wanted to paint first. The large U-shaped area, making up the sky and background foliage, was randomly spattered with water using a natural bristle toothbrush, and 1″ and 2″ flat brushes. (Application of water and pigments for this methods is done by flicking the toothbrush bristles and by splashing or flecking the flat brushes.) Then I applied the wet pigments with the same motions—beginning with the yellows, then the reds, and finally the blues. Several applications of paint, in the same sequence, were needed to build up the value, intensity, and shape of the area. The non-contact method needs to be done rapidly in order to keep the areas wet. The wetness allows the pigments to mix into secondary and tertiary colors. When the surface of the freshly painted area began to lose some of its wetness, I used the handle of the brush and my index finger to trace out trunks and suggest branches of trees. All the mat board resists were removed to evaluate the color and value of the first painted area.

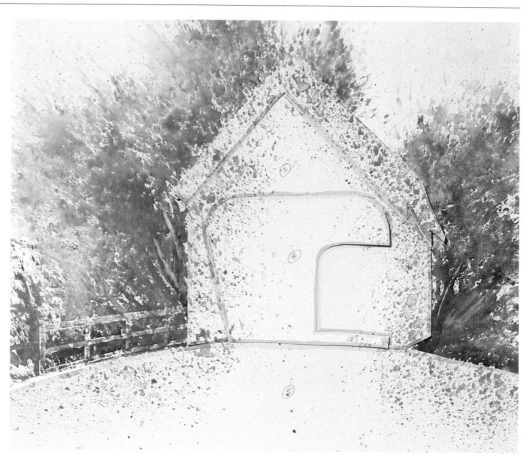

All the mat board resists were reassembled onto the painting surface, with the exception of the large foreground shape. The direction of the water and pigment droplets played an important role in depicting the long shadows of the trees on the road. I began with the sunny area of the foreground, spattering water onto the surface. Then I flecked and spattered the yellows, reds, and blues onto that area. I built up the color and pattern of the shadows by flicking and spattering in a horizontal direction. The tip of a wet round brush was used for some refinement of the shadow shapes, but the actual "splash painted" areas produced the most excitement.

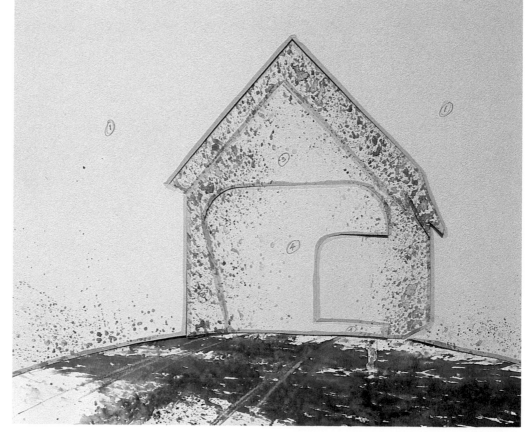

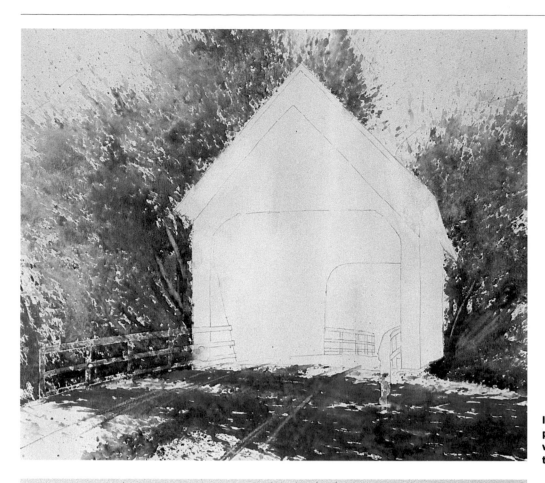

I removed all the mat board pieces so I could review the value, intensity, and color of the two areas that I had just painted.

Then I reassembled the resists onto the paper, except for the next area: the sun-drenched front of the covered bridge and the opening at the end of the bridge. Using my brushes, I applied the water and primary colors in the same manner as the previous applications. The only difference in this application was that I had to keep on diluting the paint with water to produce the brightness of sunlight.

The next area to be developed was the shadow under the eave. With all resists reassembled except for that area, I splashed and flecked the paint with a toothbrush. For this area I used a minimum amount of water and a more concentrated amount of pigment than had been used in any of the other areas. Once again the order of color application was yellows, reds, and blues.

For the final major paint application, I needed to produce the darkest shadow area, the enclosure of the covered bridge. Water was applied with a toothbrush and a 1″ flat brush, followed with concentrated quantities of yellows, reds, and blues. The reds and blues were used in dominant amounts. Most of the white paper surface was covered. When the paint was dry all the resists were removed.

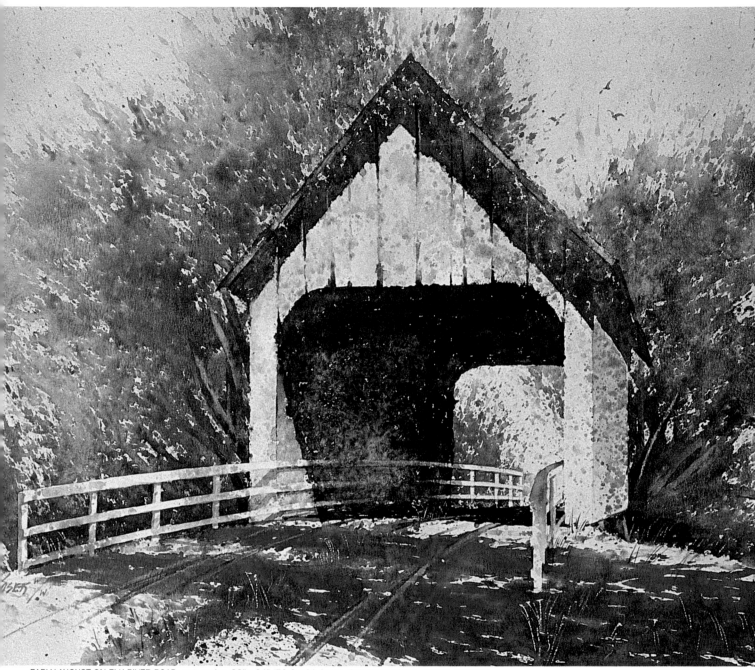

EARLY AUGUST ON ELK RIVER ROAD, watercolor, 20″ x 24″ (50.8 x 61.0 cm). Collection of Mrs. Eileen Knourek.

After the painting was reviewed, I removed the liquid resist from the fencing, and the drafting tape from around the edges. The white fence was lightly flecked with diluted amounts of pigment to bring it into harmony with the rest of the painting. A few areas of the bridge were given some calligraphic marks. This refining stage was done with a round brush in restrained manner in order to maintain the spontaneity of the painting style.

STOLKER CASTLE ON LOCH LINNHE

I was enraptured with Stolker Castle as soon as I caught sight of it, while I was traveling north on the west bank of Loch Linnhe, in Scotland. Loch Linnhe opens into the Firth of Lorn, and the tides from the Scottish coastal waters affect the height of the water surrounding the castle.

From the point of view I wanted to capture, the shoreline and the range of mountains located near the middleground made this neither a sky nor a foreground painting. There is an inverted "V" format created by the castle, which also becomes the focal point.

I chose to do this painting on rough finished watercolor board. By projecting a slide image of my painting plan onto the board, I was able to draw in the necessary guidelines. My palette for this painting was simply Indian yellow, burnt sienna, alizarin crimson, Winsor blue, and Winsor green. Since I planned to render most of my painting in a non-contact method, I made a tracing of the major shapes of the painting and used the tracing to produce mat board shapes for resists (for details on the non-contact technique, see pages 118–123).

My pencil sketch was done with no hurry, and I gradually incorporated design elements into what I was seeing to produce a drawing that became my painting plan for the studio.

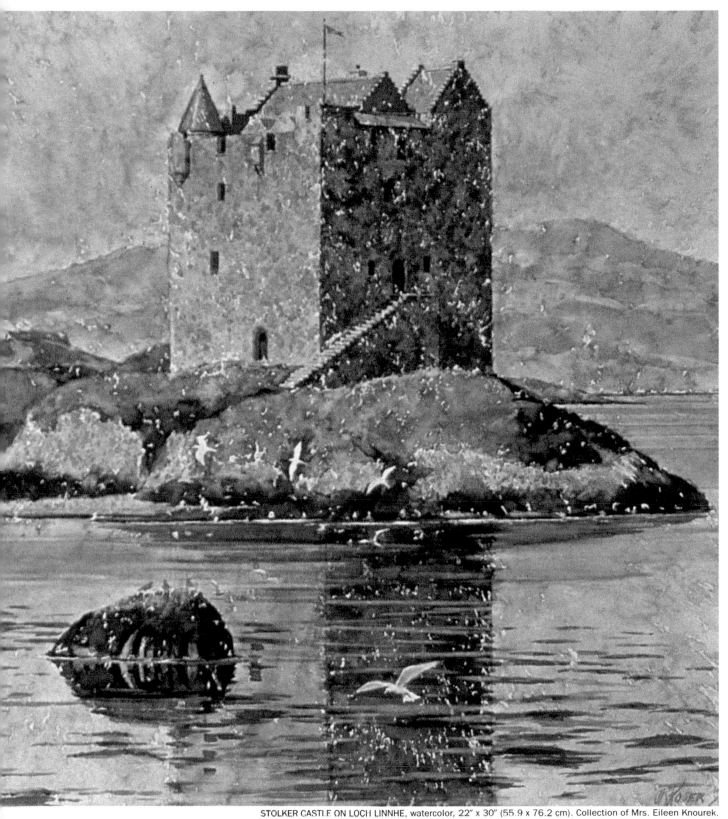

STOLKER CASTLE ON LOCH LINNHE, watercolor, 22" x 30" (55.9 x 76.2 cm). Collection of Mrs. Eileen Knourek.

I divided the watercolor board into nine painting areas: sky, background hills, island greens, island shoreline, foreground water, castle's light side and its reflection, the castle's shady side and its reflection.

The following is an overview of how I proceeded with this painting. Using the non-contact technique, each area was painted while the rest of the painting was protected by the mat board resists. Each area was allowed to dry before going on to the next area. All areas received some of the five tube colors. It was the dominance of certain colors mixed on the paper (not on the palette) that produced the local color of "blue" sky, "green" hills, or "brown" castle walls. I used trial patches to ascertain these color mixtures before applying them to the painting's surface. The tiny islands of white paper scattered over the painting surface lends a unifying texture; it was produced by the flecking of water onto the paper before the pigment was applied.

Liquid resist was used to save the white of the sea gulls. The light surface of the stairs on the outside wall of the castle was also saved as a light area with liquid resist. The painting was rendered in transparent watercolor with no opaque whites used to salvage a lost white. When using a liquid resist, the edge quality is usually rather abrupt in comparison to the other edges in the painting. It is important that you reincorporate the white edges into the painting with a diluted amount of pigment.

When the foreground water shape was beginning to dry, I used a dry 1″ aquarelle brush to lift horizontal lines to create light reflections in the water. The large rock shape in the foreground was added after all the areas were painted and dried. It was easy to paint over the light value of the water. I wet the rock shape with a #5 round brush and used the same brush to apply the pigments into this area. When the paint began to dry, I worked in the rock detail by lifting and washing out the pigment to indicate highlights. The resist covering the bird shapes was removed and the edges were reworked to incorporate them into the rest of the painting. I refined the painting with several sized round brushes.

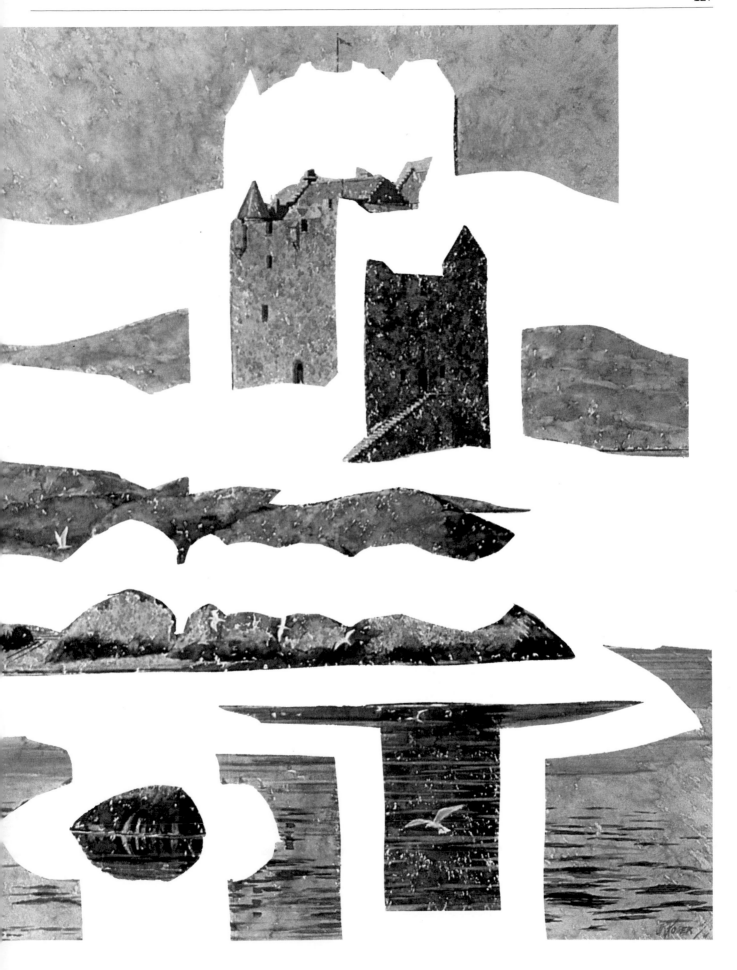

BIBURY ROW HOUSES

Dormer-windowed cottages in Bibury wear the centuries like a blessing. This magical spot is located in a tiny Cotswold valley. I was staying at the Swan Inn with my wife and had been confined indoors for most of the day because of the steady rain. But in the early afternoon the skies cleared, and the sun came out to shine on every wet leaf and blossom. As soon as the sun broke through, a woman rushed to the clothesline with wash. I spent the rest of the day sketching the village.

The painting was done in the non-contact method on rough watercolor board (for details on the non-contact technique see *Early August on Elk River Road* on pages 118–123). My palette selection included Indian yellow, cadmium red, alizarin crimson,

Winsor blue, and Winsor green. In the non-contact method, no mixing is done on a paint palette. The pigments comingle on the wet surface of the watercolor board to produce the secondary and tertiary colors.

First I projected a slide image of my sketch onto the painting surface and drew in the buildings, the figure, the clothesline, and the general shapes of the background trees and the foreground. Then I made a tracing of this drawing and transferred it onto a piece of mat board, which I developed into resists. There were four painting areas, or resist shapes: the sky and trees; the foreground buildings, figure, and clothesline; the distant buildings; and the foreground. Defining these areas simplified the painting process.

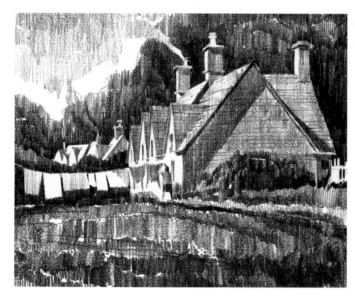

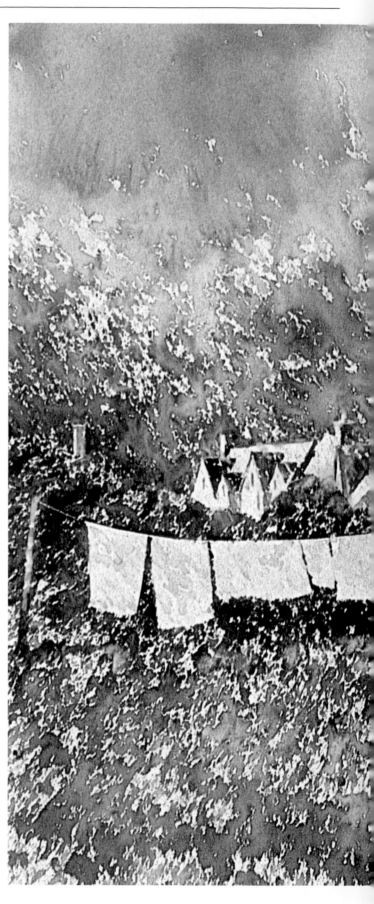

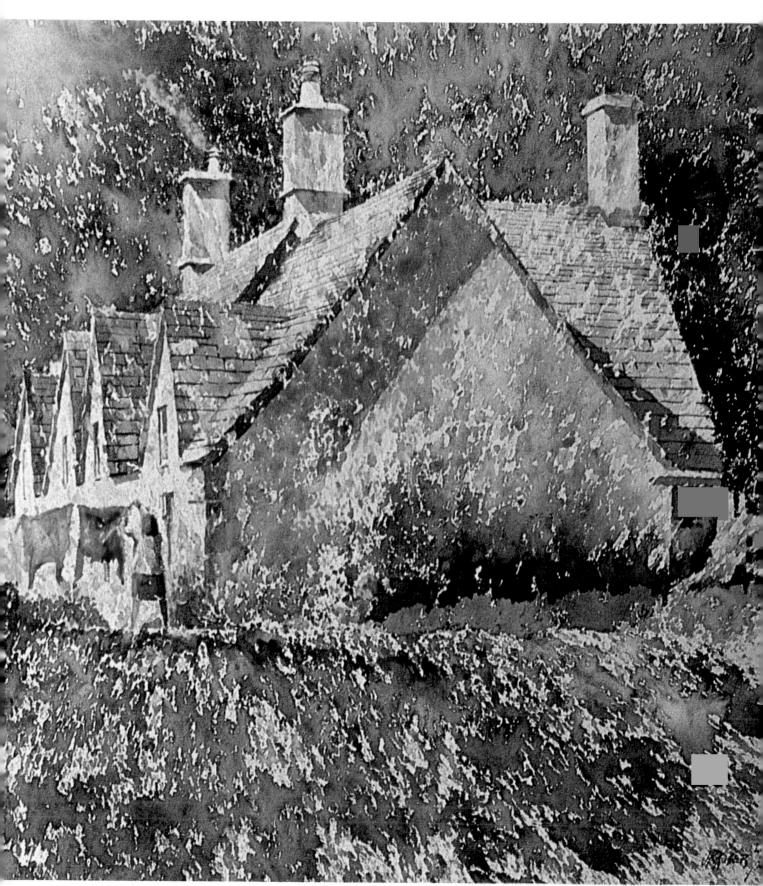

BIBURY ROW HOUSES, watercolor, 19″ x 27″ (48.3 x 68.6 cm). Collection of Mrs. Dorrie Hardin.

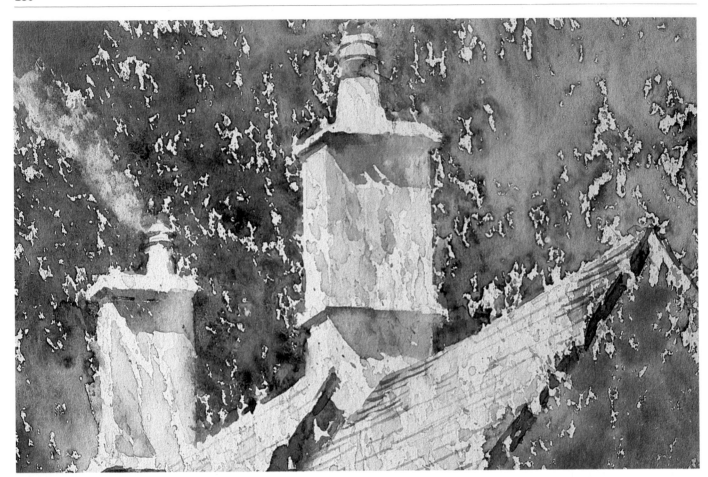

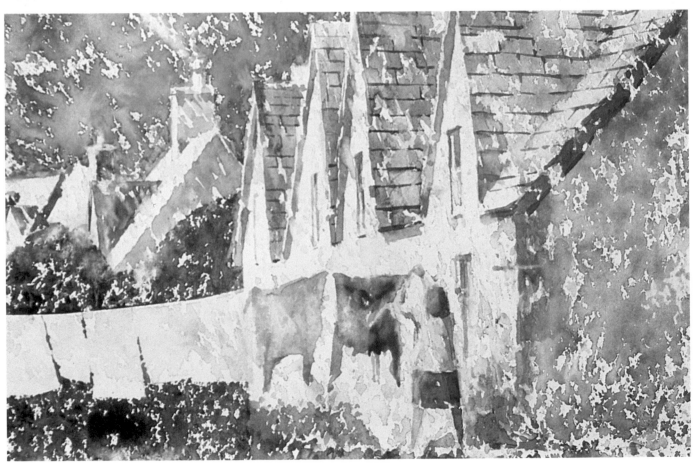

With all the mat board shapes in place except for the sky and the background trees, I spattered water into this area. The upper left-hand sky area received the first flecking and spattering of pigment. I directed the droplets of paint from the center of that area upward and out. The paint for the sky was applied thinly. The yellow, both reds, and blue were used, with a dominance of blue. I then concentrated on the tree shapes. While the sky was still wet, I introduced the yellow, reds, and blue into the foliage area in more concentrated amounts than for the sky area. I fortified selected areas with Winsor green. As for the small details dividing dark-light areas, such as the clothesline and fence slats, I left them to be refined after the main paint application was dry. The final paint application into the background foliage was made to reinforce the darks. The darks were composed of blue, green, and red, which I used behind the clothesline and behind the roof line.

The next area to be painted after the sky and foliage had dried was the major foreground shape. With all the mat board resist shapes in place for protection, except for the foreground, I spattered and flecked the water and then the primary colors onto this area. I directed the spattering in downward motions, the opposite direction of the sky and background. Once the area was dry, I removed all the resists to review the values and colors thus far. I proceeded with the remaining light areas in the same manner, but using diluted amounts of pigment in order to depict the light properly.

I felt that the tube color Winsor green was necessary to portray the gaudiness of the rain-washed foliage (left) in the bright summer afternoon sun.

When the painting was dry, I removed all the resists and spent some time deciding how I wanted to refine the painting.

My finishing and refining was done with delicate glazes over paint speckled areas, using a variety of round brushes. Care was taken not to paint out tiny islands of white paper left from the non-contact paint application.

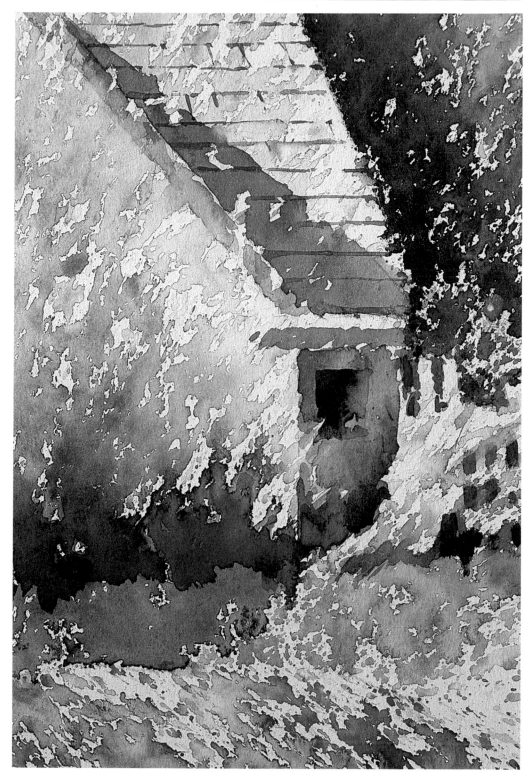

PORTLOE

Located sixty-five kilometers east of Land's End on the Cornwall coast is the tiny smuggler's cove of Portloe. Over two hundred years ago, many tiny inlets and nameless "ports" served as dropping-off points for smuggled contraband from France. The contraband was usually Cognac and perfumes. The duty collected on these items when the imports passed through a Customs tollbooth was astronomical, so sailors risked their lives using small luggers to sail into these inlets with contraband. The wages were gold if successful, death if caught. Portloe now provides homes for fishermen and one of the finest country inns for travelers.

Two design formats were used for *Portloe*. The white surf forms an S-curve format, from the breaker on the rock to the edge of water as it carries it off the page. There is also a steelyard format, with the small white buildings in the background balancing the large breaking surf. The dominant mood of the painting is cool with some warm hues in the sky and the foreground to add contrast. Pastels were incorporated in the watercolor in the final stages. The watercolor portion of the painting was rendered mostly with the non-contact technique (for details see *Early August on Elk River Road* on pages 118–123), using Indian yellow, alizarin crimson, and Winsor blue. The composition had the following painting areas: the sky, the foreground, the background hills, and the water.

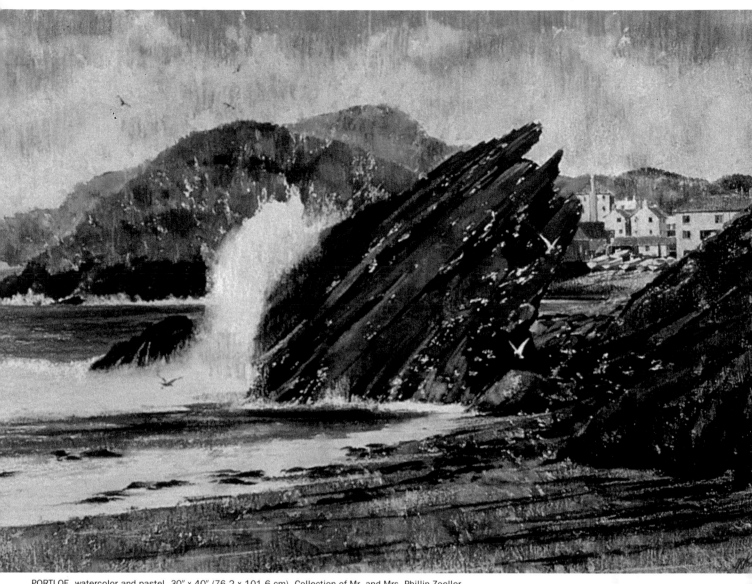

PORTLOE, watercolor and pastel, 30" x 40" (76.2 x 101.6 cm). Collection of Mr. and Mrs. Phillip Zoeller.

I was staying at an inn located on the old smuggler's cove when I did several painting plans and sketches that resulted in studio paintings. At a particular vantage point on the rim of the inlet, I was able to get a good view of entrance to Portloe from the sea. I could only gain access to this view when the tide was out. As the tide rose, it covered the bit of sandy beach in front of me and the surf would crash upon the rocks I perched myself on while putting together a rather carefully constructed painting plan. So I watched the breaking water on the rock form in front of me and at the last possible moment made my escape to higher ground.

I used a liquid resist to save the white of the sea gulls. Using mat board cutout resists, I covered the entire painting surface, except for the area I planned to paint first—the sky shape. I flecked and spattered water with different size brushes and then applied each of the three primary colors. When mixed, the primary colors produced some secondary and tertiary colors. It is the dominance of one or two of the primary colors that establishes the local color. For example, the blue in the sky area is only one of three colors used, but it is the dominance of the blue that identifies the sky. The dominance of red and blue mixed together

produce the local color of the large foreground rocks.

When the sky area was dry, I covered it with the mat board resist and exposed another area to be painted. I proceeded in the same manner until all areas were painted.

When all areas were painted and dry, I removed all the mat board resists and did some careful observational planning. I refined the distant shoreline and rendered the fishing boats and buildings using various sizes of round brushes and the same primary pigments that were used for the rest of the painting. Then I removed the liquid resist from the sea gull shapes and brought them

into conformity with the rest of the painting.

The watercolor as a whole was quite complete for this technique. However, portions of the painting were rendered slightly darker in value than I would have portrayed them because I wanted to incorporate pastels (an example of this is the foreground sand area). But as I have mentioned before, I prefer to have light value pastels rendered over darker valued watercolor pigments if any value change is to be made. The primary colored pastels were applied with vertical strokes. The stroking produced a texture of its own that helped to unify the painting.

SPRING WATERFALL IN DARTMOOR

Between the counties of Cornwall and Devonshire, in England, lies the great Dartmoor National Park. Because the park rests between the Bristol and English channels, it is subject to constant changes of weather. The day I was hiking along the Dart River, the sun was bright and the air almost balmy. At one time paint pigments were mined along the banks of the Dart River, where I discovered a spring-fed waterfall. The colors of soil and rock along the river were bright and varied. This was a perfect place to eat the lunch I was toting in my backpack. The pack also contained a sketch pad and some graphite pencils. For the next couple of hours, I enjoyed the peace and isolated quietness of this bit of forest in the moorland.

When I started my painting some weeks later, I decided to use the non-contact technique (for details see *Early August on Elk River Road* on pages 118–123), adding pastels to my composition during the final rendering stage.

In the "thumbnail" sketches I experimented with the gestures of the waterfall, which contrasted well against the dark shadow of the colorful bank. A footbridge nearby gave me the idea to introduce a cruciform format. The bridge also added a human element that reduced the somber image of the moorlands. However, I abandoned the bridge in my final drawing of the waterfall. As I was rendering the final value sketch, I felt the painting plan evolving and made decisions that would accommodate the painting I was already planning in my head.

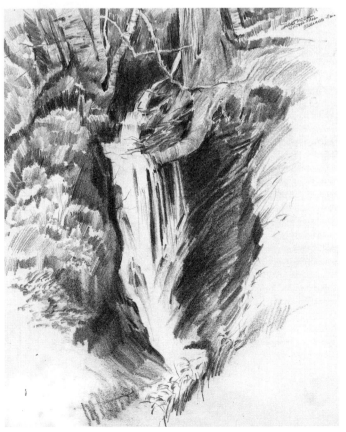

The non-contact technique of flecking, spattering, and splashing the water and primary colored pigments onto specific areas is evident on the cliffs (right). I calculated the direction in which the paint was applied to provide maximum compositional support to the painting. I used a favorite trio of pigments, cadmium orange, alizarin crimson, and Winsor blue. The white of the waterfall was protected with a mat board resist.

Watercolor and pastel work well together. The dry watercolor pigment receives pastel well, and the tooth of pigmented watercolor paper also holds the pastel in place. I carried my watercolor to near completion using the non-contact method of paint application before I started incorporating the pastels.

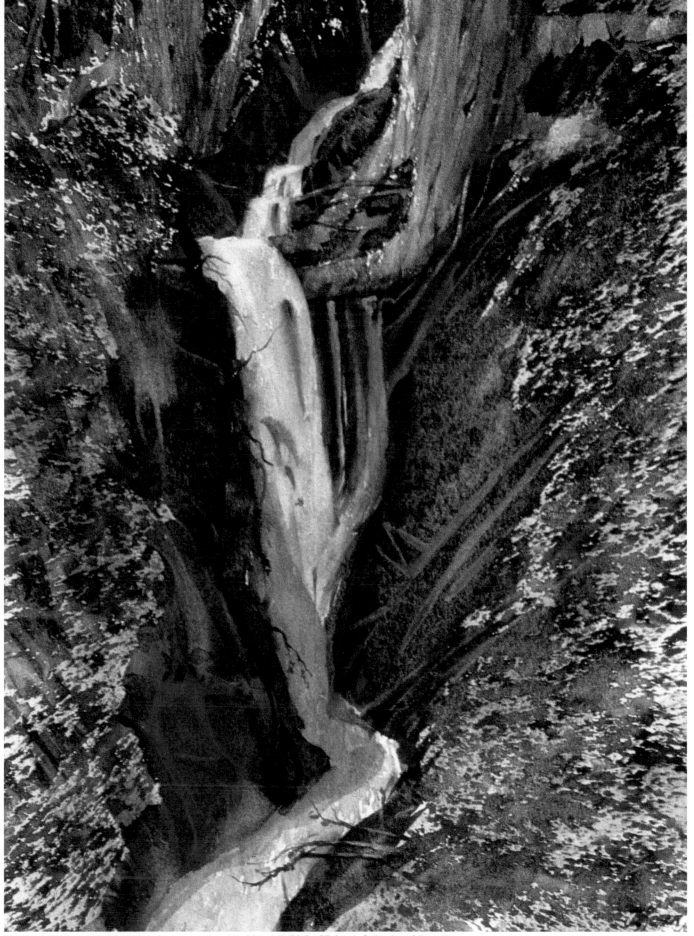

SPRING WATERFALL IN DARTMOOR, watercolor and pastel, 20" x 14" (50.8 x 35.6 cm). Collection of the artist.

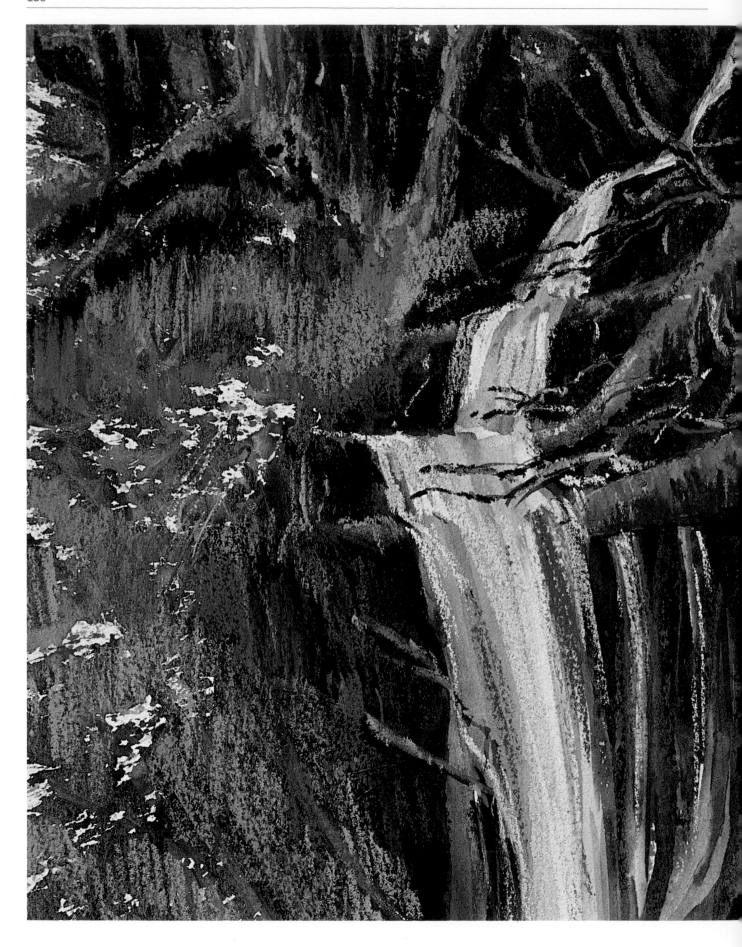

I think that pastels are more effective when lighter valued pastels are painted on top of darker valued watercolor pigments. I work with superfine oil pastel crayons. My pastel box has about sixty-five colors, but I have never used more than six colors in a painting and there are forty colors in the set I have never used.

Notice how all of my pastel strokes were done vertically to give a unifying texture to the composition. The first strokes of yellow, bright brown, and green were introduced in vertical strokes over darker valued watercolor pigments. I almost never do any smudging or blending because the textureless surface it would create would appear out of place with my watercolor textures. I gradually built up the layers of pastel over the entire surface, shaking the painting often to remove loose pastel. I do not attempt to "fix" the pastel with spray (fixatives tend to alter the value and color of the media); shaking the page to remove excess pastel dust minimizes my pastel loss after the painting is completed.

By using more yellow, bright brown-orange, and green pastels, I was able to bring more definition into the landscape. Blue and purple were used to enhance the waterfall. I also refined the forest of trees behind the waterfall and the roots of the trees. Additional strokes of orange, pink, and yellow were added to the foreground foliage.

PRAIRIE CREEK REDWOOD STUMP

The Redwood National Park extends along the Pacific Northwest Coast from Orick to Crescent City, California, with the Klamath River almost dividing the park in half as it empties into the Pacific Ocean. Prairie Creek Redwood is a part of the national park that snakes from the ranger's station on Highway 101 down to the ocean. This entire area was cut for lumber a hundred years ago. Little is left to remind the hiker that this forest was once open to indiscriminate timber harvesting, except for the occasional rotting tree stump. Some stumps are eight to ten feet in diameter. Redwood doesn't really rot; it goes through a gradual disintegration. The tree stumps are surrounded by many saplings. Vegetation abounds and the ferns are prolific. *Prairie Creek Redwood Stump* is a humble attempt to depict some of the essence of the redwood territory.

The painting has a vertical format and a dominant warm mood with some cool color relief. The color reflects the light source and atmosphere of that particular day. The primary tube colors used were new gamboge, Indian yellow, Winsor red, cerulean blue, and Winsor blue. I applied the paint in a non-contact method, with different size brushes to give variety to the paint spatter textures.

First I flecked and spattered generous amounts of water onto the surface, then I applied the pigments, beginning with the yellows, then the red, and finally the blues. No mat board cutouts were used as resists. Instead, I maneuvered the pigments in free form, following the drawing guidelines only in a very general way. The overall watercolor underpainting developed as an abstract design matrix, upon which I could build the anatomical landmarks of the forest with my pastels. I painted with the pastels in vertical strokes and carefully built up layers of light and dark over the entire watercolor underpainting. It was important to keep the movement constant during the stage of refinement. I resisted the temptation of rendering a few square inches at a time to completion. I shook the ground surface often to eliminate the loose pastel dust. The quality pastels adhere well to the tooth of the paper and to watercolor pigment. No fixative was used. I recently rephotographed this mixed media painting and it is holding up well with no loss of pastel pigment.

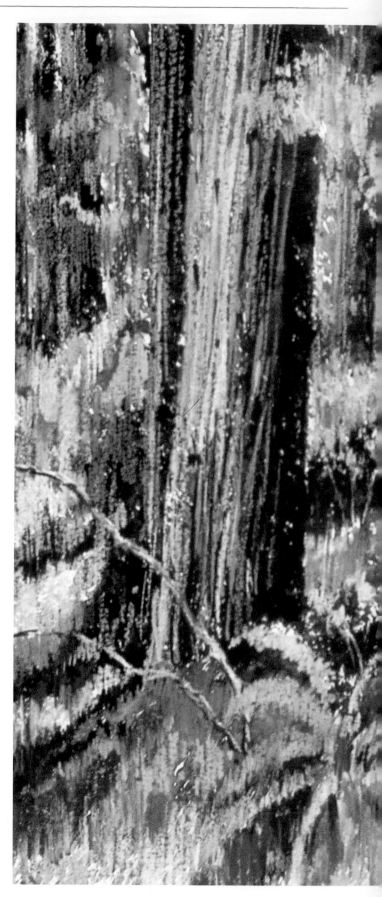

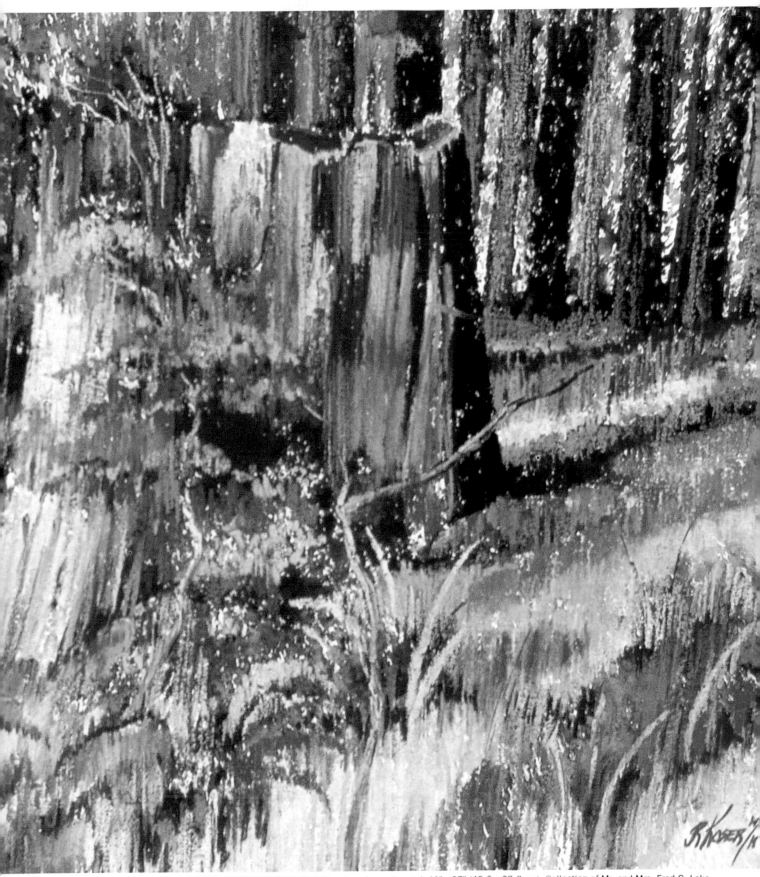

PRAIRIE CREEK REDWOOD STUMP, watercolor and pastel, 19″ x 27″ (48.3 x 68.6 cm). Collection of Mr. and Mrs. Fred G. Lake.

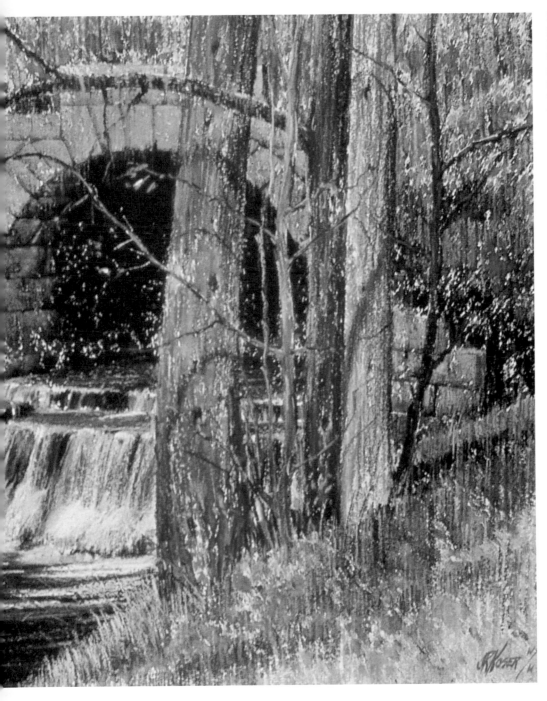

I rendered this painting on cold-press, 100% rag watercolor paper that was stretched and taped down. The drawing for the painting was done from a painting plan that I developed at the tunnel site. I transferred the drawing to the watercolor paper by projecting a slide image of the drawing onto the painting surface and tracing the major shapes and lines. Mat board shapes were used as resists for controlling the watercolor pigment application (for details see *Early August on Elk River Road* on pages 118–123). The painting has a circular format and the dominant mood is warm with a relief of cool greens.

I planned the painting as a mixed media piece. The watercolor portion was done in a non-contact method, using cadmium orange, alizarin crimson, and Winsor blue, with different size brushes. After all areas had received a spattering application, all mat board resists were removed so I could refine the watercolor portion of this mixed media painting. The waterfall, which was just a white shape, was given color and texture. Individual blocks of stone were rendered from the single shape of the tunnel.

The pastel application began with light yellows and oranges that were distributed in vertical strokes over the entire painting. Never is all of the watercolor pigment completely covered. In the foreground and background banks, the pastel is light and airy. The dark of the tunnel, which was made from alizarin crimson and Winsor blue, was hardly touched with pastel. The stream pigment in the foregound is made up of layers of yellow, orange, green, and blue pastel, stroked one on top of the other to produce the deep darks. The trees were a joy to render in pastel over the textured watercolor. The feeling of the bark, the roundness of the trunk and branches, and the saplings intertwined with these shapes almost painted themselves.

DUANESBURG TUNNEL AND WATERFALL

At the turn of the century, a second rail line was planned between New York City and Albany. The mineral baths and hot springs found in such abundance in the Catskill Mountains of upper New York State were very popular with many people as a cure for physical ailments. During the summer the heavy traffic of train travelers was augmented by vacationers fleeing the heat of the city for the cool air of the Catskills.

As the double rail line was being built, many single-track wooden trestle bridges were replaced by earth-filled bridges. This made a safer and more permanent railroad bed for the proliferating rail lines, and introduced the need for stone tunnels to support the railroad tracks. Since most of the trestle bridges that spanned across tiny gorges and valleys contained creek beds, the stone tunnels also became passageways for the water to flow through.

One of the most picturesque stream tunnels I found is located on a country road near Duanesburg. I parked my car at a convenient turn-out in the road and walked back to sketch the bridge and soak up the atmosphere of the warm summer afternoon.

During my information-gathering time, I was visited by several of the local population. Artists are a curiosity and attract the curious. I'm used to that. One of my visitors, a woman dressed in a flour-sack dress, sunbonnet, and huge apron, told me that her grandfather had helped build the tunnel that I found so fascinating. She disappeared but returned moments later with a framed, faded sepia-tone photograph of a group of men posing by this same tunnel as it was being constructed. The earth had not yet been filled over the tunnel and a part of the original trestle was showing in the photo. She pointed to one of the men as her grandfather.

An artist is something of an explorer. I think that searching and finding inspirational subject matter is a technique in itself. Knowing and understanding your subject is born from firsthand exposure.

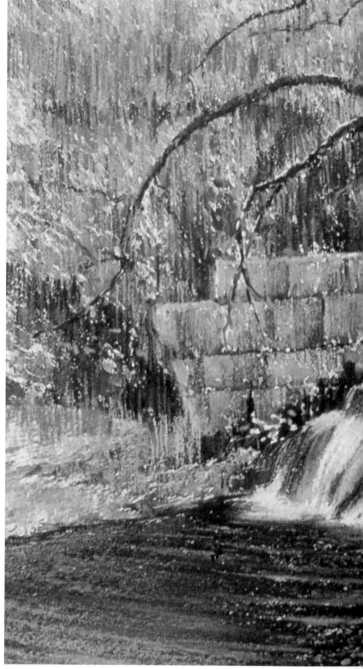

DUANESBURG TUNNEL AND WATERFALL, watercolor and pastel, 22" x 30" (55.9 x 76.2 cm). Collection of Dr. David P. Tonnemacher.

I approached the subject from different directions and made thumbnail sketches to experiment with various formats for my painting plan.

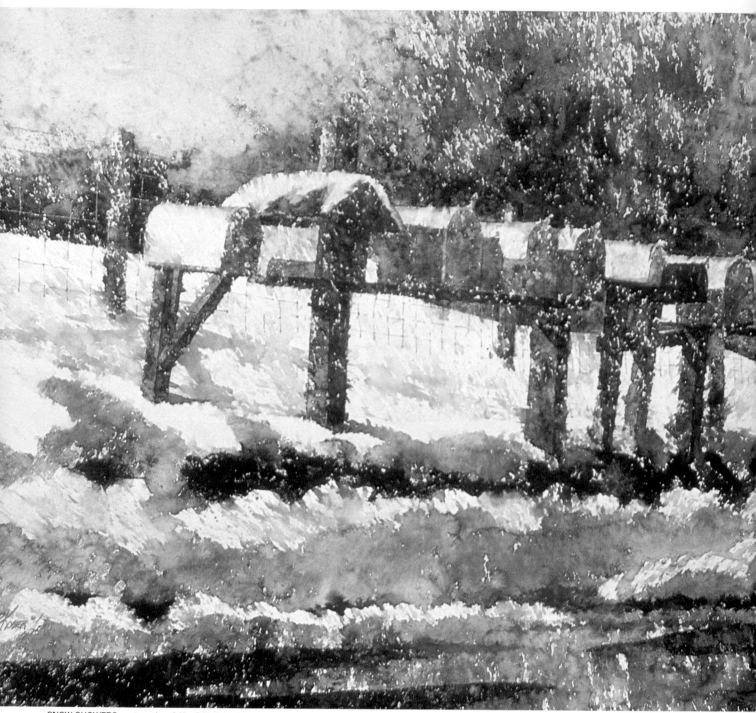

SNOW SHOWERS, watercolor, 24" x 36" (61 x 91.4 cm). Collection of Mr. and Mrs. Donald Tonnemacher.

INDEX

Aerial perspective, 52
Alcohol spattering, in texturing, 102
Atmospheric perspective, 53

Bibury Row Houses, 128–31
Blues, 79
Brandt, Rex, 9

Cast shadows, 51
Circle format, 42
Closed format, 48
Color
 complementary, 64, 69, 70
 contrast, 69
 intuition about, 63
 lifting, 94, 95
 in limited palette, 72, 73
 local and reflected, 65
 mixing on painting surface, 80
 muted and intense, 70, 71
 neutral, 64
 nonstaining, 74
 opaque, 74, 79, 90, 97
 potency, 75–77
 primary. *See* Primary colors
 push-pull effect with, 53
 saturation, 64
 secondary, 64, 72, 78
 sketches, 22
 staining, 74, 79, 96, 97
 temperatures, 64, 66
 terminology, 64
 tertiary, 64, 72, 78
 and texture, 97
 warm and cool, 66, 67
 wheel, 63, 69, 78, 80
 in working palette, 78–79
 See also Value
Complementary colors, 64, 69, 70
Composition and design
 curvilinear, 31
 diagonal, 32
 elements of, 29
 in exploratory drawings, 16
 format in. *See* Format
 horizon line in, 44, 45
 open and closed, 48

rectilinear, 30
 space in. *See* Space, designing
 unifying, 28
 value in. *See* Value
Cool dominance, 66, 72
Cruciform format, 33
Curvilinear composition, 31

Dark-value paintings, 54, 56
Design. *See* Composition and design
Diagonal composition, 32
Diagonal format, 38
Diminishing repeats, 50
Distance, illusion of, 53
Drawings
 exploratory, 16–19, 24
 painting plan, 20–24
 skill of seeing in, 14
 tracing/transferring, 82, 108, 110, 114, 128, 141
Duanesburg Tunnel and Waterfall, 140–41

Early August on Elk River Road, 118–23
Edges, 22, 24, 48, 66, 117, 126
Exploratory drawings, 16–19, 24

Focal point
 format and, 33, 35, 42
 value and, 58, 59
Format
 circle, 42
 cruciform, 33
 diagonal, 38
 grid, 36, 37
 horizontal, 36
 overall pattern, 43
 pyramid (triangular), 40, 41
 S-curve, 38, 39, 110, 132
 steelyard, 35, 132
 vertical, 36

Glazing, 90, 131
Grays, 72
Greens, 78, 80, 82
Grid format, 36, 37

High-key paintings, 54, 68
Horizon line, placement of, 44, 45
Horizontal format, 36
Hue
 defined, 64
 See also Color

Kitchen wrap monoprinting, 73, 100, 101, 110, 111

Light-value paintings, 54
Linear perspective, 50
Local color, 65
Low-key paintings, 54, 68

Middle-value paintings, 54, 55, 56, 57
Monoprinting, 73, 98–101, 110, 111
Mood, and color, 66

Negative shapes, 28, 48, 110
Neutral colors, 64
Non-contact technique, 82–87, 118–23, 124, 126, 128, 131, 132, 133, 134, 137, 138, 141

Opaque color, 74, 79, 90, 97
Open format, 48
Oranges, 82
Overall pattern format, 43

Pacifica Series VII, 110–13
Painting plan, 20–24
Palette
 amount of color on, 79
 limited, 72, 73
 working, 78–79
 See also Color
Paper
 preparing, 108
 weight and texture, 97, 114
 wetness, 88
Pastels, 133, 134, 137, 138, 141
Payne, Edgar A., 9
Perspective
 aerial, 52
 atmospheric, 53
 linear, 50

Pigment. *See* Color

Portloe, 132–33

Prairie Creek Redwood Stump, 138–39

Primary colors, 64
 limited palette, 72
 non-contact method with, 82, 83
 weights, 75
 working palette, 78, 79

Purples, 82

Push-pull effect, 43, 53, 72

Pyramid format, 40, 41

Rectilinear composition, 30

Reds, 78

Reflected color, 65

Resists
 liquid, 84, 94, 96, 108, 109, 110, 111, 119, 123, 126, 133
 mat board, 84, 119, 120, 121, 122, 128, 131, 133, 134, 141

Rooted in the Past, 108–9

Salt sprinkling, in texturing, 102, 103

S-curve format, 38, 39, 110, 132

Secondary colors, 64, 72, 78

Shadows, cast, 51

Shapes, overlapping, 20, 43

Slide transfer technique, 82, 108, 110, 128

Smith, Jack Wilkinson, 110

Space, designing, 49
 aerial perspective in, 52
 atmospheric perspective in, 53
 cast shadows in, 51
 linear perspective in, 50

Spring Waterfall in Dartmoor, 134–37

Steelyard format, 35, 132

Stolker Castle on Loch Linnhe, 124–27

Subjects, 12–13, 140

Techniques
 glazing, 90, 131
 for lifting color, 94, 95

masking. *See* Resists

mixed media, 133, 134, 137, 138, 141

non-contact, 82–87, 96, 118–123, 124, 126, 128, 131, 132, 133, 134, 137, 138, 141

regulating paint flow, 88

selecting, 106

texturing. *See* Texture(ing)

tracing/transferring, 82, 108, 110, 114, 128, 141

warm-up period and, 92, 93

Tertiary colors, 64, 72, 78

Texture(ing)
 alcohol spattering, 102
 as design element, 96
 monoprinting, 73, 98–101, 110, 111
 paper and pigment, 97
 salt spattering, 102, 103
 water spattering, 102, 117

Tina's Cottage on Big Lagoon, 114–17

Trial patches, 92, 93

Triangular (pyramid) format, 40, 41

Underpainting, 88, 119

Unity of design, 28

Value, 20, 24, 53
 balancing, 56, 57
 defined, 64
 focal point with, 58, 59
 high key and low key, 54, 68
 scale of, 54, 55, 68
 See also Color

Vertical format, 36

Warm dominance, 66, 67, 72

Warm-up period, 92

Water, spattering/flecking, 82, 117, 120, 131, 133, 134, 138

Watercolor painting. *See* Color; Composition and design; Techniques; Texture(ing)

Whites, saving. *See* Resists

Yellows, 78–79

Edited by Lanie Lee
Graphic production by Ellen Greene
Designed by Bob Fillie
Set in Century Old Style and Franklin Gothic Demi